A HISTORY OF PHOTOGRAPHY
IN 50 CAMERAS

A FIREFLY BOOK

Published by Firefly Books Ltd. 2015

First printing

Publisher Cataloging-in-Publication Data (U.S.)

Pritchard, Michael, 1964-
 A history of photography in 50 cameras / Michael Pritchard.
[224] pages : color photographs ; cm.
Includes bibliographical references and index.
Summary: "This book provides a close look at the history of 50 different cameras including its origin, its inventors, and the immense profit that it yielded. From the earliest prototype to the more modern digital cameras, the camera has given us a way to keep history itself alive, the moon-landing, World War I and II, and landmarks that have since deteriorated or disappeared altogether." – from publisher.
ISBN-13: 978-1-77085-590-8
1. Cameras—History. 2. Photography—History. I. Title. II. A history of photography in fifty cameras.
771.309 dc23 TR250.P648 2015

Library and Archives Canada Cataloguing in Publication

Pritchard, Michael, 1964-, author
 A history of photography in 50 cameras / Michael Pritchard, FRPS.
Includes bibliographical references and index.
ISBN 978-1-77085-590-8 (bound)
 1. Cameras—History. 2. Photography—History. I. Title. II. Title: History of photography in fifty cameras. III. Title: 50 cameras.
TR250.P75 2015 771.309 C2015-901282-1

Published in the United States by
Firefly Books (U.S.) Inc.
P.O. Box 1338, Ellicott Station
Buffalo, New York 14205

Published in Canada by
Firefly Books Ltd.
50 Staples Avenue, Unit 1
Richmond Hill, Ontario L4B 0A7

Original design by Peter Dawson, Grade Design
Layouts by Luke Herriott

Printed in China

Conceived, designed and
produced by
Quid Publishing
Level 4 Sheridan House
114 Western Road
Hove BN3 1DD
England

A HISTORY OF PHOTOGRAPHY
IN 50 CAMERAS

Michael Pritchard, FRPS

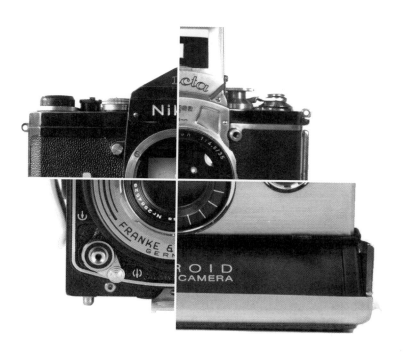

FIREFLY BOOKS

Contents

Introduction

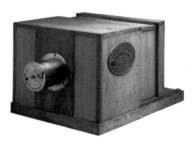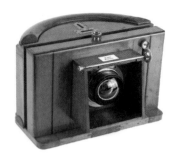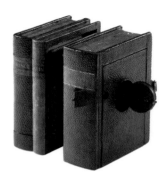

The ability to capture a moment in a photograph, to freeze it in time, has fascinated us ever since the daguerreotype process was announced in 1839. Back then, photography was the pursuit of a select few; today, the ubiquity of camera phones has turned us all into photographers. As these nano-devices attest, the history of photography, perhaps more so than any other art, is also a history of technology, one best revealed in the very vehicle that makes it possible — the camera. And yet it is also a history of people — the people who invented the cameras, the photographers who used them, and the subjects and events they photographed.

The story of the camera has been one of simplification, portability and the greater use of technology to ensure that the user can capture the image they desire. The camera obscura was the simple artists' drawing aid that, with the development of optics and chemistry, evolved into the photographic camera. The transition from the daguerreotype and calotype processes to wet-collodion in the 1850s and from collodion to dry plates in the 1880s, and the move to film from the 1890s, all left their mark on how the camera looked and handled. Then came the seismic transformation of photography from traditional silver-based emulsions to CCD — the digital equivalent of film — and other digital technology in the mid-1990s, which affected the shape and size of the camera and, crucially,

where and when photographs were taken and how they were shared.

These continual improvements and developments have meant that the type of photographs being taken, and the type of people taking them, has been in constant flux too. The technical skill needed for photography for much of the 19th century ensured that most people visited commercial portrait studios if they wanted their portrait taken. The resulting pictures were posed and formal, reflecting the long exposure times and a style of portraiture dictated by an artistic tradition. The growth of popular photography from the later 1890s, with the introduction of more "user-friendly" cameras such as the Kodak Brownie in 1900, changed this dynamic. People began to take more pictures for themselves. This coincided with, and helped to reinforce, an increasing informality in the types of pictures people took and where they took them — a trend that continues in the present day.

The field of photojournalism has also adapted itself to the camera technology available. Robert Capa, for example, would never have been able to take his dramatic images of the Normandy beach landings using plates or the large cameras of the 1850s, yet the quiet, deliberately made images of the Crimean War taken by Roger Fenton in 1855 were equally powerful to the mid-19th century

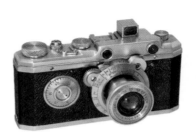
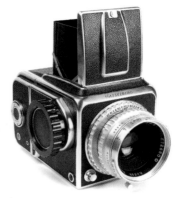

Victorians. Arresting digital images — both still and moving — from the recent wars in Iraq and Afghanistan were made possible by changing technology and of course by the skill and bravery of the photojournalists. Reportage of events such as the Arab Spring, the Haiti earthquake of 2010 and the Japanese tsunami of 2011 has increasingly relied on images taken by individuals on the ground using their camera phones, often within moments of them happening, with social media sites being used to circulate images of the events themselves.

This book seeks to tell the story of the camera through 50 landmark models, from the first wood boxes made for pioneers such as Talbot and Daguerre, to today's digital SLR cameras and camera phones. It is by no means a definitive list, nor does it pretend to be. Rather, it is a selection to spark the interest of camera enthusiasts and provide fuel for further discussion and exploration. Included are classics such as the Leica, Nikon and Hasselblad used by professional photographers, as well as amateur staples: the humblest of box cameras, the Brownie, and the single-use, or disposable camera. Alongside these are speciality cameras for stereoscopic or 3-D photography, panoramic or wide-angle work, and the Polaroid for instant pictures. Some of photography's oddities have also made the list, with novelty cameras in the shape of books and guns, and ingenious spy cameras.

Photographs within each chapter show not only the cameras themselves, but also samples of the images made with them, giving a flavor of how each new technology led to new ways of creating photographs, from early Kodak photos and 3-D View-Master images to the up-close and vivid depictions of war taken on the Contax. The story of each camera is intertwined with those of the people who used it, from Weegee and his Speed Graphic to Cartier-Bresson and the Leica's role in the invention of photojournalism, proving that in the hands of individual photographers, particular cameras have come to represent unique styles of depiction.

In the digital age, where almost everyone owns a smartphone that incorporates a camera, there is always an opportunity to take a photograph. Smartphone apps such as Snapchat, social media sites and new devices such as Google Glass and others yet to come offer new ways of creating still and moving images — and instantly sharing them. For many people, their smartphone is their only camera, and this trend looks set to continue. In a world where the best-selling cameras are phones, dedicated cameras may seem destined to become speciality tools. Yet the legacy of older cameras and photography's analog years lives on, not just in museums and collectors' hordes, but in apps like Instagram and Hipstamatic, showing that classic cameras exert an enduring fascination.

1 The Giroux Daguerreotype

PRODUCED: **1839** | COUNTRY: **France** | MANUFACTURER: **Alphonse Giroux**

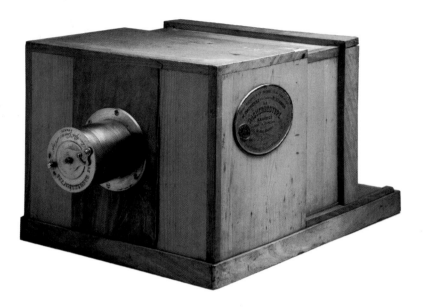

ABOVE **The Giroux daguerreotype cameras introduced in September 1839 were the first of a series of cameras designed for the world's first commercial photographic process — the daguerreotype.**

THE announcement of Louis Jacques Mandé Daguerre's daguerreotype process on January 7, 1839, finally brought to public attention years of experimentation by Daguerre, his former collaborator Nicéphore Niépce (1765–1833) and the latter's son, Isidore Niépce. A short notice had appeared in the *Gazette de France* on January 6, without any details, and news of the process quickly spread. In particular it reached London and prompted Henry Fox Talbot (see page 14) to bring forward the disclosure of his own process.

AN IMPORTANT ANNOUNCEMENT

The announcement of the daguerreotype process by physicist François Jean Arago to the Académie des sciences eventually led to an agreement between Daguerre and Isidore Niépce with the French government, dated June 14, 1839, that granted Daguerre a state pension of 6,000 francs (around $24,250 today), Niépce junior 4,000 francs (around $16,110) for life, and to their widows half of each sum. In return, Daguerre and Niépce pledged to give the Ministry of the Interior a sealed package containing full details of the invention. The process was to be validated by Arago, in his dual role as a member of the Chamber of Deputies and of the Académie, after which it would be publicly demonstrated by Daguerre. The bill enabling the pension and confirming the agreement was passed by the French Chamber of Deputies on July 3, 1839, and by the upper Chamber on July 30.

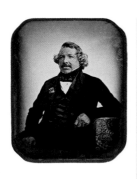

Arago reported on the process before an enormous and enthusiastic crowd on August 19, 1839. The event was hosted jointly by the Académie des beaux-arts and the Académie des sciences. Following the announcement, Daguerre was awarded the Légion d'honneur and showered with honors from around the globe. Despite Daguerre's professed intent to give his invention "free to the world," his agent patented the process in England and Wales on August 14, 1839.

AN EXCLUSIVE DEAL

Daguerre was not only the coinventor of the daguerreotype, he was also an astute businessman. Although the process had been given freely to the world (other than to England and Wales), Daguerre was keen to ensure that he profited from its commercialization. On June 22, 1839, two months before the historic announcement at the Académie, Daguerre signed a contract with his relative Alphonse Giroux to make and sell the first daguerreotype cameras. The contract gave Giroux's company the exclusive rights to produce and sell the camera and the other necessary equipment. From these sales, Daguerre would receive a payment. The basis on which a second manufacturer, Susse Frères, managed to produce its camera is unknown.

The Susse Frères camera, of which only one example survives, went on sale some 10 days before the rival Giroux camera became available. The Susse camera had a lens built by the Parisian optician Charles Chevalier, from whom Daguerre had bought lenses and materials while he developed the daguerreotype process. The camera followed the instructions given by Daguerre and had a plate size of approximately 6½ × 8½ inches (165 × 215 mm), a format that became known as full or whole plate. The camera was almost identical to the Giroux camera other than the wood finish, which was painted black, and the brand stamp, which was simply a printed paper label that stated the camera was made according to the plans of M. Daguerre, which were given to the Ministry of the Interior. The camera sold for 350 francs (around $14,100 today).

Alphonse Giroux et Compagnie quickly launched its own camera, Giroux emphasizing his close relationship with Daguerre and the fact that his camera was made under Daguerre's direct supervision. The contract of June 22 between Daguerre and Giroux allowed for sales of daguerreotype equipment in France and abroad, although Daguerre included a clause to allow him to sell or manufacture equipment in England with the prior agreement of Giroux. In return, Giroux agreed to divide half the profit of sales of each daguerreotype outfit with Daguerre and Niépce.

The first advertisement for Giroux's daguerreotype manual, camera and accessories appeared in *Le Constitutionnel* on September 7, 1839. The Giroux camera was similar to the Susse, and it too had a Chevalier lens. It was made from polished wood and bore an oval lithographic stamp signed by Daguerre himself, with a red wax seal and an inscription noting that the apparatus was only warranted if it carried the signature of Daguerre and the seal of Giroux. The Giroux camera sold for 400 francs (around $1,570 today). Today, around 15 Giroux cameras are known to exist.

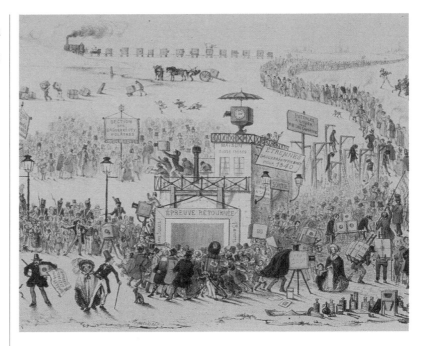

The first official description of the daguerreotype process that was available to the general public came in a handbook written by Daguerre; it included six plates showing the camera and accessories. The first edition of the manual appeared under the Susse imprint probably around September 7, 1839, and an English edition dated September 13 was quickly advertised by the London *Globe.* Further revisions and editions in different languages quickly followed throughout the remainder of 1839.

A STANDARD DESIGN

The Susse and Giroux camera design became the standard for much of the mid-19th century. It established the standard plate size, which later was divided down from the "full" or whole-plate size to half and quarter sizes. The construction, consisting of two boxes, one sliding within the other, mounted on a baseboard, was widely used, particularly in photographic studios where portability was not an issue. It remained popular through to the 1870s. It used a ground-glass screen to compose a picture and to focus the lens.

There were, however, other variants. In England and Wales, where Daguerre had patented his process and photographers were required to buy a license to operate it, the Wolcott daguerreotype camera was supplied by Daguerre's license holder, Richard Beard. Patented by Alexander S. Wolcott in the United States on May 8, 1840, it used a concave mirror to focus the image onto the sensitized daguerreotype plate. George Cruikshank included the camera in an engraving of Beard's studio in 1841.

Charles Chevalier, the Paris optician who made the lenses for the Susse and Giroux cameras, introduced his own daguerreotype camera in 1840. Chevalier had supplied optics to Nicéphore Niépce and had also introduced Niépce to Daguerre; he was probably disappointed not to have been awarded a contract to produce the daguerreotype apparatus. His design of camera could be folded down to a quarter of its assembled height. The camera was more portable than the Giroux and later camera manufacturers took up the design for wet-collodion use.

Other daguerreotype cameras were manufactured for particular demands. In 1841 Alex Gaudin designed a small camera with a short-focus lens that allowed for shorter exposures. Short exposures and more sensitive plates required greater control over the amount of light reaching the plate. Gaudin's solution was a simple cloth shutter, which gave a little more control over exposure than the usual system of simply removing and replacing a lens cover. Made by N.P. Lerebours, the camera also included a rotating disk with three apertures cut into it — a means of controlling the light entering the lens. At 8½ × 9⅛ × 10¼ inches (216 × 242 × 260 mm), the camera was larger than it needed to be to produce the sixth-plate images, but the extra size allowed for the fuming box, plate holders and accessories to be stored inside it. In 1845 in Paris, Friedrich von Martens invented a camera to produce panoramic daguerreotypes. It used curved plates and had an angle of view of 150 degrees.

BELOW **L.J.M. Daguerre,** *Boulevard du Temple,* **believed to have been taken in late 1838 to demonstrate the potential of the daguerreotype process. The exposure was over 10 minutes and shows a man having his shoes polished — the earliest known photograph of a person. Daguerre made two exposures on the same day.**

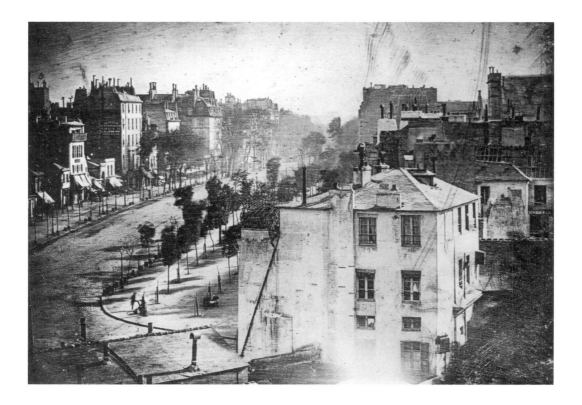

In 1841, in Vienna, Friedrich Voigtländer produced a small camera with a metal body in the shape of a truncated cone. The design meant it could be easily carried, even with the associated processing equipment. Its lens, designed by Joseph Petzval the previous year, allowed for exposures of 40–45 seconds in direct sunlight and 3½ minutes in overcast conditions or in winter — much faster than could be achieved by camaras with larger plate sizes.

In the United States, where the daguerreotype was to enjoy its longest period of use and its greatest success, the Boston daguerreotypist John Plumbe was one of the first to design and sell his own camera. It was based on Daguerre's original design but was smaller and included refinements such as guide rods to support the two boxes. In the early 1840s, other cameras made in America had a chamfered front; this feature was retained even when bellows were introduced in the later 1840s. One of the best-known manufacturers was William and William H. Lewis of New York, which was still making daguerreotype cameras into the early 1850s. In general, American-made cameras were purely functional compared to their more decorative and finely built British counterparts.

In the UK, as the daguerreotype began to achieve commercial success from 1841 with the expansion of portrait studios, scientific instrument makers, chemists and opticians began to manufacture their own camera designs. All were variants of the standard box design. Some used a single box and others sliding boxes. In contrast to the walnut wood usually used in continental Europe and the cheaper woods used in America, the British designs were generally made from mahogany, with lacquered-brass fittings and lens mounts. Their construction reflected their origin in the scientific instrument–making tradition.

The introduction of the wet-collodion process in 1851 and its rapid commercial take-up from around 1854 did not change camera design significantly.

BELOW **A typical French sliding-box daguerreotype camera (left), and the same camera's plate holder and focusing screen (right).**

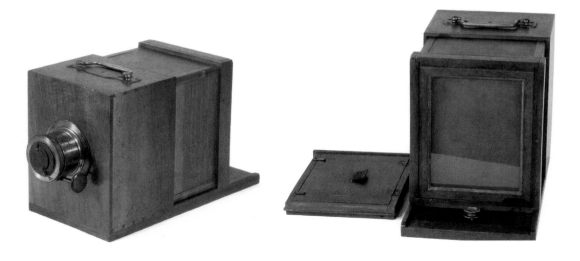

WILLIAM E. KILBURN

The daguerreotype was primarily used for portraits, although some notable outdoor views were also captured. One of the most unusual was taken on April 10, 1848, and shows a Chartist meeting at Kennington Common, London (above). It represents one of the first documentary photographs of a major news event, taken using a process that was technically difficult and not suited to recording such scenes. It was acquired for the Royal Collection by Prince Albert as a record of a time of threat to the Royal Family. The image was taken by William E. Kilburn, a well known London commercial photographer and accomplished daguerreotypist, established in Regent Street since 1846. He was noted for his portraits of royalty (such as that of Prince Albert, 1848, see right) and his daguerreotypes earned a prize medal at the Crystal Palace Exhibition of 1851.

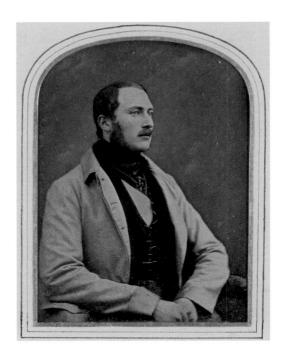

The Talbot "Mousetrap"

PRODUCED: **Late 1830s** | COUNTRY: **UK** | MANUFACTURER: **William Henry Fox Talbot**

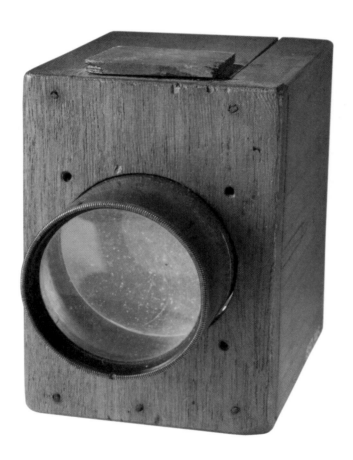

ABOVE **A crudely constructed camera that supported Talbot's experiments from 1835, which led to the development of the negative–positive process of photography and to the calotype process of 1841.**

WILLIAM Henry Fox Talbot (1800–1877) invented the negative–positive process that formed the basis of photography until the rise of digital in the early 2000s. Talbot's "photogenic drawing" process, which he published in a paper to the Royal Society on January 31, 1839, was a response to Daguerre's announcement of the daguerreotype; it was refined to become the calotype process, which Talbot patented in 1841. The principle of making multiple prints from a negative was crucial to the evolution of photography. The daguerreotype process, in contrast, despite its greater commercial success and the higher quality of the images produced by it, was a dead end that would be quickly superseded by the wet-collodion process, announced in 1851.

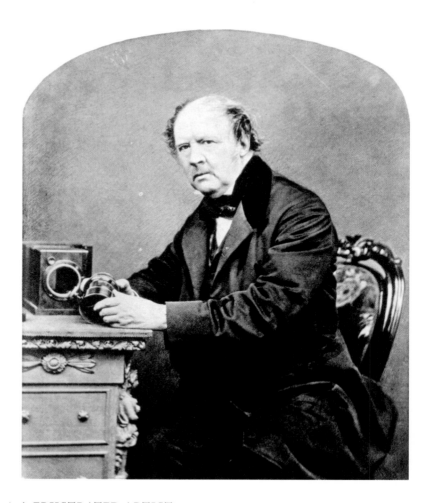

A FRUSTRATED ARTIST

A 19th-century polymath, Talbot was an accomplished mathematician and a Greek scholar, and also worked extensively on deciphering and translating cuneiform. He was introduced to the leading scientific figures of the period, including John Herschel and David Brewster, with whom he formed lasting friendships. He was also a member of Parliament and a landowner, managing the estate of Lacock Abbey in Wiltshire, England.

Talbot was also a frustrated artist and this provided the catalyst for the experiments that were to lead to the invention of calotype. In October 1833, during a parliamentary recess, he visited Lake Como in Italy with his new wife, Constance, and his sisters, taking along his drawing materials to pass the time. He quickly discovered that he was not a natural artist and, even with the help of a camera lucida — an optical drawing aid — his efforts were poor. In his 1844 book *The Pencil of Nature*, which was designed as a showcase for calotype photography, he reported that his pencil sketches were "melancholy to behold." The camera obscura, which produced an image on translucent

paper so that it could be traced with a pencil, was also of little help to him. He reported that his poor draftsmanship led him to "reflect on the inimitable beauty of the pictures of nature's painting which the glass lens of the Camera throws upon the paper in its focus — fairy pictures, creations of a moment, and destined as rapidly to fade away ... the idea occurred to me ... how charming it would be if it were possible to cause these natural images to imprint themselves durably, and remain fixed upon the paper."

Back in Britain, Talbot returned to his parliamentary duties and it was not until the spring of 1834 at Lacock that he began to work on a chemical method to fix images on paper. He was perhaps aware of the earlier work of Thomas Wedgwood (1802) and he knew that silver nitrate would darken in light. This formed his starting point and he quickly produced simple shadow pictures — or negatives — which he called sciagraphs. Talbot recognized the concept of using a negative to produce multiple copies; he also acknowledged the need to "fix" his results to prevent further darkening; something he achieved using potassium iodide.

The following year, 1835, helped by a particularly bright summer, Talbot continued his attempts to develop a process that could capture a scene with tones and not simply "shadows" of objects. What he needed was a box to hold sensitized paper with a lens at the other end — a camera. Talbot had tried to use a conventional camera obscura but the poor-quality lenses produced only a dim image, which was fine for tracing purposes but required very long exposure times to produce an image on specially prepared paper.

BELOW **A reflex camera obscura based on an illustration in Lardner's** *Museum of Science and Art* **(1855).**

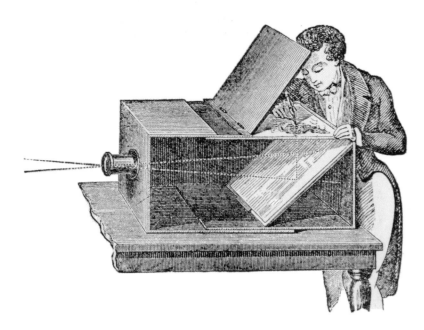

The Talbot "Mousetrap"

Latticed Window
(with the Camera Obscura)
August 1835

When first made, the squares
of glass about 200 in number
could be counted, with help
of a lens.

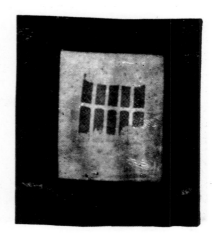

He therefore designed his own camera. He reasoned that a small image produced by a lens of large aperture and short focal length would reduce the exposure time. His "mousetrap" cameras were small boxes, around 2 inch or 3 inch (50 mm or 75 mm) cubes, and roughly made, with large lenses.

The cameras were placed around the grounds of Lacock Abbey and in the Abbey itself. The oldest surviving negative, dating from August 1835, is of a latticed window in the Abbey. By the end of the summer of 1835, Talbot had largely achieved what he had set out to do, although he realized that the results could be underwhelming compared with watercolors or engravings. His work was recognized by his family and appears to have been appreciated and reasonably successful. In a letter written on September 7, Constance asked: "Shall you take any of your mousetraps with you into Wales? — it would be charming for you to bring home some views." He resolved to improve his work before publication, but other matters, political and scientific, intervened, and he put his work on photography aside.

ABOVE **W.H.F. Talbot,** *Latticed Window* **(with a camera obscura), August 1835. One of the most important photographs ever made. This is the earliest negative in existence and was made by Talbot in the South Gallery, Lacock Abbey, looking out of the window. Talbot noted: "When first made, the squares of glass, about 200 in number, could be counted with the help of a lens."**

THE NAMING OF THE MOUSETRAP

A story, most likely apocryphal, tells that Talbot asked the Lacock carpenter Joseph Foden to make up a series of boxes for him. In reality, the cameras are so crudely made that this seems unlikely. At least one surviving camera appears to have been made from a cigar box and still has the remains of a lock on it. Their appearance led his wife Constance to describe them as "mousetraps" in a letter to Talbot of September 7, 1835 (see above).

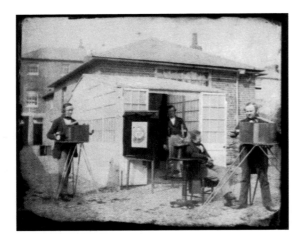

FURTHER REFINEMENTS

In November 1838, Talbot decided to return to his experiments of 1835 and refine his work into a paper that could be published. The announcement by Daguerre in January 1839 was unexpected and shocked him. Although he did not know the details of Daguerre's process, its chemistry or operation, or whether it differed from his own, Talbot knew he had to publish a paper to secure the place of his own work. However, winter was not the best time to produce new images. On January 25, the influential English scientist Michael Faraday displayed some of Talbot's 1835 photogenic drawings at the Royal Institution. On January 31, Talbot published a quickly written paper, "Some Account of the Art of Photogenic Drawing," which was read before the Royal Society; three weeks later, he detailed his working methods.

He began to experiment further and the cameras he had made in early 1839 were professionally crafted. They were larger than his "mousetraps," with some taking negatives of up to 5 × 7 inches (127 × 178 mm), and they incorporated new features. Some of the cameras had a hole in the front panel above the lens so that the image on the paper could be composed and focused. A cork or a sliding brass plate closed the hole during exposure. As Talbot's work progressed toward the development of the calotype in 1841, he purchased commercially made daguerreotype cameras. In October 1839, he ordered two daguerreotype cameras with lenses from Alphonse Giroux via the London optician and instrument maker Andrew Ross at a cost of 310 francs (around $1,210 today). Ross also reported back to Talbot on the optical properties of the Chevalier lenses on the Giroux camera.

Talbot's "mousetrap" cameras were crude but supported his experiments and helped him to achieve exposure times of around 10 minutes in bright sunlight for his photogenic drawings. A key turning point was his discovery that the sensitized papers contained a latent image that could be chemically "developed." As he refined his work and increased the sensitivity of his papers in particular, his cameras changed to reflect the need for something more precisely constructed that would support his work.

ABOVE *The Reading Establishment,* attributed to Nicolaas Henneman, 1846. One part of a two-part panorama of Talbot's photographic printing works at Reading, which was run by Henneman. Talbot is shown operating the camera on the right.

THE CALOTYPE PROCESS

Talbot patented his calotype process in February 1841 and this obliged commercial operators to obtain a license to work it. The calotype was less well regarded than the daguerreotype: the paper absorbed the light-sensitive chemicals, resulting in a soft image, compared to the well-delineated image of the daguerreotype, which was made on a metal plate. In England and Wales, amateurs could use Talbot's calotype process without a license; it was easier and safer to work with than the daguerreotype and so it proved relatively popular. Professionals, however, preferred the better definition of the daguerreotype, so few bought a license from Talbot and those who did failed to make it pay. In Scotland, Talbot's patent did not apply. There, the calotype was used by more professionals, in particular David Octavius Hill and Robert Adamson, who produced a large body of work together. In France, the calotype was highly regarded for its artistic properties, and it also found a limited market in America.

A number of calotype cameras were advertised and produced. The differences between cameras used for the daguerreotype, calotype or wet-collodion processes were slight, with only the plate holders requiring adaptation to hold the different metal, paper or glass light-sensitive supports. One of the best-known calotype cameras was designed by George Cundall, who was a strong supporter of the process. In 1844, he wrote the first practical account of the process. (Talbot had always kept the details obscure to discourage those using it without a license.) The article, which appeared in the *Philosophical Magazine* in February and was later published as a separate manual, also described a camera of Cundall's own creation. It was a sliding-box design and incorporated several new features. There were internal baffles to stop light scattering and the lens was fitted with a hood to prevent lens flare. Most importantly, given the soft-focus image the calotype produced, it included a scale that showed the optical and chemical focus. One would focus the camera for the light, and then the scale would be used to adjust for the chemical focus. The difference in focus reflected the aberrations in the lenses of the period; this disappeared as lenses were corrected.

Cundall's camera was initially supplied by an optical instrument maker, J.C. Dennis of London, and then by other manufacturers and retailers, including George Knight and Son, and Horne, Thornthwaite and Wood, from 1845. Only one example of the camera is now extant, in the Royal Photographic Society's collection.

HENRY COLLEN

Henry Collen (1798–1875) was miniature painter to Queen Victoria. In 1841 he became the first licensee for Talbot's patented calotype process. He also commissioned Andrew Ross, the London optician, to make a photographic lens — the first to be designed in Britain. Collen supplied calotype prints for Sir David Brewster's stereoscope, which until then had only used hand-drawn designs to create the stereoscopic effect. On Christmas Day in 1842, he was asked by the British Foreign Office to photograph the Treaty of Nanking, which ceded Hong Kong to the British. The document contained Chinese characters and photography was the perfect medium to make an exact copy. Collen abandoned the calotype process in 1844 when it failed to meet his commercial expectations.

Ottewill's Double-Folding Camera

PRODUCED: **1853** | COUNTRY: **UK** | MANUFACTURER: **THOMAS OTTEWILL**

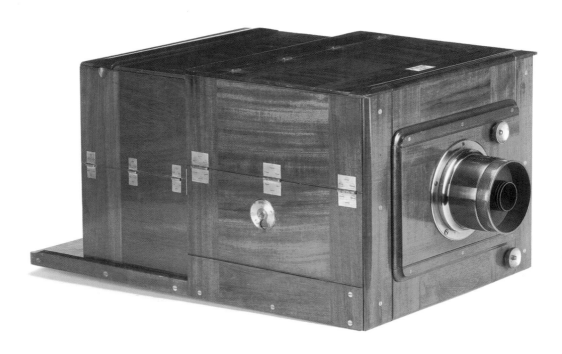

ABOVE **Ottewill's Double-Folding camera (approx. 13 × 10 × 26 inches/ 330 × 250 × 660 mm) represented the best of British camera manufacturing, with a design that made for a more portable camera for the wet-collodion process.**

MANY of the early cameras were boxlike and unwieldy, but as most photographers of the time worked in a fixed studio, portability was not a primary requirement. Before 1850, few photographers traveled; those who did generally used smaller cameras, while those determined to secure large negatives found ways to transport larger cameras that were more at home in the studio. The French manufacturer Chevalier had introduced a collapsible camera for daguerreotype use in 1840 and the design was resurrected by the London maker Thomas Ottewill in his Double-Folding camera of 1853. The result was the first portable camera of reasonable size.

A REPUTATION FOR QUALITY

Thomas Ottewill established his business as a "photographic & philosophical apparatus" manufacturer in 1851. He quickly achieved a high reputation for the quality of his wood and brass work and by the end of 1854 he had supplied a double-folding camera, two dark slides, plate boxes and accessories at a total cost of £49 11s 6d ($6,250 today) to H.E. Becker, on behalf of the Royal Household. Ottewill's business was located at 24 Charlotte Street, Islington, which was close to Clerkenwell, an area that contained many small

manufacturing workshops, including other camera manufacturers. By 1856, the firm claimed to "have erected extensive workshops adjoining their former shops, and having now the largest manufactory in England for the making of cameras, they are enabled to execute with dispatch any orders they may be favoured with." In 1861, around 20 people were employed in its workshops.

The firm's reputation was enhanced by cameras such as the Double-Folding model, the design of which was registered on May 25, 1853. The camera was a sliding box, with the smaller rear box moving inside the larger front box. A board at the front held the lens, and a ground-glass focusing screen slotted into the rear, which also accommodated a plate holder for making exposures. When the front and back were removed, hinges running the length of each box allowed them to collapse down. The design was similar to Chevalier's camera and a number of other British camera makers introduced their own versions. *The Journal of the Photographic Society* commented that Ottewill's design "combined the requisite strength and firmness with a high degree of portability and efficiency."

Despite the firm's reputation and the expansion of the business to offer collodion and chemicals for photography, Ottewill was made bankrupt in 1861 and again in 1864. The reasons are not clear, but the business was clearly struggling. New capital in the form of a Mr. Collis, who joined Ottewill from the lens maker Ross in 1867, failed to help and the firm closed shortly afterward.

Ottewill's legacy was not simply a number of beautifully made cameras; several of his apprentices went on to establish their own successful businesses. He was widely respected among his peers, but he left few traces of his business and personal life beyond the official records of his bankruptcies, the census and advertisements for his cameras.

BELOW **The same camera, closed.**

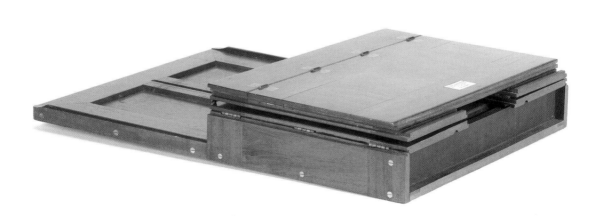

CHARLES LUTWIDGE DODGSON

The Ottewill Double-Folding camera was favored by Charles Lutwidge Dodgson, better known today as Lewis Carroll, the author of *Alice in Wonderland*. Dodgson practiced photography for 25 years, making around 3,000 negatives, mainly using the collodion process. Although he is best known for his photographs of young children, these represent only around half of his output, with families, adults and a few landscapes making up the remainder. Among his most famous portraits are those he made of the young Alice Liddell and Alexandra "Xie" Kitchin. As teaching, writing and family commitments grew, he turned away from photography.

A diary entry by Dodgson describes the purchase of a Double-Folding camera in 1856, the very year in which he met Alice Liddell and her family. Dodgson and his friend Reginald Southey, who had taught him photography, "went to a maker of the name of Ottewill … the camera with lens etc will come to just about £15. I ordered it to be sent to Ch[rist]. Ch[urch]" (Christchurch being Dodgson's Oxford college). Dodgson's £15 (around $1,877 today) would not have included the necessary chemicals or processing equipment, which he purchased additionally from London firm R.W. Thomas of Pall Mall.

The following year, Dodgson immortalized the camera in a parody of Longfellow's well known poem "Hiawatha." Dodgson's "Hiawatha's Photographing" (below) described the camera, the wet-collodion process and the process of making a photograph:

From his shoulder Hiawatha
Took the camera of rosewood,
Made of sliding, folding rosewood;
Neatly put it all together.
In its case it lay compactly,
Folded into nearly nothing;
But he opened out the hinges,
Pushed and pulled the joints and hinges,
Till it looked all squares and oblongs,
Like a complicated figure
In the Second Book of Euclid.

This he perched upon a tripod —
Crouched beneath its dusky cover —
Stretched his hand, enforcing silence —
Said "Be motionless, I beg you!"
Mystic, awful was the process.

First, a piece of glass he coated
With collodion, and plunged it
In a bath of lunar caustic
Carefully dissolved in water —
There he left it certain minutes.

Secondly, my Hiawatha
Made with cunning hand a mixture
Of the acid pyrro-gallic,
And of glacial-acetic,
And of alcohol and water
This developed all the picture.

Finally, he fixed each picture
With a saturate solution
Which was made of hyposulphite
Which, again, was made of soda.
(Very difficult the name is
For a metre like the present
But periphrasis has done it.)

All the family in order
Sat before him for their pictures:
Each in turn, as he was taken,
Volunteered his own suggestions,
His ingenious suggestions.

RIGHT **Alice Liddell as "The Beggar Maid" (detail), by Charles Lutwidge Dodgson, 1858. Alice Liddell is thought to have been the inspiration for Lewis Carroll's *Alice in Wonderland* and was his favorite model. This photograph was inspired by "The Beggar Maid," a poem written by Carroll's favorite living poet, Alfred, Lord Tennyson. Alice would later pose for British photographer Julia Margaret Cameron.**

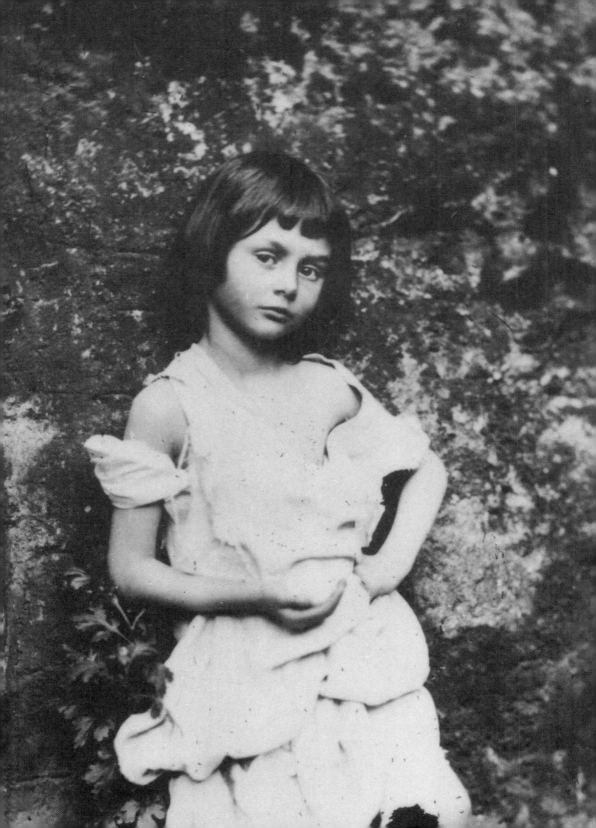

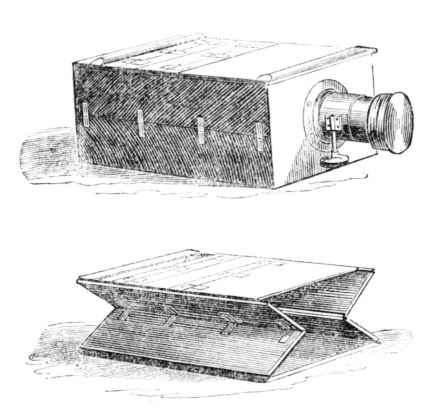

THE VERY BEST OF ENGLISH WORKMANSHIP

At this time, British camera manufacturers dominated camera making in terms of the quality and technical refinements of their cameras. Cameras made in the United States, France or Germany, although they sold in their local markets, were only exported in limited numbers. Ottewill was one of the best British camera manufacturers during the 1850s and 1860s, and he was still recognized as such in the early 20th century. He was able to capitalize on the growth of commercial portrait and amateur photography resulting from the introduction of the wet-collodion process in 1851. Ottewill was part of a small group of camera makers termed "the photographic cabinet-makers," which included George Hare and Patrick Meagher. At the 1862 International Exhibition one reviewer, Samuel Highley, noted that their cameras were "of the very best of English workmanship, and contrast very favourably with the productions of our foreign neighbours."

At least five camera makers — J. Garland, George Hare, T. Mason, Patrick Meagher and A. Routledge — all worked for Ottewill before establishing their own businesses as photographic manufacturers. Each had entered photography directly rather than having come via scientific instrument making, as was the normal route. Hare had served an apprenticeship as a joiner before he worked with Ottewill, Collis and Company, where he stayed for a short period before

ABOVE **Bland & Company's folding camera was its version of Ottewill's folding design. The company was taken over in 1864 by Negretti and Zambra, best known for its scientific instruments.**

INNOVATIVE DESIGNS

In addition to his own designs, Ottewill also made cameras designed by Frederick Scott Archer, the inventor of the wet-collodion process, and Captain Francis Fowkes, who in May 1856 patented a camera that used cloth bellows rather than wood to save weight and improve portability. It was the first British camera to use concertina-pattern pleated bellows. Fowkes' camera was manufactured from the summer of 1857, with Ottewill securing a government contract to supply the camera to the Royal Engineers. Ottewill also produced a miniature camera inspired by Thomas Skaife's Pistolgraph of 1859 (see page 46).

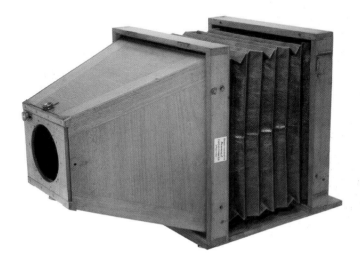

LEFT **Fowkes' camera was the first to use cloth bellows, rather than a wood body, between the lens and plate.**

establishing his own business around 1857. Meagher, similarly, started as a joiner's apprentice around 1843 before working for Ottewill and then establishing his own business by 1859. As a result, they were fully conversant with photography. Specialization helped them to develop their customer base, giving them an advantage over general instrument makers who made everything from scientific to navigational instruments.

In 1898, the *British Journal Photographic Almanac* noted that Ottewill "may be regarded as the source to which the best school of English camera-making traces its origin." Ottewill and his contemporaries represented the traditional form of handmade camera construction, producing high-quality products in limited quantities.

Despite long careers, Hare and Meagher failed to make their later products innovative or to improve their manufacturing methods beyond simple workshop machines; the cameras they were producing at the end of their careers were almost identical to those with which they had started in the 1850s. Hare had largely retired by 1911 and Meagher died in 1897. Eventually, new camera designs from the United States and Germany usurped the leading position that British camera making had held from the mid-1840s.

Powell's Stereoscopic Camera

PRODUCED: **1858** | COUNTRY: **UK** | MANUFACTURER: **HORNE & THORNTHWAITE**

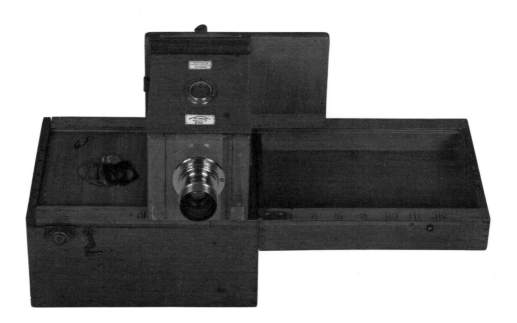

ABOVE **A portable camera designed for taking stereoscopic photographs; part of a long history of stereoscopy that stretches from before the invention of photography to today's digital 3-D cameras, 3-D television and 3-D Imax.**

THE principle behind stereoscopy was that two slightly different images of the same subject would, when combined in a viewer, produce an illusion of three dimensions. Before the announcement of photography, drawings or printed pairs of images were made to achieve this effect, and stereoscopy remained little more than a scientific curiosity.

The daguerreotype had been used for producing stereoscopic portraits, but the introduction of Fox Talbot's calotype process in 1841 gave stereoscopy a boost. The first stereoscopic photograph was a portrait of the mathematician Charles Babbage, made in 1841 by Henry Collen. Talbot produced stereo pairs of images for Sir Charles Wheatstone, a Victorian scientist with wide-ranging interests across many areas of science. Talbot did this by simply moving his camera an appropriate distance between exposures.

Wheatstone designed a reflecting stereoscope in 1838 to combine the two images, and then in 1844 Sir David Brewster developed his lenticular stereoscope and a camera with two lenses for taking portraits. This attracted little attention and it was only when Brewster traveled to Paris in 1850 and demonstrated it to the opticians Soleil and Duboscq that its value was recognized. Duboscq began manufacturing the stereoscope and produced a series of stereoscopic daguerreotypes of statues, still-life subjects and natural history, as well as portraits.

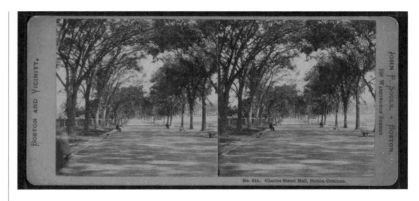

RIGHT **Charles Street Mall, Boston Common, by John P. Soule, c.1870.** From the series "Boston and Vicinity." Such views from across the world were widely sold.

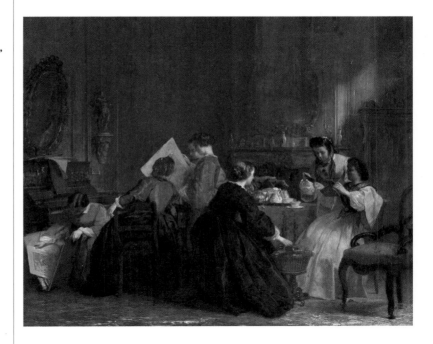

RIGHT *Company of Ladies Viewing Stereoscopic Photographs*, by Jacob Spoel, c.1860. As shown in this Dutch painting, viewing stereoscopic images was a popular parlor activity. It provided both entertainment and education.

THE STEREOSCOPIC CRAZE

The 1851 Great Exhibition acted as the catalyst that transformed stereoscopy from a minor scientific interest into a popular one that quickly spread across the world. This, combined with the introduction of the wet-collodion process, made possible the mass production of stereoscopic photographs and slides. As a result, stereo photographs became easier and much cheaper to produce. Photographers, print dealers, booksellers and companies such as the London Stereoscope Company, which was founded in 1854, began retailing hundreds of thousands of stereocards of people and places. By the 1860s, no middle-class home was complete without a stereoscope and a selection of stereocards.

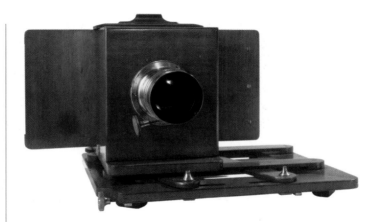

The first camera that achieved any great popularity specifically for taking stereoscopic pairs of photographs was demonstrated by Josiah Latimer Clark at the Photographic Society of London on May 5, 1853. Prior to this, photographers had generally used a single-lens camera and simply moved it between exposures to capture the two images required to make a stereo pair. The technique limited the photographer to taking still-life subjects or views where any movement or changes between exposures would be minimal.

The Latimer Clark camera was mounted on a movable parallelogram frame so that it could be shifted the required distance between exposures. A string and pulley system connected to the plate holder ensured that the second exposure was taken on the other half of the sensitized plate. This arrangement allowed for the two exposures to be made in quick succession so that any changes in the scene between the two were minimized. The design remained popular and continued to be advertised well into the 1870s.

Perhaps the simplest and most obvious way to secure the two photographs required was to have a camera with two lenses mounted side by side. The first British provisional patent for such a camera was granted in July 1853 and the first twin-lens stereoscopic camera that was offered for general sale was made to the design of John Benjamin Dancer, patented on September 5, 1856. The design was a more advanced model of one that he had first described in 1853.

THE PORTABLE STEREOSCOPIC CAMERA

John Harrison Powell, an optician working in Newgate Street, London, registered his design for a portable stereoscopic camera on November 27, 1858. The small camera was mounted in a wooden box, the lid of which acted as part of a track along which the camera moved to make the two exposures. Adjustments allowed for the internal lenses to converge slightly toward a subject that was close to the camera. The mahogany camera had hinges along its sides that allowed it to collapse down — much like the Ottewill camera — when it was not in use. The camera, along with its plate holders and accessories, fitted inside the mahogany box, which, at 9 × 5½ × 6 inches (229 × 140 × 152 mm) and weighing 5lbs (2.3kg), could easily be carried.

Powell's design was made by the London firm Horne & Thornthwaite, a company that made and retailed photographic and scientific apparatus. It is likely that Powell worked for the company. The intention behind the camera was reported in *The Photographic News* on January 7, 1859: "The object in the construction of this apparatus has been to make it portable, and at the same time as simple as possible, so that it may be easily put together; also to avoid the use of loose pieces, which are objectionable from their liability of being left behind when packing up."

STEREOSCOPY REVISITED

The public interest in stereoscopy began to wane by the 1870s; although cameras and stereographs continued to be sold, the mass interest of the 1850s and early 1860s had dissipated. However, stereoscopy continued to reappear at roughly 30-year intervals: in the 1900s, the 1930s, the 1950s and the early 1980s. During these periods of popularity, camera manufacturers tended to adapt existing cameras by enlarging them and adding an additional lens, thereby turning a regular model into a stereo camera. In some cases, they designed a new model to meet public demand. Manufacturers of sensitized goods — plates and papers — produced appropriate sizes, standardized at $2^{7}/_{16} \times 5^{1}/_{8}$ inches or $1^{13}/_{16} \times 4^{1}/_{4}$ inches (60 × 130 mm or 45 × 107 mm), to support the taking of stereo pairs and the printing of them onto paper, or for turning into slides for viewing by transmitted light in a stereoscope.

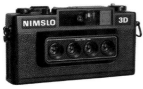

ABOVE **The Nimslo camera of 1980 was a short-lived attempt to resurrect stereo photography. The cameras are now collectible and continue to be used by a dedicated group of enthusiasts.**

The revived interest in stereoscopy in the early 1980s followed the introduction of the Nimslo camera in 1980, with which lenticular prints were made from four negatives. These used tiny lenses on the surface of the print to help create the three-dimensional (3-D) effect. However, that interest was short-lived and the Nimslo company collapsed in 1989. There has since been a renewed interest focused on digital techniques for producing 3-D images. In July 2009, the Japanese Fuji company launched its W1 camera. This was followed by the W3 in August 2010, which was a stereoscopic compact point-and-shoot camera with the ability to capture 3-D images and videos. The camera featured a rear screen that showed the 3-D image and Fuji also offered a printing service, as well as a 3-D digital photo frame in which to display the captured images.

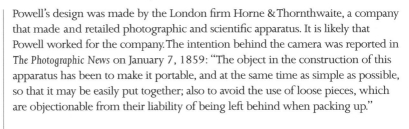

TOWARD A 3-D FUTURE?

New digital techniques are now widely available to allow photographers with single-lens cameras to combine a pair of images for a 3-D effect, and this has coincided with a renewed interest in 3-D television, 3-D films and 3-D Imax. Public imagination has once again been stimulated and it seems that 3-D may yet achieve a permanent breakthrough. Sales of 3-D–enabled televisions have grown, rising from 2.26 million units in 2010 to 41.45 million in 2012. However, development of a 3-D television set that functioned without the need for special glasses (autostereoscopy) intended for the consumer market was abandoned by Philips in 2011 because customers were slow to move from 2-D to 3-D. The recurring problem of having to provide a special viewer or glasses and the need to provide 3-D digital content for public consumption may yet delay mass take-up for another 30 years.

5 The Sutton Panoramic

PRODUCED: **1859** | COUNTRY: **UK** | MANUFACTURER: **Thomas Ross**

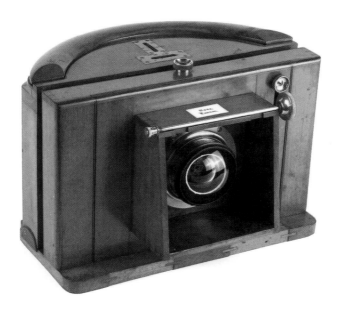

ABOVE **Thomas Sutton's panoramic camera of 1859. The flap shutter has been removed to show the distinctive water-filled lens.**

DESPITE the limitations and complexity of the daguerreotype and wet-collodion processes, landscape and outdoor photography was a popular pursuit for photographers and one that offered significant commercial opportunities for the sale of photographs. As early as 1842, the French photographer Joseph-Philibert Girault de Prangey was touring the Mediterranean taking pictures of places using the daguerreotype process. But the conventional camera lens gave an angle of view of only 40 to 50 degrees and so, in order to do justice to the landscape views they were shooting, photographers would take multiple photographs and either show them in sequence or mount them together.

Once the wet-collodion process and more portable cameras were introduced, photographers were able to take pictures of remote places. Increasing tourist travel meant that there was a growing market for such photographs and the panoramic photograph could command a higher price than a single image. Other than joining separate photographs together, photographers had three ways of making such pictures in a single operation using their camera: they could rotate the lens to cover an elongated plate; they could move the light-sensitive plate or film across the projection of the lens (in both these cases there would have to be a slit over the plate); or they could use a camera with a wide-angle lens. All of these methods were employed from the mid-1840s onward. The first two methods required complex mechanisms such as strings and pulleys to effect the movement in an even and controlled way. The third was simpler but required the use of new lens designs.

THE FIRST WIDE-ANGLE LENS

The first panoramic camera with a wide-angle lens was Thomas Sutton's camera, which used a lens that he patented on September 28, 1859. The British patent described "improvements in the construction of apparatus for taking photographic pictures, consisting of and entitled an improved panoramic lens for taking photographic pictures." The lens design was distinctive in that between the glass elements a liquid was added, most commonly water. This changed the refractive index on the lens. The glass plates onto which the light-sensitive emulsion was coated were curved to conform to the irregularities in the optical performance of the lens. This ensured that the scene was sharply focused across its width and from top to bottom.

Sutton was a photographer, an opinionated commentator on photography and the editor of his own periodical, *Photographic Notes*. In the December 15, 1859 issue of *Photographic Notes* he wrote a lengthy description of his camera and the equipment needed to make panoramic photographs. He explained the problem: "The most serious trouble which the photographic tourist has hitherto encountered arises from the circumstance that his lens will only include small angle of view." He noted that his lens would "include more than one-third of the entire horizon, and an angle of from 30° to 40° vertically." Full of self-confidence, he concluded: "Such is the construction of the Panoramic Lens; an instrument which opens a new and important field to photographers, and will, no doubt, amply repay any artist of energy and ability who takes it up at once."

ABOVE **Sutton's panoramic lens was initially made by Frederick Cox and then by the London optician Thomas Ross. It gave an angle of view of 120 degrees.**

BELOW **Taken from Thomas Sutton's publication** Photographic Notes, **the illustration shows the camera and associated apparatus including a stereoscope for viewing panoramic pictures.**

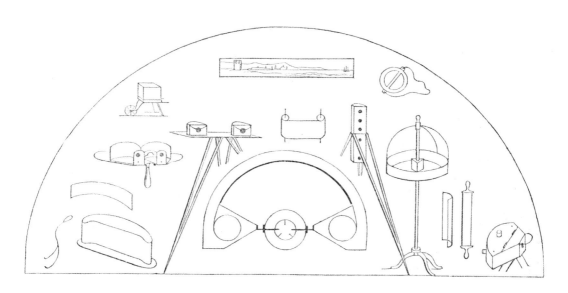

PANORAMIC LENS AND APPARATUS

CAMILLE SILVY

Camille Silvy (1834–1910) was a minor French diplomat whom Cecil Beaton named the "Gainsborough of commercial photographers." He took up photography in 1857 to supplement his poor drawing skills and moved to London in 1859, setting up a portrait studio with a clientele from the upper classes and royalty. He was probably the first photographer in London to make cartes-de-visite ("visiting cards," small photographs mounted on card). Silvy was one of the first photographers to purchase Thomas Ross' "Sutton's Patent Panoramic Lens" as, in addition to his practical photography, both commercial and artistic, he was interested in landscape photography. He even invented his own camera to take panoramic images, which was demonstrated with a photograph of the Champs Elysées in 1867. Silvy retired due to ill-health in 1868 and moved back to France. As well as being a commercial photographer, he considered himself an artist. His *River Scene* (1858), taken near Nogent-le-Rotrou, France, which made use of multiple negatives to produce the final image, was widely exhibited and praised. He also made still lifes in the old master painting tradition and a series of street scene studies which, although posed, were almost documentary in nature. He experimented with transferring photographs to ceramics and making them permanent with printing ink.

RIGHT *River Scene*, Camille Silvy, 1858. The photograph was highly praised for its artistry and widely exhibited at the time.

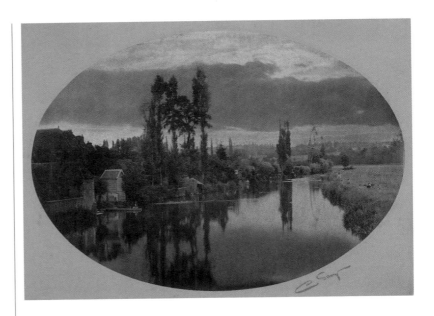

A CAMERA TO FIT THE LENS

Sutton commissioned the London photographic and scientific instrument maker Frederick Cox to manufacture the camera that would carry his globe lens. The first model was produced taking 6 × 15 inch (152 × 380 mm, but always sold in inches) plates, and in April 1860, a second model was made in two sizes for 3 × 7 inch and 10 × 25 inch (106 × 178 mm, 254 × 635 mm) negatives. By November, it was being advertised in four sizes: 1¾ × 3½ inch, 3 × 7½ inch, 4 × 10½ inch and 6 × 15 inch (45 × 83 mm, 76 × 190 mm, 101 × 267 mm and 152 × 380 mm). Only five or six examples were

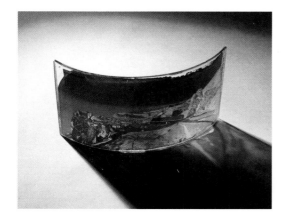

manufactured by Cox, who was encountering difficulties in finding suitable glass for the lenses. In January 1861, Sutton announced that Thomas Ross, the London optician and instrument maker, would take over the manufacture of the camera and lens. By the beginning of May 1861, Thomas Ross had made his version of Sutton's panoramic lens, which was a considerable improvement on Cox's. The panoramic lens was the first significantly wide-angle lens to be offered for sale and gave an angle of view of 120 degrees.

Ross purchased the rights to Sutton's patent in August 1861 and by November was advertising cameras in three sizes: 5 × 9 inch, 6 × 12 inch and 8 × 16 inch (127 × 229 mm, 152 × 305 mm and 203 ×406 mm). His first customer was the London society and studio photographer Camille Silvy, who was to patent a roll holder for the camera. Sutton's panoramic camera does not seem to have been advertised after 1862.

In practice, the camera seems to have been used only to produce wet-collodion negatives on glass. The curved glass plates required curved plate holders, as well as curved printing frames in which to produce the prints. The camera made use of curved plate holders to hold either paper, glass or mica as the support for the emulsion. It was not very practical, but it did what it was intended to do. Although few cameras and lenses were made, it did travel and at least two of these cameras ended up in Australia, where they were used to record the growing towns and settlements. Kilmore, a small settlement near Melbourne, was photographed between c.1861 and 1865 with a Sutton panoramic camera.

Although there were some competitors to Sutton's wide-angle lens, such as Harrison's Globe lens of 1860, it was not until new optical glasses and new methods of calculating lens design appeared in the 1890s that wide-angle lenses began to be developed more widely. Cameras designed only for taking wide-angle, or panoramic, photographs have appeared right through to the present. Today, panoramic features on digital cameras show that the demand for wide-angle views by tourists remains, and single-use panoramic cameras are still manufactured for both amateurs and professionals.

6 The Kodak

PRODUCED: **1888** | COUNTRY: **U.S.A.** |
MANUFACTURER: **The Eastman Dry-Plate and Film Company**

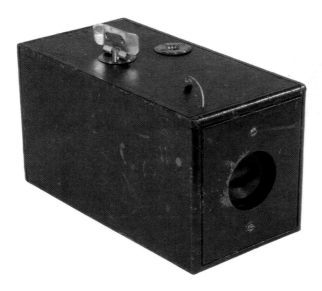

ABOVE **A landmark camera that changed photography, not so much for its design but for the system of photography that it introduced.**

THE introduction of the Kodak camera in 1888 is frequently seen as the start of popular photography. The reality is more nuanced. Although the Kodak camera was a milestone on the road to mainstream photography, it is more important for some of the innovations that the camera successfully introduced: simplicity of operation, celluloid roll film, and a develop-and-print service. Later cameras from Eastman Kodak Company were to build on these new measures and, arguably, do more for the growth of amateur photography than did the original Kodak.

DEVELOPMENT OF THE ROLL HOLDER

The glass plate and wet-collodion process constrained camera development; it also limited photography to those willing to expend considerable effort and time in operating cumbersome equipment and manipulating a complicated process. The development of a reasonably sensitive dry plate in 1871 and its commercialization and acceptance from the later 1870s opened up opportunities for new camera designs. Glass plates were still limiting, and efforts were made to find an alternative base to carry light-sensitive emulsion. In the 1850s, there had been several attempts to use a sensitive paper band to allow a photographer to make images consecutively. None of the designs had amounted to much. In 1875, Leon Warnerke, a Russian living in London, described a roll holder that used a paper roll coated with a film of gelatine or collodion onto which a light-sensitive emulsion was applied. After exposure

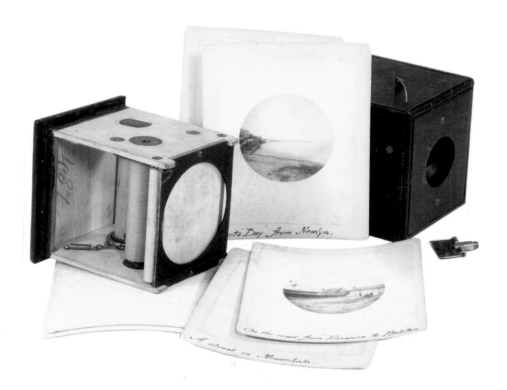

ABOVE **The Kodak
camera. On the left is
the roll holder, through
which the stripping
(and later celluloid),
film was threaded and
wound to make the 100
exposures. The camera
made distinctive 2¾ inch
(70 mm) circular images
that were mounted
onto cards.**

the emulsion was stripped from the paper backing for processing.
The Eastman–Walker roll holder was patented in 1884 and placed on the
market the following year. It was invented in Rochester, New York, by George
Eastman, who had achieved considerable success selling sensitized glass plates,
and William H. Walker, a camera manufacturer. The holder carried Eastman's
negative paper, which was threaded through the device. It was made in a
variety of sizes and was designed to fit most standard plate cameras.

Roll holders offered immediate advantages to the photographer. They
allowed multiple exposures to be made without the need to carry heavy
glass plates and processing equipment, and they would fit existing cameras.
They were popular, and a number of designs were introduced by a variety
of manufacturers, although the Eastman design saw the greatest success.
During the summer 1888 outing of the Camera Club, one of the larger
London photographic societies, some 35 percent of its members' negatives
were made using a roll holder.

Camera design evolved to incorporate a fixed roll holder as part of
the camera body. Eastman saw the potential of incorporating a roll holder
directly into a camera, and in 1886 he was granted a patent with Franklin
M. Cossitt for such a camera. The design was difficult to make, and only
50 cameras had been completed by June 1887. However, Eastman
learned from the experience and designed a simpler camera that would
prove revolutionary.

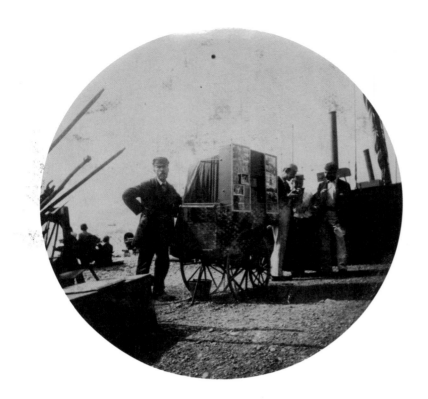

THE COMPLETE PACKAGE

On May 9, 1888, in England, Eastman was granted patent number 6950 for "Cameras; shutters; roller slides." The patent stated: "Consists of a rectangular box, in one end of which an instantaneous shutter is fitted, and in the other a roller slide." Eastman had combined a roll holder with a simple camera and shutter mechanism. It was sold as the Kodak camera. The Kodak used a paper-backed stripping film on which 100 negatives, each 2½ inches (64 mm), were made. Stripping film was Eastman's first attempt to develop a flexible film and consisted of a paper backing for the film, which was removed or "stripped" during processing. The lens was such that subjects more than 3 feet 3 inches (1 m) away would be in focus. All the photographer had to do was point the camera, set and fire the shutter, and wind on the film for the next exposure. Simple!

But the camera was only part of the package. Eastman recognized that his market extended beyond amateur photographers with some interest in the technical side of photography to anyone who simply wanted to make pictures of family and friends and the places they visited — in other words, the general consumer market. Eastman's revolutionary idea was to provide the Kodak ready-loaded, and for it to be returned to the factory or dealer for

ABOVE **Unknown photographer, c.1890. The subject is shown with his portable darkroom and would have made tintype "instant" portraits. This photograph was made with a Kodak camera and is a good example of the new style of informal photography that the Kodak helped to introduce.**

the film to be processed and printed. The camera was then reloaded and returned immediately to the customer, followed by the prints.

Eastman wrote in *The Kodak Primer*: "The principle of the Kodak system is the separation of the work that any person whomsoever can do in making a photograph, from the work that only an expert can do.... We furnish anybody, man, woman or child, who has sufficient intelligence to point a box straight and press a button ... with an instrument which altogether removes from the practice of photography the necessity for exceptional facilities, or in fact any special knowledge of the art."

The photographic press was fulsome in its praise. *Amateur Photographer* magazine described it as "the most beautiful object that has ever been offered to the public in connection with photography." The *British Journal of Photography* called it "a little marvel of constructive skill" and the *Photographic News* foresaw that it would bring in to photography "those who do not wish to devote the time and attention which is necessary to really practice photography, but who desire to obtain records of a tour, or to obtain views for other purposes."

Commercially, the Kodak camera was less successful. After an initially enthusiastic response, sales softened so that no more than around 10,000 were sold worldwide. It was expensive at $25 or 5 guineas (around $564 in today's money) for the camera, with reloading and printing costing $10 (around $235) for the 100 exposures. A new model, the No. 2 Kodak, was introduced in 1889 and at the end of that year celluloid — a far more practical carrier for the sensitive emulsion — replaced stripping film.

GEORGE EASTMAN

George Eastman (1854–1932, pictured left) was a bank clerk by profession; he practiced wet-collodion photography as a hobby and in 1878 started making his own dry plates, which he sold commercially from 1880. His roll holder of 1884 introduced a flexible emulsion support, and the launch of the Kodak in 1888 began the company's inexorable growth, which continued until the 1980s. He recognized the importance of selling film (not only cameras) to succeed in the industry, and played a key role in planting photography at the forefront of popular culture. As the *Chicago Tribune* observed in 1891, "The craze is spreading fearfully ... when amateur photography came, it came to stay." Eastman introduced innovative products and dynamic ways of marketing them, and also recognized the importance of research and development.

THE KODAK EFFECT

The overall effect of the Kodak camera was threefold. The camera and the ideas that underpinned it were quickly copied by rival companies in the United States, Britain and Europe, although none of the competing designs had the finesse of the Kodak, and none had the extensive infrastructure to provide the develop-and-print service that would make the company profits. Competition within the market resulted in new designs and lowered prices.

Secondly, the Kodak introduced new methods of marketing to the photographic industry. These were underpinned by methods of mass-production and by the idea that sales of the camera would generate sales of film, where the real profits were to be made. The focus of marketing shifted from the camera to the taking of photographs. Eastman's company introduced these ideas and realized them more rapidly than any of its rivals. As a result, it quickly made significant profits that funded further expansion of its factories and retailing. They also supported what economists term "vertical integration." The Eastman Dry-Plate and Film Company began manufacturing its raw materials, or bought companies that could supply them; it set up a series of stores to retail cameras, sensitized materials, and developing and printing services. In addition, it established a dealer network, which it supported through generous trade discounts, and also attempted to monopolize aspects of the photographic trade.

The third effect was on the type of photographs being taken. The Kodak camera and its successor models helped to introduce an informality to photography. Subjects were frequently more relaxed, laughing and smiling; they were candid; babies and children were portrayed playing; and they showed people caught unawares, informal groups in parks and on beaches, picnicking, holidaying, traveling, or simply at home in domestic settings or undertaking domestic chores. These were a world away from the formal studio portrait with its stern faces and reflected the fact that they were being taken by people who were not photographers — exactly as Eastman had expected. The trend toward informality continued throughout the 20th century. Even main-street studios adopted less formal styles of portraiture. The revolution in photographs started by the Kodak has now found its ultimate expression in the informality and immediacy of today's camera-phone pictures.

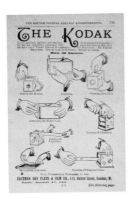

ABOVE **The Kodak camera was advertised widely from its introduction. This advertisement from the 1889 British Journal Photographic Almanac shows the steps needed to operate the camera and process the film.**

"YOU PRESS THE BUTTON, WE DO THE REST"

The Kodak system of photography was groundbreaking in its concept and Eastman supported it with an extensive advertising campaign under the headline: "You press the button, we do the rest." Advertisements appeared not only in the photographic press, but also in popular titles such as Punch and newspapers such as The Times. Dealers were supplied with supporting literature and examples of the photographs the camera could produce. New models of Kodak cameras were regularly introduced, each with new features and all supported by what were seen as American methods of marketing and advertising. Eastman targeted women, whom he saw were more likely to take photographs, and children, too, were used in advertising. Photography was no longer the largely male pastime it had been since its introduction some 40 years previously.

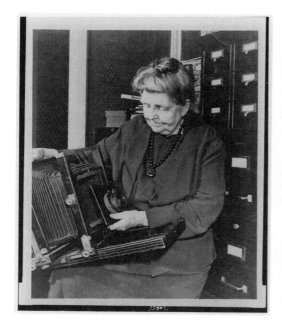

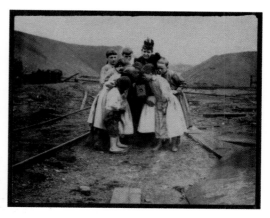

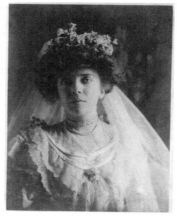

ABOVE LEFT **Frances Benjamin Johnston pictured with one of her studio cameras.**

ABOVE TOP RIGHT **Johnston surrounded by children, who appear fascinated by her Kodak camera.**

ABOVE BOTTOM RIGHT **Portrait of Alice Roosevelt on her wedding day, 1906, by Johnston.**

FRANCES BENJAMIN JOHNSTON

Often referred to as America's first female photojournalist, Frances "Fanny" Benjamin Johnston (1864–1952) was given her first Kodak camera by George Eastman, a close family friend. After studying painting in Paris, Johnston returned to Washington, determined to make her own living and forge a photographic career. She opened a portrait studio — where she captured many well known faces, including Mark Twain, Admiral Dewey and Alice Roosevelt — and earned herself important commissions at the White House. She ventured underground to photograph coalminers and aboard the USS *Olympia* in 1898 to show the world the sailors who had helped to win the Battle of Manila Bay. More unusual were her efforts to photograph educational establishments, including the Hampton Normal and Agricultural Institute — a school set up to educate former slaves. Although she never joined a feminist campaign, the independently minded Johnston encouraged other women to pick up a camera as a means to earn money, and went to great lengths to support the work of other female artists, even arranging exhibitions of their work for the 1900 Paris Exposition.

7 The Stirn Concealed Vest Camera

PRODUCED: **1888** | COUNTRY: **Germany** | MANUFACTURER: **Western Electric Company**

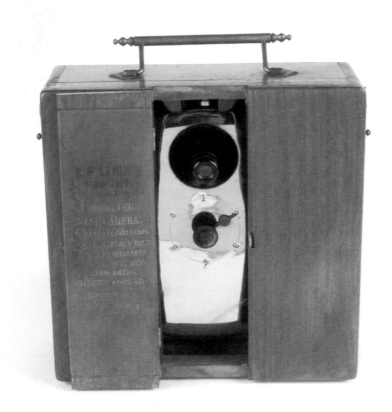

ABOVE **A Stirn Vest camera contained within its wooden traveling box. The box could also be mounted directly onto a tripod for taking pictures.**

THE introduction of dry plates brought about changes to camera design, in particular with the release of smaller and more compact cameras. Around the same time, various novelty cameras came onto the market. Many, such as the Scovill Book camera (see page 56) and the Enjalbert Revolver de Poche (see page 44), saw limited sales. The Stirn Vest camera was to prove an exception.

The practice of hiding a camera within, or incorporating it as part of, an item of clothing was popular. Several designs for hat cameras were invented during the 1880s and 1890s, and the French Photo-Cravate, patented by Edmund Bloch in 1890, concealed a camera containing six 1 inch (25 mm) diameter glass plates within a gentleman's cravat. Ladies' handbags, parcels and attaché cases were also used to conceal cameras.

The Concealed Vest Camera, patented separately by Robert D. Gray and C.P. Stirn, was an exception to most designs in that it was commercially successful at a time when there were many novelty and disguised cameras available.

CONCEALED UPON THE PERSON

The Vest camera was patented by Gray on July 27, 1886. United States patent 346,199 described a portable photographic camera "to be carried concealed upon the person" and "a camera which shall be wholly concealed under the clothing, and yet admit of being readily brought into proper focus for obtaining the image of an object or person." Gray first showed his camera on December 22, 1885 at a meeting of the New York Amateur Association. His prototype was in a slightly different form to the camera design that eventually went on sale from 1886. It was slightly bulkier and came complete with a false shirt front. The camera lens mount was in the shape of a tiepin and it protruded through a special opening in the vest or waistcoat. Six exposures were taken on an octagonal glass dry plate. The *Photographic News*, reporting on the camera, noted that "a man wearing it would look so remarkable as to attract some attention; but possibly a flat-breasted woman might wear a concealed camera in a similar way without being noticed."

RIGHT **The French Photo-Cravate, patented by Edmund Bloch in 1890.**

The final design of the camera dispensed with the accompanying false shirt. The lens would protrude through a buttonhole in a normal waistcoat. Exposures were made on a circular plate. These changes reduced the bulkiness and weight of the camera, making it easier for the photographer to use. Gray described it thusly: "I have constructed a camera ... to be worn as a vest, concealed under the outer garments, the lens being brought to the centre of the chest to facilitate directing it toward an object, and made to serve the secondary purpose of a stud or button for the outer vest and coat, and thereby to pass unobserved as a lens." Gray's camera was manufactured for him by the Western Electric Company and sold in America by the Scovill Manufacturing Company.

In the middle of 1886, C.P. Stirn commenced negotiations to purchase the rights for the camera from Gray. A deal was struck and Stirn went on to patent the camera under his own name in Britain on July 27, 1886, and in Germany on July 28, 1886. Stirn's brother, Rudolf, working in Berlin, had begun production of the camera by October 1886. The camera, as sold, showed only minor differences to Gray's model, with a hinged back instead of a fully removable one and an improved shutter mechanism. It was sold under a variety of names such as the Secret, Geheim and Waistcoat.

A COMMERCIAL SUCCESS

The Stirn brothers made the camera a major commercial success. At least four models were produced, the original making six exposures of 1⁹⁄₁₆ inch (40 mm) diameter on a plate and a second making four 5½ inch (140 mm) exposures; a third was made for 2⅜ inch (60 mm) exposures and another for four 1⁹⁄₁₆ inch (40 mm) square plates. Although intended to be hung on a cord around the photographer's neck, it could also be mounted on a tripod when contained in a mahogany box, with the camera's lens peeping through an opened door. A range of processing accessories was also produced to help the photographer to develop and print from the circular plates.

The design was popular and as a result it was copied by other manufacturers, despite the protection conferred by the patent. In France, the Fetter Photo-Éclair appeared; it was patented in Britain on September 7, 1886. The design closely resembled the Stirn camera. By 1890, Stirn was advertising that some 18,000 examples of the camera had been sold since its introduction in October 1886, which was a remarkable achievement for any camera at that time.

The reaction of the photographic press was generally positive, with reviews commenting on the quality of the negatives possible with the camera. Writing in The Photographer's Indispensable Handbook (1887) about the Secret camera, which was J. Robinson & Sons' branded version of the Stirn camera, Walter Welford noted that "the prices are low enough to enable every amateur to try it. Complete in case, with plates, 35s."

BELOW **In Britain, the Stirn Vest camera was sold by J. Robinson & Sons of London as The Secret Camera for 35 shillings (around $235 in today's money). This advertisement is from The** Photographer's Indispensable Handbook, **1887.**

The Stirn Concealed Vest Camera

AT WAIST LEVEL

Although the waistcoat camera did not last beyond the Stirn design, it did highlight the fact that a camera held against the body at chest or waist level gained a certain amount of stability. Pictures taken with the camera braced in this way were less susceptible to camera shake from the use of slow shutter speeds.

The idea of using hand cameras (during the 1880s and early 1890s these were known by the term "detective" cameras) at waist level, supported against the body, came to be widely adopted by amateur photographers. The Kodak, box and later folding cameras were all used in this way well into the 20th century, with such cameras being fitted with a viewfinder designed to be looked into from above. It was not until the introduction of the reflex camera and rangefinder cameras, which were held at eye level, that this changed for most photographers. Many amateurs continued to use the hand camera held at waist level until the shift away from box cameras in the 1960s, with the introduction of the Kodak Instamatic and its competitors, which were designed to be used at eye level. With the arrival of digital cameras featuring LCD screens, including camera phones, cameras have again become devices to be held at arm's length.

FREDRIK CARL STØRMER

Fredrik Carl Størmer (1874–1957) was a Norwegian mathematician and physicist and an amateur street photographer. In his professional life he became best known for being the first to photograph the Northern Lights, but he had honed his photography skills much earlier during his high school and university years. Oslo's National Library is home to 40 volumes of Størmer's covert photography — taken in the 1890s with his Stirn Vest "spion" or "spy" camera. During the summer months he would walk along the main streets of Kristiana (now Oslo) with the camera concealed beneath his topcoat, the lens protruding through his buttonhole. He managed to photograph artists and celebrities such as Henrik Ibsen (see right), as well as university professors, the prime minister and even King Oscar II.

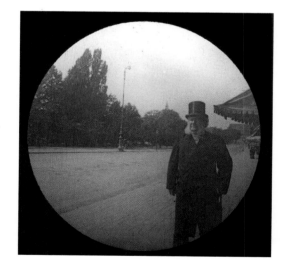

8 The Enjalbert Revolver de Poche

PRODUCED: **c.1890** | COUNTRY: **France** | MANUFACTURER: **Enjalbert**

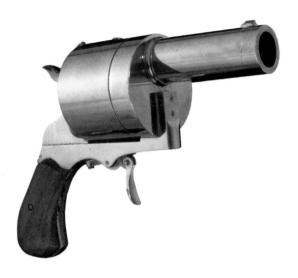

ABOVE **The most distinctive of all the gun cameras, which sold in very small numbers.**

THE popularity of cameras that could be disguised as other objects began in earnest in the late 1870s. Such efforts were made viable by the introduction of photographic dry plates and films and the development of methods of manufacturing that allowed for cameras to be made smaller and in nontraditional shapes.

Since one "shot" both a photograph and a firearm, it was perhaps inevitable that making a camera in the form of a gun would occur to someone. (Indeed, "snapshot" as a term for a hurried shot by a hunter predates the invention of photography.) As early as 1856, Thomas Skaife (1806–1876), a British inventor, had designed a loosely pistol-shaped camera that he called a Pistolgraph. The camera was designed to be held like a gun, and the photographer pointed it at the subject of the picture when taking the photograph. One story suggests that Skaife was arrested by the police when he aimed his Pistolgraph at Queen Victoria during a procession. The camera was made for him by Ottewill in London in very limited numbers.

An Englishman, Mr. Thompson, about whom nothing else is known, designed and patented a more realistic pistol camera on January 20, 1862, which was made by the Parisian instrument maker A. Briois. The camera was demonstrated at the Société française de photographie in July 1862. The gun barrel contained a lens, and a short barrel mounted on top acted as the viewfinder. The camera made four exposures on a circular glass plate. Only a handful of cameras were made, with the few surviving examples now housed in museums.

THE REVOLVER DE POCHE

The most realistic of all the gun cameras was the Enjalbert Revolver de Poche, designed by Albert Posso (1854–1932), who worked for the French firm Enjalbert in the late 19th century. Posso, a French Alsatian, was born in 1854. He was apprenticed to a gunsmith between 1871 and 1874 and resided in Paris during the 1870–1871 siege. During this time he was working as a gunsmith at the Ateliers nationaux de réparation d'armes (National Arms Repair Workshop) based at the Louvre. Following France's loss of Alsace to Germany, Posso became a German national, and between February 1, 1875 and September 16, 1877 he was in military service. His military duty was undertaken in the German army, where he was a sergeant (*Feldwebel*) working as an "*Etatsmässiger Büchsenmacher*," or a fully qualified gunsmith.

After leaving the army, Posso returned to France and started working for the Enjalbert photographic firm, where he designed and made the Revolver de Poche camera. Posso had no previous experience of camera work, so it seems likely that his skills as a gunsmith were the prime reason he was employed by the company.

Posso started his own business in 1885, producing metal dark slides and sheaths for photographic plates that were the subject of various patents from 1895 onward. These bear close similarities with the dark slides used in the Enjalbert camera. The camera maker was awarded a bronze medal at the 1900 International Exhibition in Paris for his photographic slides, and the

BELOW **Detail of the Revolver de Poche from a French advertisement. The cutaway view shows the shutter mechanism, plate chambers for exposed and unexposed plates, and the lens; below are the plate holders.**

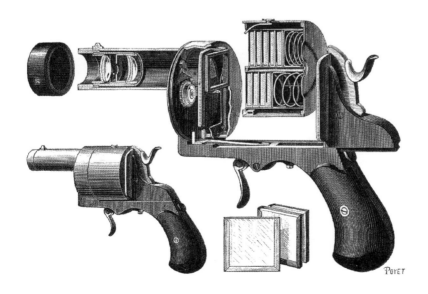

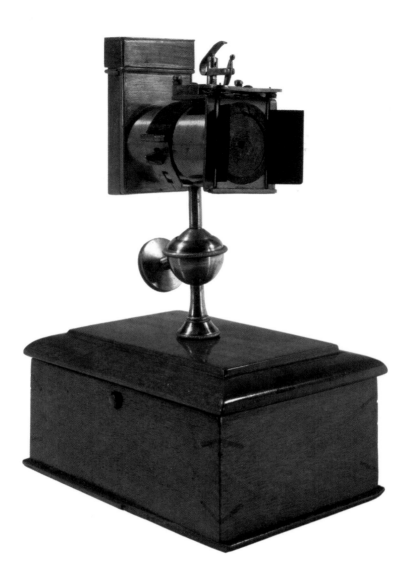

The Enjalbert Revolver de Poche

ABOVE **Thomas Skaife's Pistolgraph camera of 1856 was mounted on a wooden box, which acted as a support when pictures were taken and also as a container for accessories.**

design was copied by all major camera manufacturers. Posso maintained a friendly relationship with the Enjalbert family after he left their employment to set up his own business.

The Revolver de Poche camera produced a ¾ × ¾ inch (20 × 20 mm) negative on glass plates. It had a nickeled brass body, with the barrel containing a lens and the gun's sighting pin helping the photographer to aim the camera. The "bullet" cylinder contained 10 plate holders. Following exposure, the cylindrical plate magazine was rotated by a half-turn, which transferred the exposed plate to the second compartment; another half-turn brought a new plate into the taking position and reset the shutter. The gun trigger acted as the shutter release. *The Photographic News* reported on the camera:

Enjalbert's Photo-Revolver. — M. Enjalbert, whose name is more particularly known as the inventor of ingenious apparatus, has presented to the Photographic Society of France this photo-revolver. The receptacle D [the plate holder] contains ten sensitive plates, which by action of the trigger are lodged by turn in a box by the side of that containing the unexposed plates. The motion of the trigger causes the shutter in front to act, which is capable of being regulated in rapidity. On pulling the trigger, the receptacle D makes one complete revolution, and is capable of making ten successively for the ten plates, which are square sided 2 centimetres long. Aim is taken by keeping point A in position in front of the knob placed at the end of the barrel. For enlarging these minute pictures, M. Enjalbert has had an apparatus constructed. The barrel or lens of revolver U is fixed in front of the condensing lens R, and the whole is placed in a camera; the negative slide is at T. Nothing can be more simple. The whole thing is well conceived, and the little negatives thus taken instantaneously, of course, are little gems. We can only find one fault with this pretty apparatus, in its bright nickel case, but it is a grave one — that is, that it takes the form of fire-arms.

Enjalbert also produced a version of the revolver camera for $2\%_{16} \times 2\%_{16}$ inch (40 × 40 mm) plates. Other gun cameras were produced. In Britain, a revolver camera was patented in 1894 by a Mr. Smyth that looked similar to the Enjalbert. The firm of Sands & Hunter produced a camera in 1885 in the form of a rifle that *The Photographer's Indispensable Handbook* described as "an ingenious novelty; but nothing much to recommend it beyond that fact." Much like *The Photographic News*, the *Handbook* took issue with its form being a gun. While the idea might have had some merit in producing a camera that could be held steadily, a "gun" would attract far more attention than a camera and would quite likely get the photographer arrested.

From the 1880s up to the 1950s, cameras were frequently disguised as other objects so that the photographer could take photographs without being observed or for novelty purposes. Guns rarely featured except as pure novelty items. True spy cameras such as the Minox (see page 116) appeared from the late 1930s onward and were more suited for serious espionage.

A MURDEROUS APPEARANCE

Charles Sands, a partner in the firm of Sands & Hunter, reported on his gun camera at a meeting of the Photographic Society in 1882. The gun was created to photograph birds and was designed for discreet shots. The anti-photography movement of the early 1880s, however, noted that the camera's "extremely murderous appearance might cause the user to be subject to rather unceremonious treatment if he were endeavouring to secure a portrait of an Irish landlord or of the Queen."

The Rouch Eureka

PRODUCED: **c.1890** | COUNTRY: **UK** | MANUFACTURER: **W.W. Rouch & Co.**

ABOVE **A popular hand, or detective, camera that incorporated multiple plates inside it.**

W.W. ROUCH & Co. was established in London around 1854, selling cameras, collodion and a range of chemicals and papers. When dry plates came onto the market in the 1870s, it also turned to manufacturing these, although they did not enjoy the same success as the firm's own brand of collodion. The company produced a range of traditional mahogany cameras from the late 1850s. Some of their designs, such as their Patent Portable camera, patented in 1878, were innovative and attracted positive reviews. The Portable was widely used by travelers and explorers, including Henry Morton Stanley. All Rouch cameras were made to high standards, reflecting traditional British camera manufacturing.

The hand camera, also known early on as the "detective" camera, was a design introduced around 1881 by Thomas Bolas. Compared with traditional bellows cameras, the hand camera design was unobtrusive. Many manufacturers produced their own designs during the 1880s and 1890s, and Rouch's Eureka camera was one of the most successful, with many thousands being produced. It was based on Rouch's patents of 1887 and 1888, and the camera contained metal sheaths to hold glass plates. The back incorporated a built-in changing bag so that the user could move his exposed plate and insert an unexposed one ready for his next shot, without the need for a darkroom or separate plate holders.

The Eureka was immediately popular and was awarded the only medal for a detective camera at the 1888 Photographic Exhibition at the Crystal Palace. In its first form the camera produced 3¼ inch (82 mm) square plates, but new models were introduced in different sizes. Other improvements were later added, including better-quality lenses and shutters. A focal-plane shutter was made that gave a top speed of ¹⁄₁₀₀₀ of a second, making it perfect for capturing moving subjects. Rouch introduced a range of sensitized gelatine plates that it also called the Eureka. The company claimed they were the most rapid on the market and suitable for "studio, dark interior, general landscape, and instantaneous work."

By the mid-1890s, the invention of roll film meant that much smaller cameras could be manufactured, half the size of their competitors. The Eureka and its competitors lost their competitive advantage, with new cameras such as the Kodak making photography simpler for amateurs. For the more serious amateur, the new hand-and-stand models such as the Sanderson (see page 58) were suited to a greater range of subjects while remaining portable.

CANDID CAMERA

In the hands of an accomplished photographer such as Paul Martin (1864–1944), the hand — or detective — camera could be used to secure previously unimaginable candid images of people going about their normal business. Martin, a trained wood engraver, used a Fallowfield Facile camera, a contemporary of the Eureka, and during the 1890s he photographed on the streets of London, in Great Yarmouth and on the island of Jersey. Initially, he concealed the camera in brown paper, to create the impression of a parcel, until a particularly wet-weather outing proved disastrous. Martin's Facile was then recased in black leather (this camera is now part of the Royal Photographic Society's collection). Of this approach — secretly photographing the ordinary people of busy streets, market places and sandy beaches — he wrote: "It is impossible to describe the thrill which taking the first snaps without being noticed gave one."

RIGHT **By Paul Martin, c.1900. A shoe shiner at work in a London street.**

10 The Goerz Anschütz

PRODUCED: **1890** | COUNTRY: **Germany** | MANUFACTURER: **C.P. Goerz**

ABOVE A Goerz Anschütz camera in its classic form, which remained popular well into the 20th century. Also pictured are three plate holders, each holding six glass plates.

Ottomar Anschütz was a professional photographer in German Lissa (now Leszno, Poland), and a key figure in the development of faster camera shutters and instantaneous photography. His work was supported by the development of more sensitive photographic emulsions and through his collaboration with the German optical and camera manufacturer C.P. Goerz. Together they developed, and Goerz manufactured, a camera to a design that was widely used in Europe and the United States from around 1900 until the 1950s.

FREEZE FRAME

Anschütz began experimenting with instantaneous photography in order to analyze the movements of birds and animals. He developed a focal-plane shutter that would allow fast shutter speeds so that he could freeze the movement of his subjects, which would allow him to analyze how they moved. He designed his first shutter in 1883 and used it to support his studies of animals in motion. Anschütz patented his shutter in 1888 in Germany and in 1889 in Britain. British patent number 56 of 1889 described a "shutter which moves before the exposure opening, immediately in front of the sensitive surface, consists of two pieces of cloth connected at the margins

by a cord so as to leave a slit between them." Adjusting the size of the slit altered the exposure, giving exposures as short as ¹⁄₁₀₀₀ of a second which, at the time, was considerably faster than all other shutters.

Anschütz's shutter was incorporated into a camera made by C.P. Goerz, initially constructed in the shape of a truncated pyramid. From 1892 it was made in a more conventional box-form design, with the shutter set into the back of the camera.

This was followed around 1896 by a collapsible version of the Goerz Anschütz camera that became very popular, with the design being used well into the 20th century. C.P. Goerz's advertising succinctly summed up the camera's benefits: "Extreme lightness. Extreme smallness. Extreme portability"; "The camera is so simple and efficient as to ensure excellent results." The standard quarter-plate model sold for £12 2s 0d (around $877 today) and was available in sizes up to whole-plate 7⅛ × 9⅜ inches (180 × 240 mm). A more complex model appeared in 1905 with slower speeds, followed by a model with a self-capping shutter that did not require the lens to be covered between exposures, which made it more practical to use.

A LASTING LEGACY

The Goerz Anschütz design was widely copied by different manufacturers. In France and Germany several manufacturers produced their own versions; Amalgamated Photographic Manufacturers Ltd. in Britain made the APeM folding focal-plane camera, which it described as "for the amateur photographer specializing in high-speed pictures, the Press and Professional Photographer." It was continued as the Soho Duaflex Press camera. Peeling and Van Neck made a very close copy from 1919, which they named the British Anschütz, and their 1932 model, the VN Press camera, was used well into the 1950s by newspaper photographers.

ON THE MOVE

Fast shutter speeds and portability made the Goerz Anschütz camera suitable for a new type of photographer wanting to capture popular activities such as cycling races, rowing and other sports. The photographs were used by the growing number of photographically illustrated periodicals and newspapers which, from the late 1890s, started to feature photographs on their pages. The alternative was the heavier and bulky single-lens reflex (SLR) camera.

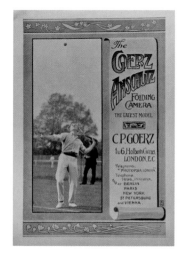

11 The Thornton–Pickard Royal Ruby

PRODUCED: **1890s** | COUNTRY: **UK** | MANUFACTURER: **Thornton–Pickard Company**

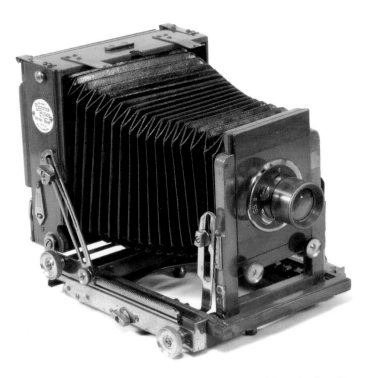

ABOVE **The Royal Ruby was one of the best-known field cameras, a term used to describe a popular design of camera made in a large number of plate sizes in the late 19th and early 20th centuries.**

THE Thornton–Pickard Company described its "king of cameras," the Royal Ruby field camera, as "the world's standard high-class camera." The term "field" was suggestive of lightness and portability, and was coined to describe this type of portable folding bellows camera, irrespective of the manufacturer. The Royal Ruby was introduced in 1902 in a range of sizes: quarter-plate, 5 × 4 inch (127 × 102 mm), half-plate and whole-plate. The Ruby name was first used by Thornton–Pickard around 1889 and over time the company increasingly used it for a range of camera types: field, hand-and-stand and reflex. The Royal Ruby was the top-of-the-range field camera. It was based on the standard Ruby model but had extra features to improve its usefulness to photographers, such as additional movements and the ability to bring the rear standard closer to the lens for wide-angle work. In 1907, a new strut arrangement and front standard were introduced, which allowed even greater movements. An overseas model made in teak and with screwed joints was also available, the construction of which ensured that the camera would not distort in the heat and humidity of the tropics of the British Empire. Manufacturers also described this design as "tropical."

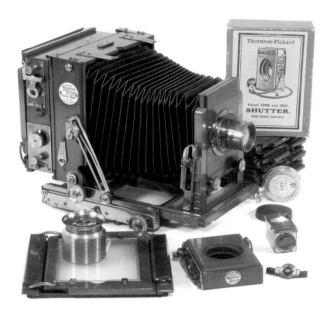

ABOVE **A Royal Ruby camera showing the focusing screen for composing the picture, the roller-blind shutter that fitted to the lenses, and an accessory focal-plane shutter.**

BELOW **The Kinnear-pattern camera, introduced in 1857, was the first step toward making a more portable folding-plate camera.**

The first box-form camera designs of the 1840s and 1850s had been quickly superseded by the introduction of bellows from the mid-1850s. Then came the tailboard camera, in which the back of the camera could be pushed up against the front and the baseplate hinged so it folded up to protect the exposed focusing screen. It was a popular design for both amateurs and commercial photographers.

The use of conical bellows, which allowed camera designs to evolve into something more portable and compact that would fold into a smaller space than square bellows, was first put forward by Colonel C.H. Kinnear and influenced many camera designs. George Hare's new patent camera, introduced in 1882, was a front-focusing bellows camera, which developed the Kinnear design by hinging the baseboard to the camera body, with the lens support attaching to the baseboard by means of screws. The *British Journal of Photography* described the camera as forming "the model upon which nearly all others in the market are based." The design was popular and was widely copied, despite being protected by patent.

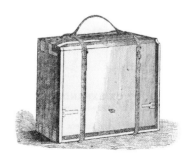

A GOLD MEDAL FOR DESIGN

The next significant step in the evolution of the camera was the result of the work of Samuel D. McKellen, a jeweler and watchmaker from Manchester, England. Based on his experiences as an amateur photographer worn out by carrying around a heavy half-plate camera with 12 plates, he decided to produce his own design. He defined the requirements of what he felt would make the perfect camera:

- It should be light.
- It should be rigid.
- It must be easily opened for use and easily folded down in a compact shape.
- It must allow for close focus lenses as well as the use of a lens at least twice the length of the plate.
- It must be simple and reparable at a reasonable cost.
- It must have a swing back and front that can be used in parallel to each other.

McKellen used these principles to design a camera that had a hole cut into the baseboard so that a turntable could be mounted, allowing the camera to be turned in any direction when mounted on a tripod. McKellen's design was patented and manufactured as the Double Pinion Treble Patent camera. It was widely acclaimed and when it was exhibited at the Photographic Society of London's annual exhibition in 1884, it was awarded a gold medal. The camera was lighter and more versatile than any design hitherto produced and it began to be widely copied. McKellen tried, with limited success, to defend his design against rivals and failed to make the fortune that should rightly have been his.

BELOW **The Amber camera, which could be used on a tripod, but was light enough to be supported against the body with a neck strap.**

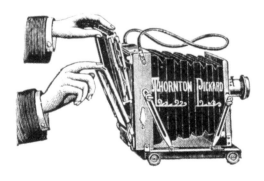

Elsewhere in Manchester, John Edward Thornton opened his camera-making business around 1885/86 and by 1887 had met Edgar Pickard. Together they formed the Thornton–Pickard Manufacturing Company to manufacture the firm's roller-blind shutter, which formed the main part of its output. The Thornton–Pickard company began mass-manufacturing field cameras around 1888, when the Ruby name was first used. It was described in the *Photography Annual* as "one of the finest instruments we have had the pleasure of handling." The Ruby was similar to McKellen's Treble Patent camera and McKellen sued the Thornton–Pickard company. The eventual outcome of the court case is not known, but it clearly did not harm Thornton–Pickard, which began mass-producing field cameras, with the Ruby and cheaper models such as the Amber becoming very popular. The company became one of the largest manufacturers of field cameras in the UK.

From the 1880s until the 1920s, the field camera was widely used by amateurs and professionals where lightness and portability was required. By the 1920s, the design had become obsolete, although some, such as the Royal Ruby, were still being advertised until 1939. The number of sales after the First World War is likely to have been very small. More specialized camera designs took over: the reflex for press use, the tailboard or technical for studio use. From the mid-1920s new, smaller cameras such as the Leica, Exakta and Rolleiflex increasingly found favor.

However, the field camera design continued to be popular with studio photographers and those wanting to make large negatives, particularly for landscape and outdoor photography. Photographers such as Ansel Adams and Edward Weston created many of their famous images with such cameras. Even today, several manufacturers make wooden field cameras of a similar design. The Tachihara, Wista, Ebony and Canham models of the late 20th century continue to attract their devotees in the pursuit of the ultimate quality.

THE GANDOLFI

One of the best-known field cameras was made by the British Gandolfi company, founded in 1885. The family was still making traditional field and tailboard cameras until 1993, when the firm was taken over. Gandolfi cameras were sold under the company's own name and made for other companies, and the firm eventually became the last traditional British camera maker. It made Kodak's Specialist studio cameras, as well as special cameras for the prison service designed to make front and side view mugshots on a single plate.

Its field cameras were popular. Orders would take several years to be fulfilled, as each camera was handmade from carefully seasoned mahogany. The brass was lacquered and the wood finished by hand — skills that would have been familiar to Ottewill's workmen in the 1850s. The internationally known landscape photographer Charlie Waite continues to use a Gandolfi, as do many other serious photographers who appreciate the skill and consideration that go into large-format photography. Gandolfi cameras are now sought-after collectors' items at auction.

12 The Scovill Book Camera

PRODUCED: **c.1892** | COUNTRY: **U.S.A.** | MANUFACTURER: **Scovill and Adams**

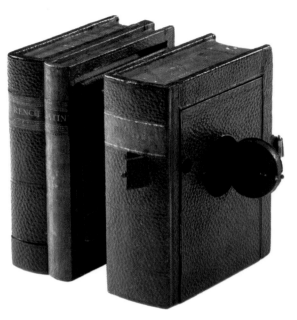

ABOVE **A camera that epitomized a craze for increasingly bizarre and novel designs of camera.**

THE period between 1880 and 1910 saw designers who were keen to present the public with something novel, using their ingenuity to create cameras in new forms such as satchels, parcels, revolvers, binoculars and groups of books. This was made possible through the introduction of new materials and methods of manufacturing cameras. Increasing mechanization and new tools allowed metal to be stamped out to particular shapes and worked more precisely. This, coupled with the ability to make smaller components, such as gears, cogs and pinions, helped designers to realize strange new designs, in many cases without considering whether the camera would be a commercial success. These disguised cameras — and they were disguised rather than spy cameras — rarely saw great sales and were generally treated as novelties rather than as cameras for serious picture-taking, although some, such as the Stirn Vest camera (see page 40), were capable of producing good results.

A DISTINCTIVE DESIGN

If the Enjalbert (see page 44) was the best of the gun cameras, then the Scovill and Adams Book camera was the most distinctive of the more box-form style of disguised camera. The Book camera was the subject of a United States patent filed on April 7, 1891. It was granted on March 15, 1892, as patent number 470,783, to Andrew B. Dobbs of New Haven, Connecticut. In his filing, Dobbs stated: "The object of my [patent] is to produce a compact, simple and efficient

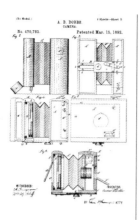

A. B. DOBBS.
CAMERA.
No. 470,783. Patented Mar. 15, 1892.

camera which will not have the appearance of a camera when in the condition to which it is adjusted for transportation."

Dobbs had worked for Samuel Peck and Co. of New Haven, which was a subsidiary of the Scovill Manufacturing Company, in the 1870s, but in 1881 he set up his own manufacturing business to supply cameras to Scovill. It is probable that he made the Book camera. The camera was advertised by Scovill and Adams:

> *The general appearance of this new camera is of three leather covered books encircled by a strap. Attached to this strap is a neat handle by which to carry the camera. No lady or gentleman need have any fear that this parcel will attract attention as a camera for it certainly looks much unlike a camera as any thing can, and it is a very striking counterfeit of a parcel of three bona-fide books. The lens for this ingenious instrument is a rectalinear combination, of the wide-angle variety, with interchangeable stops and made expressly for this camera, and is superior to any thing yet offered at its very low price. The construction of the shutter is after the leaf pattern, and is located between the lens glasses — a feature not used in ordinary hand cameras. This gives a wider range of angle and does away with the use of a stopper for the lens.*

The three books are generally stamped "French," "Latin" and "Shadows," although other variants also exist. In order to operate the camera, the leather strap wrapping the three "books" needed to be unbuckled, and the internal camera could be focused using bellows. A plate holder was inserted into the back to make the exposure.

The camera met Dobbs' requirement of being discreet when being carried but its operation, particularly if it was mounted on a tripod, would have been obvious and attracted far more attention than a discreet hand camera.

As a collectible today, the Scovill Book camera is considered rare. Despite the backing of one of the United States' largest photographic companies, perhaps fewer than 30 cameras were ever sold. Only a handful survive today.

ABOVE **The American patent drawings for the Scovill Book camera. The patent was granted to Andrew Dobbs in 1892.**

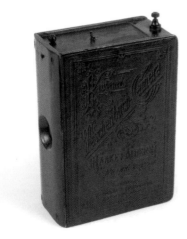

KRÜGENER'S BOOK CAMERA

The Scovill and Adams Book camera was not the first to be patented and sold. Dr Rudolph Krügener's book camera, which was made in Germany by Haake and Albers from 1888, had been patented in a number of countries, including Britain, France and the United States, and had been extremely successful. Several thousand were sold in various countries, and it was often customized: in Germany the camera sold as the Taschenbuch, in France as the Photo-Livre, in Belgium as the Photo-Carnet and in Britain as the patent Book camera.

13 The Sanderson Hand Camera

PRODUCED: **1899** | COUNTRY: **UK** | MANUFACTURER: **Houghtons Ltd.**

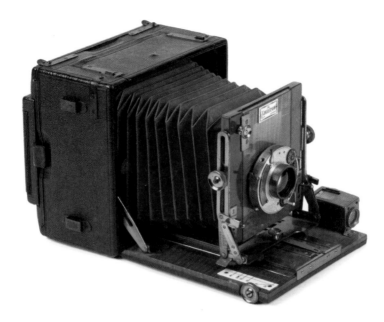

ABOVE **One of the longest-lived and most popular hand cameras, which was widely used by amateur and professional photographers.**

THE Sanderson hand-and-stand camera was one of the most long-lasting and successful examples of this design of camera. From its introduction in 1899 until it was last listed in Ensign Ltd.'s 1938 catalog, upward of 26,000 examples of 60 distinct models of Sanderson camera had been made. The camera's designer was Frederick Sanderson, who was born in July 1856 to a long-established Cambridge family. He had started work as a cabinetmaker and a wood and stone carver, and became interested in photography in the 1880s. Sanderson took a leading role in his local photographic society and photographic retailing was soon added to his cabinetmaking business.

A MATTER OF PERSPECTIVE

Sanderson had a particular interest in architectural photography and, when he was unable to find a camera to meet his needs, with the movements necessary to retain the correct perspective, he set about designing one. The outcome of his work was the subject of British patent number 613 of January 10, 1895. The patent described a method of supporting the front or back of a camera that allowed it to be fixed at any angle. In practice, the design was incorporated into a double strut on each side of the front standard that could be locked into any position. The patent also referred to a rotating lens panel into which the lens was mounted eccentrically and to bellows that tapered on their lower side to aid the extreme movement available with the strut arrangement.

Sanderson licensed the design to George Houghton and Son of London, who initially had the camera made by the London camera makers Holmes Brothers. When this firm was incorporated into Houghtons Ltd. in 1904, the camera was subsequently made and sold by Houghtons and, from 1930, their selling company Ensign Ltd., until its demise after a direct hit during the Blitz in 1940. It was reborn after the war but never achieved its earlier success. Frederick Sanderson does not appear to have made any further significant contribution to photography; he died on July 9, 1929.

CONTINUAL IMPROVEMENT

The Sanderson field camera proved popular and the model was made in a large range of plate sizes; a hand-and-stand model was offered from 1899. The hand camera underwent a process of continual improvement, with further patents from Sanderson and others being incorporated into the design. The camera body was made of polished mahogany, covered externally with a fine-grained leather. The focusing back was removable and could be rotated 90 degrees to allow for horizontal or upright format negatives. The removable back also meant that it could be used with Eastman roll-film backs, which allowed the photographer to take a series of pictures on film rather than individually on single glass plates. The camera's struts and the ability of the baseboard to drop down gave it greater versatility than its competitors: none of them were able to match its success.

In 1902 the original model was improved and renamed the Regular. At the same time, other models were introduced, including a roll-film model that incorporated a fixed roll holder. Later years saw the release of simplified models, a tropical model made of teak to withstand the heat and humidity of the tropics, and a specific postcard format model. The Tropical de Luxe was made in teak or heavily brass-bound Spanish mahogany.

Few changes were made between 1910 and 1928, when the Regular model was updated to house a revolving back and a finish of black and nickel. This version continued to be made until manufacturing was stopped in the late 1930s.

The Sanderson hand-and-stand camera found favor with keen amateur photographers, particularly those who were members of cameras clubs, rather than casual users. Commercial photographers, too, liked the camera, which offered versatility across different types of photography, both indoors and out. Writing in their 1904–1905 catalog, Houghtons noted that: "it is very gratifying to find the demand for the Sanderson Hand camera growing each season by leaps and bounds. The cause of the increasing popularity of this instrument is not far to seek. It supplied a want that has been growing year by year, a want shared by thousands of workers who, having become tired of the 'Press the button Photography,' have decided on a more serious course of work, and the demand for an instrument more capable and adapted to a wider range of Photography naturally is the result, and a good universal Camera becomes a pressing need."

At £6 10s 0d (around $940 today) for the Regular quarter-plate model, the camera was attractively priced.

BELOW **The pre-1914 instruction booklet for the Sanderson hand camera. The cover illustration showed the extension and movement possible with the camera.**

14 The Kodak Brownie

PRODUCED: **1900** | COUNTRY: **U.S.A.** | MANUFACTURER: **Eastman Kodak Company**

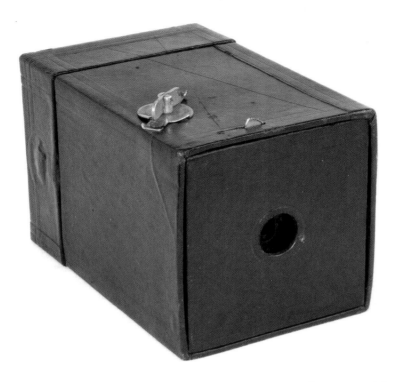

ABOVE **Asked to name the camera that transformed amateur photography, most people would choose the humble Brownie box camera. For much of the 20th century the Brownie was the first camera people bought, and even in a digital age the name continues to be used as shorthand for an amateur camera.**

BETWEEN 1900 and 1980, a vast range of camera models, more than 125 in total depending on definition, were sold under the Brownie name. They were well designed, simple to operate and low in price. The camera changed over the years — from being made of cardboard to molded plastic, and including box and folding models — but these basic concepts remained throughout. The Brownie camera was the most successful range of all time and introduced photography to many millions of people across the world.

The original Brownie of 1900 was designed by Frank Brownell. He had been working for George Eastman, the owner of Kodak, making the Eastman–Walker roll-film holder from 1885 and undertaking woodworking for Kodak cameras. In 1892, Eastman built a factory next to his own that he called the Camera Works and rented it to Brownell, who began designing and making cameras for Eastman's rapidly expanding company. By the time Brownell retired in 1902 and Eastman bought the factory, more than 60 new camera models and designs had come out of the Camera Works. Eastman described Brownell as "the greatest camera designer the world has known."

BACK TO BASICS

The original Kodak camera of 1888 had done much to simplify the process of photography, but it was expensive and it sold in relatively low numbers. The Pocket Kodak of 1895 took the idea of a simple box-type camera further, and it was more popular, selling some 100,000 in its first year. Eastman recognized that if he could produce a cheap, reliable camera for under a dollar, it would encourage more people, particularly children and women, to take up photography; this in turn would boost the sales of film and paper, where most of Eastman Kodak Company's profits were made. To bring the cost of manufacturing down would require going back to basics in terms of the design of the camera and how it was produced. So it was that in 1898, Eastman asked Brownell to design a camera that would be cheaper and easier to use than any Kodak had yet made.

The resulting Brownie camera was little more than a cardboard box with a lens mounted at the front, and yet it was innovative in that it simplified the camera to a bare minimum. The camera body was made of jute board, reinforced with wood and covered in imitation black leather. The few controls were nickel-plated. At one end was a simple meniscus lens of 100 mm focal length and aperture of f/14, and a simple single-speed rotary shutter. The camera back was held on by two metal springs and was removed to allow a newly introduced daylight-loading roll film, later designated 117, for six exposures each of 2¼ × 2¼ inches (made and sold in inches, approx. 60 × 60 mm), to be inserted. The shutter release and the winding key to advance the film were located on top of the camera.

To take a picture the camera was simply pointed at the subject and the button pushed. There were no other controls; it was the simplest point-and-shoot camera able to produce acceptable results in sunshine. From July 1900, a separate clip-on waist-level viewfinder was available for an additional shilling (5 cents).

The camera was launched on February 1, 1900, for the price of $1 in the United States and 25 shillings in the UK. The first 15,000 cameras were designed with a push-on back; following feedback from customers and dealers, the camera back was strengthened, and by June a redesigned version was being sold.

If the original Kodak camera of 1888 had taken the photographer away from the darkroom, then the Brownie brought photography within the reach of everyone. The camera was affordable, even to the working classes, and the six-exposure films cost only 7d (25 cents). A network of drugstores and photographic dealers offered developing and printing services, although the camera was also supported with a processing kit and a range of accessories that would allow the owner to produce his or her own photographs. The resulting images could then be put into Brownie albums.

Kodak Ltd. in Britain was excited by the camera. In its *Trade Circular*, sent out to the photographic trade, it proclaimed the Brownie would "bring into photography thousands of new workers and users, and — as with all our inventions, simplifications and advertising — will create new customers for our dealer friends."

BELOW **A Kodak Ltd. advertising brochure for the Brownie camera, c.1906.**

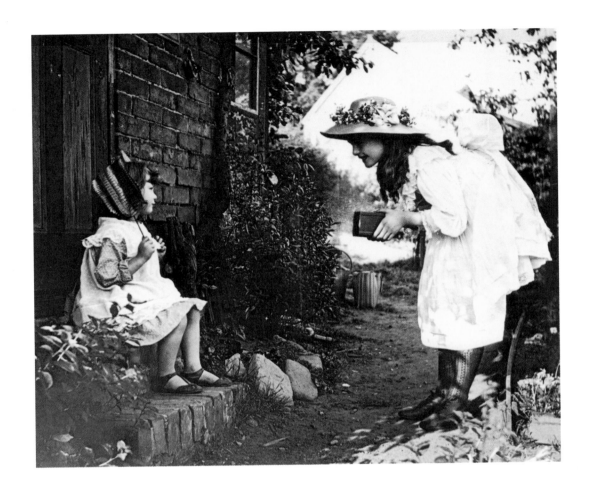

BERT HARDY

Between 1941 and 1957, Bert Hardy (1913–1995), a former war photographer, worked for the illustrated magazine *Picture Post*. With cameras and photographic equipment restricted by government controls after the Second World War, a debate arose about how important the camera was for securing great photographs. Hardy claimed that it was not the camera but the person behind it that resulted in a great picture. To attract readers, *Picture Post* ran a photography competition and sent Hardy off to Blackpool to prove his point. Armed with a box Brownie camera presented by the Lord Mayor, he headed down to the town's Golden Mile promenade where he captured one of his most iconic images: two former members of the Tiller Girls dancing troupe — Pat Wilson and Wendy Clarke — seated, laughing, on the railings above the beach. Published in the magazine on July 14, 1951, it became an instant classic, proving that in the hands of a great photographer, the simplest box camera could produce truly memorable pictures.

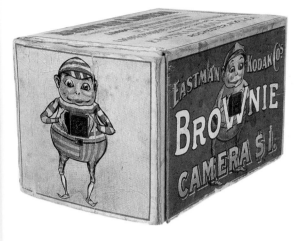

THE OTHER BROWNIES

In many respects, the camera was unremarkable. What made it the success it became, other than the price, was the associated marketing. The Brownie name — nothing to do with Frank Brownell — came from a series of well known children's books by Palmer Cox that had been popular since 1881. Characters from these were used by Kodak to advertise the camera and they appeared on the camera's packaging until around 1907. Reportedly, Kodak's marketing department used the characters with no acknowledgment or payment to Cox, which is ironic considering the lengths Kodak went to in preserving its own trademarks.

LEFT **A girl taking a photograph using a Kodak Brownie camera, c.1905.**

The company envisaged the Brownie as being everyone's first camera, after which they would then move on to more expensive models. It was deliberately aimed at children and women rather than men, who had hitherto been the main buyers of cameras. To support sales, the Kodak company quickly announced a Brownie Prize Competition in 1901, which was open to members of its Brownie Kodak Club. Membership was limited to boys and girls under 16 years old. Prizes totalled £100 and more than 3,000 entries were received.

The camera was advertised extensively in newspapers and magazines to reach its intended market. In the United States in June 1900, the magazines carrying Brownie advertisements had a combined circulation of 6 million. Dealers were supported by Kodak, which supplied printed circulars, banners and show cards for store windows.

AN INSTANT HIT

The response from the public was exceptional. "They are selling like wildfire," the company announced one month after its introduction; it struggled to supply its dealers' orders. By the time the original Brownie was superseded by the No. 1 Brownie in October 1901, around 245,000 had been sold. Needless to say, other camera manufacturers quickly brought out their own models, copying the simplicity of the Brownie and aiming at the same markets Kodak was targeting. They used names such as Buster Brown, Kewpie, Nipper and Scout, but none had the impact of the Brownie, which had Kodak's massive advertising and marketing spend to propel it into the limelight.

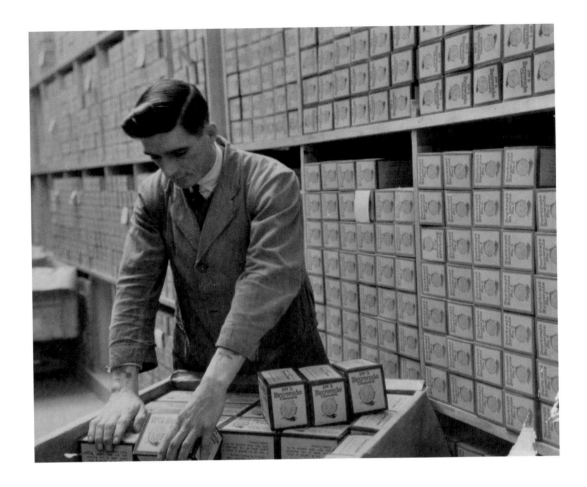

ABOVE **No. 2 Brownie cameras being packed at a Kodak Ltd. warehouse, ready for shipping to retailers for sale.**

The Brownie camera of 1900 was just the start. New models of box Brownie were regularly introduced. These appeared in different sizes, often with more controls for photographers to allow them to react to different lighting conditions, for example, or so that portraits could be taken with greater success. More metal was incorporated into the camera body as manufacturing was mechanized and moved away from the hand assembly of Brownell's workshop. This helped to keep the cost of the camera down. The basic box design remained the same until the 1950s when, with the use of new materials such as molded plastics, the design became more streamlined, a style commensurate with the postwar age. The camera lenses also changed from glass to plastic. The traditional black box changed to brown, tan and gray colors and new features such as coupled or built-in flashguns allowing pictures to be taken indoors became the norm. Reflex models imitated more serious cameras. As color films became more sensitive, with greater latitude to poor light conditions, and public demand grew, Brownie pictures moved from black-and-white to color.

DECLINE AND LEGACY

During the late 1950s and 1960s, the Brownie range was increasingly seen as old-fashioned. Helping the brand for a while were molded plastic and updated body designs, as on the incredibly successful Brownie 127 camera produced between 1952 and 1967, which sold in the millions. In Britain, Kodak Ltd. brought in industrial designer Kenneth Grange to update the Brownie 44A and 44B cameras, which lost their box shape to make them look like "proper" cameras. The biggest drawback of the Brownie was its use of roll film, mostly 120, 620 and 127 films. These required care when threading the film through the camera to a take-up spool. It was a fiddly, error-prone process that could result in missed pictures due to the film not advancing through the camera.

The introduction of the Kodak Instamatic (see page 168) range of cameras in 1963, with a drop-in cartridge, did away with this and ensured that the film moved properly through the camera. It was fail-safe. Technically, the Instamatics were box cameras too, but the Kodapak 126 cartridge allowed for a more compact design and better reflected the modern age than did the Brownie.

By the end of the 1960s, having long been the first camera for many tens of millions of people, the Brownie was consigned to history. It was briefly resurrected in 1980 when the Brownie name was used on a 110 cartridge camera celebrating the centenary of the founding of George Eastman's company.

Even today, the Brownie name resonates in popular culture and remains part of photography's folklore. In May 1900, Kodak had promoted the Brownie camera to its dealers with the phrase: "Plant the Brownie acorn and the Kodak oak will grow." Sure enough, the acorn had borne a whole forest of oaks and the Brownie had become the most famous and successful camera range of all time.

ABOVE **The No. 1 Brownie of 1900 (top) and the last Brownie camera made to take the 110 cartridge in Britain between 1980 and 1982 (bottom).**

FOLDING BROWNIES

The box design was limiting in some ways, mainly because it was not compact. Other cameras, including many from Kodak, made use of bellows, which allowed the camera to collapse down from its picture-taking shape to something that was pocket-sized and more easily carried. The first folding Brownie camera appeared in 1904 as a horizontal camera with red bellows that allowed the lens to be pushed back into the body. Once in position, the shutter and aperture controls, in keeping with the box cameras, were limited and simple to operate. A Stereo Brownie was sold between 1905 and 1910, producing a stereo pair of images. Compared with Kodak's other folding cameras, the Brownie range offered few options. The folding Brownie was mainly produced between 1904 and 1926, although Kodak Ltd. in Britain made several models in the late 1930s and immediate postwar period, designated the Six-20 Folding Brownie.

15 The Ticka

PRODUCED: **1904** | COUNTRY: **UK** | MANUFACTURER: **Houghtons Ltd.**

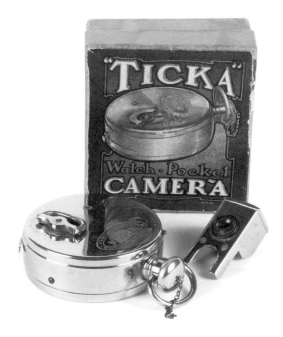

ABOVE **Disguised as a pocket watch, the Ticka was popular and produced good-quality photographs.**

THE disguised camera had a checkered history. Some were impractical, some were too obvious and others were simply no more than a novelty, with no pretension toward being a serious camera. The Ticka camera, which was placed on the market during 1906, was different. Made in the form of a pocket watch, it was also equipped with a reasonable lens that, coupled with a negative of only 1 × 1½ inches (25 × 38 mm), ensured that the enlargements could, in the words of the *British Journal of Photographic Almanac*, "yield quite excellent little prints" of up to 3 × 2 inches (76 × 50 mm).

The Ticka was the most popular watch-form camera ever made. Many thousands of the standard model were sold around the British Empire. In the United States, a version of the camera was sold as the Expo Watch camera and was still being listed in 1939 — some 35 years after Magnus Nièll's original patent.

Nièll was a Swedish camera designer who came up with several innovative designs, including the Ensignette and the Ensign Midget, both of which were popular in their own right. Little is known about Nièll, other than that he came from Djursholm, near Stockholm, and that many of his camera designs were taken up and sold by the British firm Houghtons Ltd. and its successor companies. At one point in the early 20th century Houghtons was the largest camera manufacturer in the UK, even larger than

Kodak in Britain, and it had a history going back to 1834, pre-dating the birth of photography. The firm had been involved in photography since its announcement in 1839.

The Ticka camera was patented in Britain on October 14, 1904, although the original application had been lodged in 1903. It described a watch-form camera and claimed the lens, the film holder and the shutter as the novel parts. Three subsequent patents in 1908 improved the camera further by describing and protecting a special developing device for the Ticka film spools, a focal-plane shutter and an improved film spool. One of the most innovative features of the camera was the drop-in film cartridge, which coupled with the film advance gear and a counter to keep count of the exposures made. The film cartridge, as a single unit with a spool holding the film and take-up spool, was novel and gave the amateur a foolproof method of ensuring that the unexposed film moved correctly within the camera. The idea was taken up again in 1963 with the introduction of the Kodak Instamatic camera (see page 168).

The rights to manufacture the Ticka in Britain were granted to Houghtons Ltd., which had a large factory in Walthamstow, North London, and several large retail and distribution outlets across Britain and the British Empire. Wishing to distinguish the camera from German imports, Houghtons claimed that "the Ticka is British made throughout. It is made in our own factories by our own men, and is not imported." It was sold from 1906 at 8s 6d ($63 today) and was described positively in the photographic press: "The apparatus though so compact, is nevertheless better than a toy."

THE COMPLETE OUTFIT

From its launch the Ticka was accompanied by a full range of accessories, such as developing and printing equipment, printing papers, mounts and albums to support the camera — much as Kodak had offered with its cameras.

The camera was available in outfits that made it perfect for buying as a gift. It was also supported by a special Ticka developing and printing service since its target market, much like many Kodak buyers, was not likely to be interested in the technical side of photography.

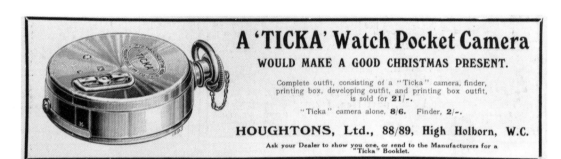

TICKA COLLECTIBLES

In 1908, two new additions to the Ticka range were announced. The Watch Face Ticka had the usual camera mechanism, but instead of the flat metal panel engraved with the Ticka monogram, a whole new face was provided, "which is quite an ordinary watch dial, with two hands, which stand at seven minutes past ten, serving as a pair of lines roughly indicating the angle of the picture" (although the hands do not appear in this exact position on all surviving models). The camera was intended to be mistaken for a watch and it sold for 10s 6d ($78 today). The second model was the Focal-Plane Ticka. The camera featured a better-quality lens, a Cooke f/6.5, which could be focused. It was made by Taylor, Taylor and Hobson of Leicester, one of the leading lens and optical manufacturers in the country. The camera was also fitted with an adjustable focal-plane shutter, giving five speeds from $1/75$ to $1/400$ of a second, plus "time," which kept the shutter open for as long as the release button was depressed. The camera cost £2 10s ($352 today) and was described in the press as a "really nicely made instrument." Both of these models sold in very limited numbers and were only listed for a few years, as they added complexity and this raised the price.

Another addition to the range was the silver Ticka, made to the standard specification except that the body was silver rather than nickel-plated brass. The body and fittings, such as the winding key, were all hallmarked, and those seen all date to 1906, suggesting that only one small batch was made. The "Solid Silver Ticka," as the camera was described in the 1914 Houghtons catalog, was advertised with a viewfinder and a morocco-leather case for 31s ($203 today), as against the 8s 6d ($60) of the regular model.

ABOVE **The Watch Face Ticka featured a real enameled face, with the hands set to show the angle of view of the lens.**

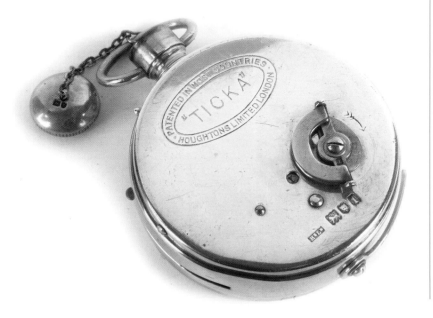

LEFT **A silver Ticka camera with the hallmarks clearly visible at the lower right near the winding key.**

A GLOBAL SUCCESS

The success of the Ticka camera was mirrored elsewhere. Magnus Nièll patented the camera in Germany in 1904, but it was in the United States that it had its greatest longevity. The American patent of 1904 was quickly taken up by the Expo Camera Company, which started manufacturing it from 1905. The camera made use of the usual 25 exposures on a cartridge. Around 1910, an improved model for 10 exposures was introduced. The company was taken over by the photographic dealer Gennart in the late 1920s and changes were made to the design, which by this time was dated. Variations in the engravings on the camera appeared, and around 1935 a range of colored enameled versions were manufactured in blue, red and black.

In Japan, the Uyeda Camera Company produced its own copy of the Ticka called the Moment, made around 1910. Its construction matched the Ticka and Expo cameras, with even the Moment monogram closely resembling that of the British Ticka.

The overall impact of the camera is hard to gauge. Commercially, it was undoubtedly successful, although in Britain it did not survive the First World War. The camera was clearly aimed at the general consumer market and its size and ability to capture images successfully supported this. The images that survive show that it was used in the same way as the popular Kodak cameras of the period — capturing family, friends and places in an informal way.

BELOW **"The King, George and his two Sons,"** from the *Christmas Gift Book*, by Queen Alexandra, 1908. The picture shows Edward VII, the future George V, and George's sons, the future George VI and Edward VIII.

THE ROYAL SEAL OF APPROVAL

Queen Alexandra (1844–1925) was an active photographer from the mid-1880s. She had a number of cameras, including a No. 1 Kodak, a No. 4 Kodak and a Ticka camera. In their first advertisement for the Ticka in the *Almanac*, Houghtons claimed "Her Majesty the Queen uses a 'Ticka' Camera and has written to say that she is very pleased with the pictures she has taken with it." A selection of her photographs were shown by the Kodak company in London in 1897 and in New York in 1898, with further exhibitions of her work in 1902, 1904–1905, 1906 and posthumously in 1930. The *Daily Telegraph* published Queen Alexandra's *Christmas Gift Book* in 1908, which featured her personal photographs, including informal pictures of the Royal Family. More than 500,000 copies were sold and the proceeds were donated to over 30 charities.

16 The Soho Reflex

PRODUCED: **c.1905** | COUNTRY: **UK** | MANUFACTURER: **Marion and Company**

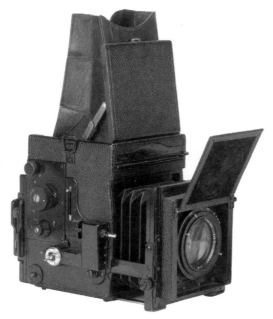

ABOVE **Introduced in 1905, the Soho Reflex was the definitive reflex camera, extensively used in a variety of plate sizes until after the Second World War. The general design was adopted by a large number of manufacturers in Britain and Europe.**

REFLEX cameras incorporate a mirror through which the photographer can view the subject before making an exposure — a feature still found in DSLRs (digital single-lens reflex cameras) today. With a twin-lens reflex (TLR) camera such as the Rolleiflex, two lenses are employed — one to allow the photographer to view the subject, the second to make the exposure. By incorporating a mirror, the single-lens reflex (SLR) utilizes one lens both to view the subject and to make the exposure, the mirror being moved out of the way when the exposure is made. The first true SLR camera was invented by the English photographer Thomas Sutton and patented by him in 1861. The camera was designed for portraiture and it was made by two London manufacturers, Ross and Dallmeyer. Only a very small number were produced.

THE ADVENT OF THE REFLEX CAMERA

The nature of the wet-collodion process meant that reflex viewing was not of significant advantage for the photographer. The limited sensitivity of the photographic emulsion meant that it was not possible to capture movement, and photographs of still subjects could be carefully composed through the back of the camera. It was not until dry plates were introduced that the advantages of the reflex camera became increasingly apparent. A number of designs came onto the market in the 1880s. Loman's SLR camera of 1889

was commercially successful and incorporated a focal-plane shutter, although its operation required some care. During the 1890s, new designs were produced by a number of manufacturers. Of these, the Graflex reflex camera, launched in 1898, was the most long-lived and influential in terms of defining the general design of reflex cameras.

The basis of the Soho Reflex camera was British patent number 22,698, taken out on October 21, 1904, by Abraham Kershaw for "Improvements in Photographic Cameras." The patent described a reflex camera, the movement of the mirror and a mechanism to ensure that the mirror was properly raised before the camera shutter was released and the exposure made. The mirror operated independently of the shutter, with the shutter-release button moving the mirror and operating the shutter in sequence. The patent was incorporated into a reflex camera made by the Kershaw company in Leeds. The design was initially licensed to Marion and Company, one of Britain's largest manufacturers and retailers of photographic equipment and materials, as the Soho Reflex. The name Soho was applied to reflect the location of its headquarters in Soho Square, London, and the camera was sold by the company from 1905.

The 1906 *British Journal Photographic Almanac* described the camera's advantages: "The notable feature in this new pattern of reflector camera is, first of all, the arrangement of the mirror by which a more compact construction can be adopted.... It carries a Kershaw focal plane shutter, working at one tension only, from $\frac{1}{16}$ to $\frac{1}{800}$ of a second.... There is considerable rise and cross movement of the front, and altogether the camera answers the most varied demands of the photographer who purchases it, first of all, for the boon of actually focusing his picture." The camera sold for £12 (around $1,720 today) with no lens.

BELOW **The Loman reflex camera of 1889, one of the more successful reflex designs.**

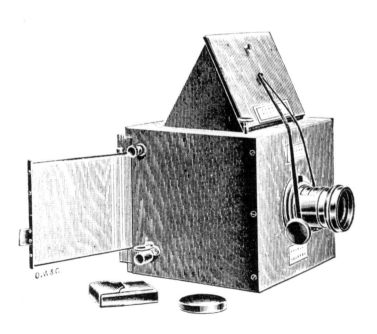

Kershaw made the reflex camera for a range of different manufacturers to retail under their own names, including Marion, Ross, Dallmeyer, Beck and the London Stereoscopic Company, as well as for itself. These are usually identifiable by an initial letter prefix to the serial number stamped into the body. The Soho Reflex camera was made in a wide range of plate sizes; there was also a stereoscopic version and a tropical model. Marion advertised the camera as "For Artists, Travellers, Journalists, Naturalists, All Photographers."

Marion and Company took part in the merger of some of the major sensitized goods and photographic equipment manufacturers — including Kershaw — in Britain in 1921 to form Amalgamated Photographic Manufacturers (APM) Ltd. The Soho Reflex continued to be manufactured, while the Baby Soho produced negatives of 4½ × 6 inches (114 × 152 mm) and was aimed at "travellers, lady photographers and all those to whom, for one reason or another, weight and size are of the utmost importance."

By 1928, when APM was split and Soho Ltd. formed, the reflex camera was being advertised as "the Aristocrat of the Camera World." The top-of-the-range Soho Reflex camera was the Tropical model, which cost £30, against £23 10s (around $2,500 against $877 today) for the standard quarter-plate model in 1930. The Tropical was made from teak and was designed to be used in the tropics and subtropical countries where heat and humidity would warp and degrade the body of an ordinary mahogany model. In reality, the Tropical model was a luxury camera and it is likely that few saw active use in extreme climates.

TOWARD A PORTABLE PRESS CAMERA

The reflex camera was widely used by press photographers and those photographing topical events, where the reflex viewing gave greater certainty that a subject had been properly captured. Although many press photographers had begun to opt for 35 mm and medium-format roll film, glass plates and cut film continued to be used well into the 1950s. Quarter-plate models could be fitted with a film-pack adapter or a roll-film back that would allow multiple exposures to be made before the film needed changing.

During the 1920s, more compact designs were gradually introduced. Companies such as Ihagee in Germany and Houghtons in Britain launched folding reflex cameras, which proved attractive when compared to the solid, bulky box-shape of the Soho Reflex and its contemporaries. There was a move to smaller sizes as photographic emulsions improved, with more sensitivity and finer grains. Models designed solely for roll film were also produced.

By the 1930s, the traditional reflex camera seemed dated when compared to new camera designs: the 35 mm rangefinder; the TLR, such as the Rolleiflex; and, by the mid-1930s, 120 roll-film and 35 mm SLR cameras epitomized by the Exakta and Kine Exakta. These were all smaller cameras that were quicker to operate and capable of producing perfectly acceptable results for use in newspapers and the illustrated weekly press, such as Picture Post in Britain, Life magazine in the United States and the Berliner Illustrierte Zeitung and Münchner Illustrierte Presse in Germany. For traditionalists, the Soho Reflex continued to remain the camera of choice; for the new generation of photojournalists and press photographers, it was a throwback to the past.

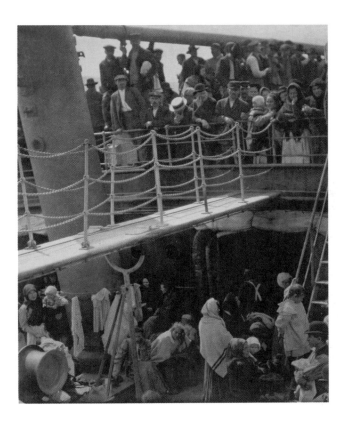

LEFT *The Steerage*, by Alfred Stieglitz, 1907. The image was Stieglitz's most well known work and his first modernist photograph. It depicts passengers traveling in the lower-class section of a steamer going from New York to Bremen, Germany. It was taken on an Auto-Graflex reflex camera.

THE GRAFLEX

The influential Graflex camera, once known as "the camera for more interesting pictures," was the invention of William Folmer who, in partnership with William Schwing, ran a bicycle company in New York City — Folmer and Schwing Manufacturing Company. Due to the popularity of outdoor photography and pursuits, bicycles and cameras had a general association, and the company was already selling cameras in 1898 when Folmer invented the first Graflex. It had a complicated focal-place shutter with a variable aperture, which was adapted in 1904 to a simple cloth curtain with a series of apertures of different widths; this design was manufactured for more than 60 years. In 1905, the company was bought by Kodak's George Eastman, and it became a division of Eastman Kodak Company until 1926. Graflex's flagship product for many years was the Speed Graphic — a solid, reliable camera that became the go-to gadget for press photographers of the early 1900s. It was probably used most famously by New York photographer Arthur Fellig, known as Weegee (see page 136). Alfred Stieglitz used his Auto-Graflex to capture early 20th-century class divisions in "The Steerage" aboard a steamer traveling from New York to Bremen, Germany, and Dorothea Lange was pictured atop her station wagon in 1936 using her Graflex Super D, the same camera she used to photograph "Migrant Mother," the most famous of her works. The Graflex name was long associated with quality and reliability — "sure, simple, certain," claimed one advertisement, "the superior camera for important pictures."

17 The Vest Pocket Kodak

PRODUCED: **1912** | COUNTRY: **U.S.A.** | MANUFACTURER: **EASTMAN KODAK COMPANY**

ABOVE **A remarkable camera that sold nearly 2 million examples and became known as "The Soldier's Camera."**

THE Vest Pocket Kodak, introduced in April 1912, was one of the most successful cameras of its day, with the first model selling around 200,000 units. The Autographic version introduced in January 1915 sold around 1.75 million, with its sales boosted by the First World War when it was advertised as "The Soldier's Camera." The design continued in various forms until 1937, with total sales from 1912 running to around 2 million.

For the casual user, the box camera was the simplest and cheapest camera available, and when used in bright sunlight with normal subjects it gave reasonable results. Kodak had always seen the humble box camera as a starting point and aimed to encourage amateurs to progress to better-quality and more expensive cameras: to embrace photography as not just a means of capturing events, but a hobby in its own right. All of which would boost film sales, where the greatest profits lay. Like most large manufacturers, Kodak offered a range of cameras with various features and at different prices. For many customers the next step up from a box camera was a simple folding bellows camera.

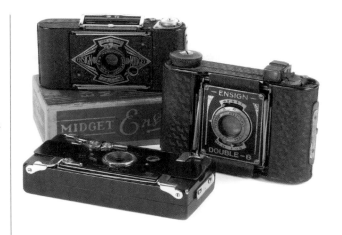

THE ENSIGNETTE

In 1909, Houghton's Ensignette camera was introduced to the public — a small roll-film camera that collapsed from its taking position to a compact unit of no more than 4 × 2 × ¾ inches (101 × 50 × 19 mm). It achieved this through the use of a bellows and strut arrangement that allowed the front lens support to collapse down into the main rear body of the camera. The camera produced a 2¼ × 1½ inch (60 × 38 mm) negative, which was large enough to yield reasonable enlargements. Houghtons introduced a series of improved models, which were accompanied by a variety of accessories and processing equipment specially made to support the negative size, together with albums to hold contact prints made directly from the negatives. The Ensignette was an immediate hit and the last model was only discontinued in the late 1920s.

The Ensignette started a trend for more pocketable cameras that other manufacturers quickly adopted. The Eastman Kodak Company's response was the Vest Pocket Kodak of 1912. The bellows camera did not incorporate the strut arrangement of the Ensignette; instead, it featured a scissor arrangement — known as lazy-tongs — that connected the front lens board to the camera back on both sides. Lazy-tongs offered rigidity, and the front could simply be pushed back without the awkward unclipping at four points that the Ensignette required. The Vest Pocket Kodak also made use of a new 127 roll-film format with a compact centre spool, which meant that the camera could be smaller than normal. It gave negatives of 1⅜ × 2½ inches (35 × 64 mm).

The *British Journal Photographic Almanac* for 1913 described the camera when closed as having "an excellent roundness of shape, being quite free from all projections, unless one so regards the very slim winding key of the film-spool." The camera was just 4¾ × 2½ × 1 inches (120 × 64 × 25 mm) in size when closed. In order to appeal to a nontechnical market, the lens was set in an Eastman Autotime scale, which negated the need to have any knowledge of f-numbers and shutter speeds, with the diaphragm being set according to

In 1913 and 1914 Henry Jacques Gaisman was granted a series of patents for an invention that allowed the photographer to write information (such as dates and locations) on the film while it was still in the camera and which would appear at the edge of the finished photograph. The potential of Gaisman's idea was recognized by George Eastman, who paid him $300,000 (approx. $7.04 million in today's money) for the rights to his invention. The autographic feature was rolled out across many of Kodak's roll-film cameras and Autographic backs could be bought for existing roll-film cameras. The Autographic feature remained on all popular Kodak cameras, other than Brownie box cameras, until the early 1930s. The Autographic Vest Pocket Kodak camera was introduced in 1915.

the subject and only two shutter speeds. The report concluded: "In the very excellent design and finish of the apparatus we see the familiar determination of the Kodak makers to produce always the best type of a given article. The Vest Pocket Kodak, though taking a very small picture, is nevertheless a thoroughly reliable instrument, and is not at all dear at its price of £1 10s." The film produced for use in the camera gave eight exposures per spool and cost 10d.

Kodak's internal dealer publication, the Kodak Trade Circular, extoled the camera to the photographic trade in its March–April issue, stating that "never have we put such good work into such small space," with the optimistic statement that "the Vest Pocket Kodak brings appreciably nearer the time when it will be the exception to stir out of doors without a Kodak." The remaining issues of the Circular for 1912 were full of accessories and ideas for dealers on how to promote the camera to the public.

THE SOLDIER'S CAMERA

With the outbreak of the First World War, the business of photography began to boom. Main-street portrait studios experienced a growth in demand as men called up to serve left their portrait behind for family members; sweethearts were photographed before being separated. Sales of cameras, along with sensitized materials, increased significantly as people bought cameras to record their family members. It was, in fact, a court-martial offence for soldiers to bring a camera to the front, but the regulation was widely flouted by officers as well as men. Cameras such as the Ensignette and Vest Pocket Kodak were easily carried and concealed. Kodak noted to its dealers that any fear about the sale of Vest Pocket Kodaks to soldiers and sailors being forbidden by the authorities could be dismissed. It added that "Enquiries have failed to disclose any such restriction."

From late 1914, Kodak Ltd. in Britain began to promote the Vest Pocket Kodak as "The Soldier's Camera," with owners being encouraged to "make your own record of the war." Kodak saw enormous purchasing power in what it estimated as 2 million British men in active service. Of these, there were some 50,000 officers and 150,000 noncommissioned officers who were all able to afford a Vest Pocket Kodak.

The *Kodak Trade Circular* in January 1915 reported on a Soldier's Kodak Selling Scheme that aimed to encourage dealers to target British soldiers directly with the Vest Pocket Kodak. The scheme noted that there was no difficulty in getting soldiers interested in the Vest Pocket Kodak and it exhorted dealers to: "Push *now* and push *hard* — next month it may be *too late*." It was a tremendous success with dealers, and Kodak's promotional material was reprinted several times. The same issue noted that sales of the Vest Pocket Kodak in France were "at the present time phenomenal." Sales of the camera in Britain in 1915 were five times those of the previous year and the general boom continued until 1917.

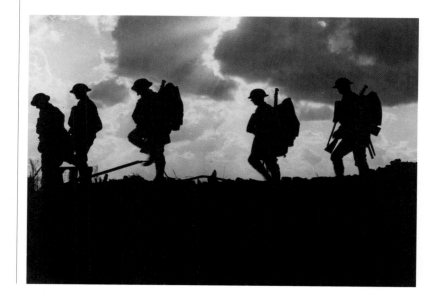

RIGHT **Ernest Brooks' iconic image of silhouetted men of the 8th Battalion, East Yorkshire Regiment, going up to the line near Frezenberg.**

THE OFFICIAL VERSION

During the First World War, news photography was heavily controlled. Britain's first official war photographer appointed by the military was Ernest Brooks (1878–1936), who had previously worked at the *Daily Mirror*. Using handheld folding plate, SLR, panoramic and field cameras, Brooks produced around 4,400 images between 1915 and 1918; more than one-tenth of all official British photographs taken during the war. He was known specifically for using the Kodak Panoram No. 4, which recorded an arc of 142 degrees to convey the scale of events. Brooks enlisted for military service on January 25, 1915, initially as official photographer to the Admiralty. He was given the honorary rank of Second Lieutenant and in 1916 was transferred to the War Office and sent to photograph the Western Front. He was the only professional photographer to cover the Battle of the Somme — witnessing the successions of troops going over the top. As an official photographer, his photographs were often posed, and very different from those captured hurriedly by soldiers on the Vest Pocket Kodak, but occasionally his work conveyed some of the horror of the war.

THE HUMAN FACE OF WAR

A great number of images of informal military activity were taken with "The Soldier's Camera," suggesting that Kodak's intuition — that the camera would be taken to the front line and used to record subjects that had not previously been photographed — was correct. Direct military engagement was rarely the subject of these photographs; they tended to feature views of the trenches, bombed buildings and people, whether local civilians or soldiers relaxing or undertaking social activities. This was evidence that the Vest Pocket Kodak was used to capture the same subjects, albeit in a different context, that the civilian population wished to photograph.

RIGHT **British soldiers wearing gas masks, unknown photographer, 1917. This informal photograph away from the front line was almost certainly taken with a Vest Pocket Kodak.**

The Thornton–Pickard Mark III Hythe Camera Gun

PRODUCED: **c.1918** | COUNTRY: **UK** |
MANUFACTURER: **Thornton–Pickard Manufacturing Company**

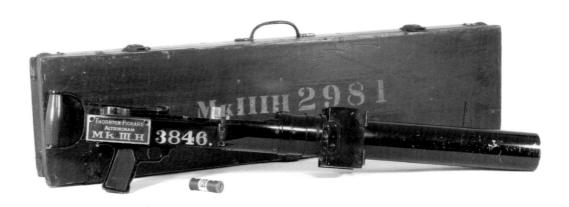

ABOVE **The Hythe Mark III camera gun, introduced to help airmen improve their gunnery skills in the First World War.**

THE various camera guns that had been produced before the Thornton–Pickard Hythe was introduced had not been serious cameras, despite the fact that they could all take photographs. The Enjalbert Revolver de Poche (see page 44) was realistic, as was the Sands and Hunter Photographic Gun in the form of a rifle, but at £15 (around $2,185 today) the Sands & Hunter was an expensive camera. In many ways, the general design of a gun was ideally suited to photography: both the gun user and the photographer needed a device that was stable and could be aimed at the subject (or target) and fired.

It is no coincidence that many terms used for firearms were applied to photography, from shooting one's subject to firing the shutter and the term "snapshot." *The Photographer's Indispensable Handbook* described the Sands and Hunter Gun as "an ingenious novelty, but nothing much to recommend it beyond that fact." That summed up the photographic camera gun. They were too conspicuous to be discreet, and in order to fit the camera into the shape of a gun many compromises were made, which in turn limited their functionality as cameras.

THE WAR EFFORT

The Mark III Hythe camera gun was designed to fulfill a practical need: the training of gunners for accuracy, using film as a cheaper alternative to live ammunition. The Thornton–Pickard Manufacturing Company was a large camera manufacturing business located in Altrincham, just south of Manchester, England. It had started manufacturing roller-blind shutters for use on field and hand cameras, and gradually moved on to making brass and mahogany field cameras and a range of other cameras. By the start of the First World War, it was one of Britain's largest photographic equipment manufacturers, along with Houghtons Ltd. in London, J. Lancaster and Sons in Birmingham and A. Kershaw and Sons in Leeds.

The outbreak of war in 1914 put an end to the manufacture of cameras for consumers as the government requisitioned factories and gave orders for munitions. Many photographic manufacturers secured contracts for optical munitions, and war work helped to support businesses that were already starting to struggle against German and American competition. A government contract paid for a major factory building for A. Kershaw and Sons, which the business was able to use after the war ended.

For the first time in an armed conflict, photography was to play a significant role. It quickly became an important aid to military intelligence, especially when coupled with aircraft, which were also being used for the first time. A demand was created for aerial cameras to use in reconnaissance work.

All of Thornton–Pickard's wartime production was centered on contracts for the Royal Flying Corps (RFC): aerial cameras and camera guns for the training of aircrew. For the early part of the war, the organization and placement of orders were haphazard and it was not until February 1915 that a serious attempt was made to organize photography for the RFC. Eventually, a unit specifically devoted to aerial photography was established under the leadership of Lieutenant J.T.C. Moore-Brabazon.

Thornton–Pickard's company secretary was called to a meeting with Moore-Brabazon and the design for an aerial camera was worked out. The Type A, made at the company's factory, was the first official RFC aerial camera for oblique work, where the photograph was taken at an angle to

BELOW **The Type A aerial camera (left) and Type E aerial camera (right), taken from a Thornton–Pickard sales brochure.**

the ground rather than directly overhead. In the summer of 1915, a Type C followed, which was designed to be mounted vertically on the outside of an aircraft. A Type E came out in fall 1916; this model was intended to be mounted inside an aircraft. This was the last model to be designed and built by the Thornton–Pickard company; the Williamson Manufacturing Company in London made later models.

TARGET PRACTICE

The other camera Thornton–Pickard went on to design for the armed forces was the Mark III Hythe camera gun. Traditional methods of training in gunnery for land forces could not be applied to aerial combat, where distances between the gunner and the target and their positions were continuously changing. There was therefore a requirement for a camera similar in form and action to a real machine gun. Such a camera was developed at the School of Aerial Gunnery at Hythe in Kent and manufactured by Thornton–Pickard from around 1916. The Mark III was the result of an evolutionary design process and contained significant improvements over the Mark I and II models. The approximate shape of a Lewis gun, with a lens and shutter mechanism fitted inside the gun barrel, the camera made 14 exposures on 120 roll film. The procedure for operating it was the same as that for a real gun. A marked glass screen placed in the focal plane of the camera provided a guide to the accuracy of the "shooting."

The firing of film rather than bullets was a matter of economy, but it also offered other advantages, which Spencer Leigh Hughes MP described: "The Gun Camera shows and records on the film how many hits the man would have made had he been firing bullets at the aeroplane which he is photographing." It also provided a precise measurement of how many drums of "ammunition" were being used, as well as being a key tool in helping the gunner to judge distances. Hughes also noted that "soon after the authorities had given what was a reluctant consent to have it used for training purposes a very great improvement in the shooting of British aviators was noticed. Indeed, it was so remarkable that it could not be considered as a mere coincidence."

The Hythe Mark III camera gun was manufactured up until the end of the war and was supplied to Britain's air force and those of her allies France, Italy and America. It continued to be sold to the newly formed Royal Air Force. After the war, Thornton–Pickard's aerial cameras and camera gun were also supplied to civilian firms, where the latter cost £50. A booklet issued by the company called *Aviation Photography* described some of the firm's wartime activities and acted as a sales tool for prospective customers.

The Air Ministry, writing in 1919, noted that "the value of [the Hythe camera gun] cannot be overstated, and the large numbers used testify the importance of this instrument as a means of training pilots to shoot accurately." By the end of the war, the Thornton–Pickard factory had given up making any cameras other than the Hythe Mark III. Leigh Hughes noted that "those who are capable of forming a definite opinion that is worth anything on this matter,

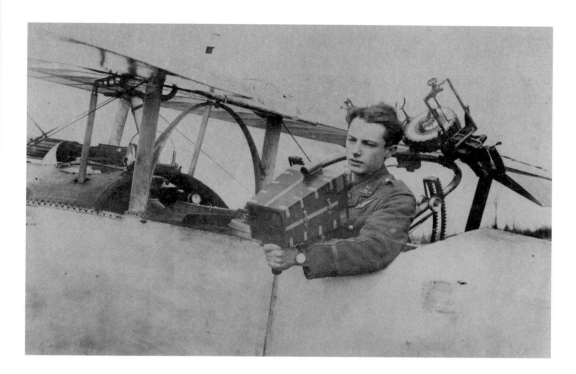

ABOVE **Lieutenant S.C. Thynne of the Royal Flying Corps demonstrates the use of a Thornton–Pickard Type A aerial camera for photographic reconnaissance from the back seat of a Nieuport aircraft.**

declare that the Mark III Gun Camera was the main factor in the supremacy of our men in the air, and for their absolute dominance over the enemy."

The reliance of Thornton–Pickard on the Air Ministry contracts was only of short-term benefit to the company. In the postwar era it struggled to develop new products to meet market demands and mostly continued production of updated versions of prewar cameras.

The Hythe Mark III continued to be made until 1937. By this time the company was a shadow of its former self, its products having been overtaken by precision-engineered cameras from Germany and amateur cameras from Kodak and Houghton-Butcher, both of which had modern factories able to mass-produce products.

AERIAL PIONEER

J.T.C. Moore-Brabazon (1884–1964) was a pioneer of aviation in Britain. He attended Harrow School and studied engineering at Trinity College, Cambridge. His holidays were spent volunteering for Charles Rolls as a mechanic. He learned to fly in 1908, and on March 8, 1910, became the first person to qualify as a pilot in the UK. In 1914 he joined the RFC and made a significant contribution to the new techniques of aerial reconnaissance. After the war he entered politics, becoming a Lord in 1942. He went on to serve in several official roles, including president of the Royal Institution.

19 The Ermanox

PRODUCED: **1924** | COUNTRY: **Germany** | MANUFACTURER: **Ernemann**

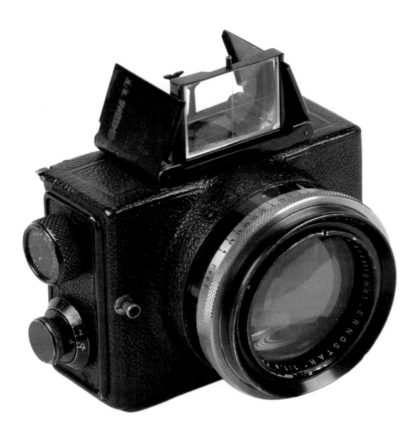

I N THE short period after the end of the First World War, and before the Leica and other 35 mm cameras began to dominate photojournalism, one camera stood above all others. The Ermanox of 1924 was manufactured by the Ernemann company of Dresden and made 1¾ × 2¼ inch (45 × 60 mm) plate negatives. The camera featured a wide-aperture Ernostar lens designed by Ludwig Bertele, which, at the time, was the widest-aperture lens of any miniature camera.

Announced in July 1924, the Ermanox was a development of the company's "vest pocket" range of plate cameras. It was initially sold with an f/2 lens; an f/1.8 lens was available from 1925.

THE PHOTOJOURNALIST'S FAVORITE

The Ermanox was well received. It was advertised under the headline: "Night photography without a Flash Light" and the *British Journal Photographic Almanac* noted: "The camera has its special uses for indoor shutter exposures under conditions of lighting that would be impossible with lenses of smaller aperture."

Among the users of the Ermanox camera were Felix H. Man and Alfred Eisenstaedt. Eisenstaedt became a photographer in 1927 and was later told by an editor: "If you want to succeed in photography, you should look at the work of Dr. Erich Salomon." Salomon, a pioneering news photojournalist (see page 86), used an Ermanox and Eisenstaedt immediately bought one in the hope of emulating his success. His first commission with the Ermanox was to photograph a meeting of the Salvation Army. Eisenstaedt described the use of the camera in his 1969 book *The Eye of Eisenstaedt*: "You approach with camera and tripod, ask permission to photograph, and set up. First you must focus through the camera's ground-glass back, using a small pocket magnifier. Then, put in the metal plate holder with its glass plate, and remove the slide. Next you have to watch very closely. Replace the slide, remove the plate and holder. One shot. In looking back, I'm amazed we were able to get the candid results we did." He later purchased a Leica camera in 1932, with which he took some of his most famous images (see page 90).

Another user of the Ermanox was the chemist Dr. Hans Böhm, who used it to photograph Max Reinhardt's theater performances in Vienna in 1924–1925. Using highly sensitive plates, Böhm took photographs from the auditorium of performances as they happened. Shots of theater productions had previously always been set up, but Böhm was able to capture the actors' expressions and gestures exactly as the audience saw them.

ABOVE **An advertisement for the Ernox, or Ermanox, camera from the British importers Duke & Neddermeyer in the 1925** *British Journal Photographic Almanac.*

LENS DESIGN BY LUDWIG BERTELE

Bertele, the camera's lens designer, was a gifted optical designer who started his career in 1916 as an assistant designer with the Rodenstock company. In 1919 he moved to Ernemann and started to design photographic lenses the same year, a period of work that culminated with the Ernostar. In 1923, he patented his first large-aperture lens, the f/2 Ernostar. With the incorporation of Ernemann into Zeiss Ikon in 1926, Bertele continued his work for the new company. He developed new lenses based on the Ernostar that were marketed under the name Sonnar. These had an f/2 aperture but used a smaller number of lens elements, which improved the contrast and lessened light dispersion. In 1932, an f/1.5 Sonnar was developed, which was fitted to Zeiss Ikon's Contax cameras. In 1934, Bertele developed a series of wide-angle lenses based on the Sonnar, sold under the Biogon name. From 1943 Bertele worked for Steinheil; after the war he joined the Wild company in Swizterland, as well as continuing to work for Zeiss Ikon. He received his last patent in 1976.

ABOVE **From left to right: Benito Mussolini, German Chancellor Heinrich Brüning and Foreign Minister Julius Curtius in the Hotel Excelsior, Berlin. Taken by Erich Salomon, August 1931.**

ERICH SALOMON

The best-known user of the Ermanox was Erich Salomon. He took up photography to copy documents and soon after acquired an Ermanox camera. He found early fame when, using an Ermanox hidden inside his bowler hat, he photographed a defendant on trial for murdering a police officer. From 1928 he worked for the *Berliner Illustrierte Zeitung* as a photographer and quickly earned a reputation for photographing politicians, catching them unawares and in less formal situations than was the norm for such subjects at the time. During the signing of the Kellogg–Briand Pact in Paris in 1928, Salomon boldly helped himself to a vacant seat and captured several photographs of the proceedings.

A well known picture, taken at a conference in Switzerland, shows ministers from the world's major powers conversing informally around a small table. Other photographs show conference delegates casually joking, yawning and chatting. Salomon's photographs gave them a human dimension missing from the photographs of his contemporaries.

In England in 1929, Salomon visited the Appeal Court and photographed judges about to pass a death sentence. He subsequently learned that this was a criminal offence, so he refrained from publishing

the picture. He also photographed a session of the United States Supreme Court, one of only two photographers known to have done so.

Salomon's nondescript appearance helped him to slip into meetings unnoticed, and he secured his pictures through a combination of keen observation, photographic expertise and patience. As his fame grew, Salomon came increasingly to be expected at events where politicians gathered. In the early 1930s, at a secret German–British summit, Dr. Otto Braun, prime minister of Prussia, was asked whether Salomon would be allowed on board the vessel where the meeting was taking place. He is said to have replied: "Surely it's inevitable. Nowadays, you can hold a conference without ministers, but not without Dr. Salomon." A similar remark is attributed to the French foreign minister, Aristide Briand: "Where is Dr. Salomon? We can't start without him. People won't think this conference is important at all!"

In 1931, when Salomon was at the height of his fame, he published a book, *Famous Contemporaries in Unguarded Moments*. As the political situation in Germany became increasingly difficult he moved to The Hague in the Netherlands, his wife's home country. There, he was able to photograph world meetings and Dutch politicians. He continued to travel and photograph surreptitiously in concert halls. After Germany invaded the Netherlands he went into hiding, but he and his family were discovered and taken to a concentration camp. He died in Auschwitz in July 1944.

The editor of *The Graphic*, a London illustrated weekly publication, coined the term "candid camera" for Salomon's work in its issue of January 11, 1930. The term continues to be used today. Salomon described himself as an historian with a camera. He lived through one of the most remarkable periods of the 20th century and, uniquely, was able to photograph many of the statesmen associated with it.

The Ermanox camera was manufactured until 1931, by which time the Leica was seen as better designed for capturing the type of images that Salomon had photographed.

The Leica I

PRODUCED: **1925** | COUNTRY: **Germany** | MANUFACTURER: **Leitz**

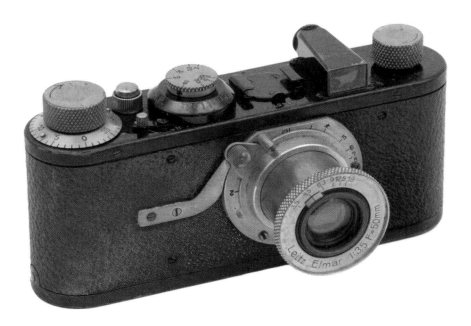

ABOVE **An iconic product series, introduced in 1925, the Leica quickly attracted a following. It has been used by some of the world's most famous photographers and still inspires an almost cult-like devotion.**

MUCH mystique has been attached to the Leica camera. The instrument itself was not the first 35 mm camera, but it came at a time when there was a growing demand by professional photographers for more spontaneous images, to which the 35 mm format was ideally suited. The camera was adopted by a group of photographers whose images quickly became part of a wider international visual currency, capturing the era in ways that would previously have been difficult to realize.

THE RISE OF 35 MM FILM

Perforated 35 mm film had been developed around 1891–1892 with Edison's kinematograph and it became the standard format for the nascent cinematography industry. However, it couldn't be used in still cameras until the sensitivity and quality of the film stock had been improved, with the consistent coating of the emulsion onto the celluloid base. The small size meant that any defect would be more apparent once it was enlarged.

One of the first patents for a 35 mm still camera was granted to A. Léo, P. Audobard and C. Baradat on March 9, 1908, although there had previously been other designs produced in very small numbers. The 1908 design used a similar mechanism to a motion-picture camera to advance the film. It does not appear to have ever been manufactured and the first commercially successful 35 mm cameras were the French-made Homéos, patented by Colardeau and Richard in 1913, and the American Tourist Multiple, which appeared the same year. Other designs were also introduced, with none selling in any great number, although the Levy-Roth Minigraph camera of 1915, which took standard $\frac{3}{4} \times 1$ inch (18×24 mm) motion-picture frames, the Swiss Sico (1920), the Austrian Amourette (1925) and the American Ansco Memo (1926) achieved some commercial success.

THE MAKING OF A LEGEND

The most significant step in popularizing the 35 mm film format came with the Leica of 1925. It was based on the designs of Oskar Barnack, who had joined the Leitz optical company in 1911. He had designed a small portable camera to make use of "short ends" of 35 mm motion-picture film. Barnack's prototype of 1913, named retrospectively the Ur-Leica, was held horizontally, and it had a small collapsible lens and a focal-plane shutter. A viewfinder could be mounted on top. The negative was $1 \times 1\frac{1}{2}$ inches (24×36 mm) — twice the usual motion-picture frame size. After the First World War the camera attracted the attention of Dr. Ernst Leitz and his company decided to produce a series of 31 samples in 1923. A collapsible optical finder was fitted and the camera was calibrated for 40 exposures.

The camera was shown to the public at the 1925 Leipzig Spring Fair and became available during the summer, its name being derived from Lei-tz (the company name) and ca-mera. The production camera featured an Anastigmat lens and a self-capping shutter with speeds from $\frac{1}{25}$ to $\frac{1}{500}$ of a second. Further variants quickly followed, with an Elmax lens and then the standard Elmar lens. The initial lack of slow shutter speeds was overcome by fitting the camera with a standard Compur shutter instead of the internal focal-plane shutter.

An important development was the move from lenses fixed to the camera body to interchangeable lenses and, from 1931, a standardized body and lenses, which meant that any Leitz lens would fit any standardized camera body. Leitz supported the camera with an ever-increasing range of accessories to allow it to be used for everything from close-up photography to telephoto work, as well as darkroom equipment.

The Leica I was superseded by the Leica II in 1932, which incorporated a built-in rangefinder coupled to the lens. The design remained largely unaltered, other than by incremental improvements, until the Leica M series was introduced in 1954.

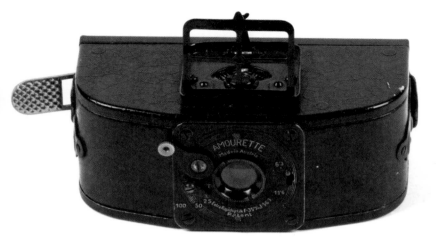

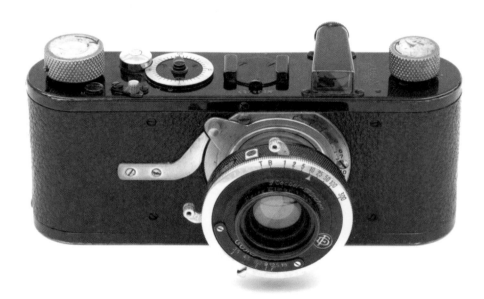

LEFT **The Austrian Amourette camera of 1925 (above), which used 35 mm film. The Leica I(b) camera of 1928 (below) with a rimset Compur shutter, which allowed for more shutter speeds than the Leica's usual internal shutter.**

V-J DAY KISS IN TIMES SQUARE

Alfred Eisenstaedt's *V-J Day Kiss in Times Square* was taken on August 14, 1945, near Times Square in New York, and was published a week later in *Life* magazine. It captured a spontaneous kiss between strangers (or a sexual assault, as several researchers contend), as President Harry S. Truman announced the end of the war on Japan. The photograph has become absorbed into wider culture, being represented as statues, in numerous Hollywood films and even in *The Simpsons*. Over the years, a number of individuals have claimed to be in the photograph, but the identities of the two people kissing have never been confirmed.

The Leica became a success where early and even contemporary designs failed because Leitz built it to a very high standard, as one would expect from an optical instrument maker. The body and parts were precisely engineered and supported by a range of high-quality lenses. These were calculated by Max Berek and others directly working for Leitz and were specifically designed to be used on the camera with the 35 mm format. This combination allowed good enlargements to be made from what was, for the period, a small negative. The format was termed subminiature, reflecting most photographers' familiarity with roll film and with plates giving negatives at least four times the size.

The strengths of the camera were not immediately recognized by the photographic press., but the *British Journal Photographic Almanac* described the Leica as "quite an innovation in pocket cameras" and noted its quality: "in design and workmanship the camera is of the highest description." The camera, which included a fixed lens, sold for £22, with the separate rangefinder costing another £2. One thousand cameras were sold in its first year, and by 1932, when the Leica II was introduced, some 90,000 cameras had been sold. For many photographers, the high quality of the Leica's mechanics, its cosmetic build and its optical quality, set it apart from other cameras and helped to establish a reputation that persists today.

A NEW BREED OF PHOTOGRAPHER

A new breed of what would be termed photojournalists adopted the Leica. They required a small, portable and unobtrusive camera that could be successfully used in a variety of situations and conditions. By 1954, when the camera was fully redesigned, many photographers who would become household names had used the Leica, producing a range of iconic images of the 1930s and, particularly, of the Second World War.

Alfred Eisenstaedt, Robert Capa, André Kertész, Andreas Feininger, Aleksander Rodchenko, Leni Riefenstahl, Robert Doisneau, Bert Hardy and George Rodger all used the first-series Leica cameras. For many, these cameras were so reliable that they continued to give good service long after they had been superseded by the M series.

Despite competitors such as the Contax and Kine Exakta, the Leica retained its status as "the photographer's camera" and it was not seriously challenged until the arrival of the Nikon F in 1959.

ABOVE **Leica advertising poster, c.1930.**

LEFT **By Henri Cartier-Bresson, Alicante, Spain, 1933. This image was taken with his first Leica camera (pictured below).**

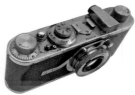

HENRI CARTIER-BRESSON

In September and October 1933 *Henri Cartier-Bresson and an Exhibition of Anti-Graphic Photography* was showing at the Julien Levy Gallery in New York City. Cartier-Bresson (1908–2004) had only purchased his first 35 mm Leica that same year but was to become one of the most famous photographers to use the camera. He was given a box Brownie as a child and studied art as a young adult, but did not discover his passion for photography until 1930 when he saw a photograph by Hungarian photojournalist Martin Munkácsi that inspired him to move from painting to photography. After initial landmark exhibitions in New York and Madrid in 1933, he began traveling the world in search of new subjects to photograph.

The Leica proved the perfect partner for Cartier-Bresson; its quick and unobtrusive nature matched and informed his feline style of shooting. He even went so far as to cover the camera's aluminium casing with black leather tape to make it less visible, enabling him to capture his subjects without their knowledge and remain an unnoticed witness to events. He was involved in founding Magnum Photos in 1947, Robert Capa's brainchild, with David Seymour, George Rodger and William Vandivert. The organization was the first cooperative agency for worldwide freelance photographers. The significance of his work was appropriately honored in 1947 with a one-man exhibition at the Museum of Modern Art in New York. In 1952, he published his most influential book, *The Decisive Moment* — a phrase that perfectly reflects the momentary genius of his images and the Leica's instantaneous capabilities.

RIGHT **By Henri Cartier-Bresson. Place de l'Europe, Gare Saint Lazare, Paris, 1932.**

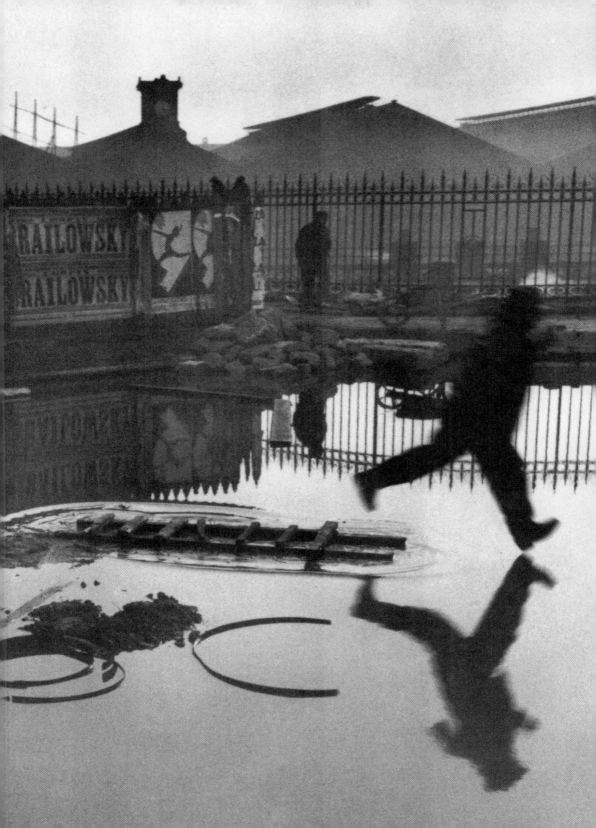

21 The Contax I

PRODUCED: **1932** | COUNTRY: **Germany** | MANUFACTURER: **Zeiss Ikon AG**

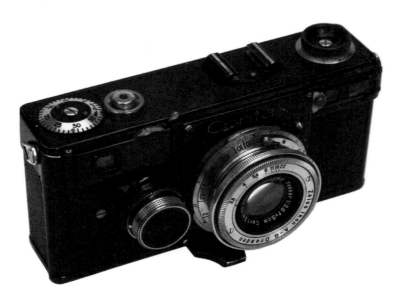

ABOVE **A 35 mm camera designed to compete with the Leica II.**

WHEN the Leica camera (see page 88) was introduced in 1925 it met with considerable commercial success, so it was inevitable that other manufacturers would seek to introduce their own 35 mm cameras. One of the largest quality-camera manufacturers was the German Zeiss Ikon AG, based in Dresden. The company had been formed in 1926 as a result of the merger of four of the leading German camera makers — Contessa-Nettel, Ernemann, C.P. Goerz and Ica — under the auspices of the lens manufacturer Carl Zeiss of Jena. Each of these companies was a well-established and successful business, but merging gave them greater financial stability and strength at a time when the postwar German economy was struggling and inflation was affecting consumer buying power.

Zeiss Ikon offered something for everyone: from simple box cameras through to more complex instruments intended for amateurs and professional photographers, along with the accessories, films and supporting materials needed for photography. Initially, the company simply rebadged cameras made by its constituent companies, but gradually these were improved and new models introduced. The Ernemann company had a history of producing small precision cameras such as the Ermanox, with its fast f/1.8 lens, and this experience was used in developing new products. Zeiss Ikon's Kolibri, which used 127 roll film, was popular, as were smaller roll-film cameras such as the Baby Ikonta. It was increasingly clear that a 35 mm camera was needed to meet the expectations of customers and to compete head-on with Leitz's Leica.

THE UNIVERSAL CAMERA OF TODAY AND TOMORROW

In spring 1932, Zeiss Ikon announced its competitor to the Leica II, which it called the Contax camera. The name was chosen after a poll among its employees and Dr. Heinz Küppenbender, a doctor of engineering, was the camera's main designer. The camera was made between 1932 and 1936.

Like the Leica, the Contax featured a built-in rangefinder coupled to the lens, but the features and fittings on the camera were similiar to other Zeiss Ikon cameras. The Contax body was square-cut rather than having the rounded corners of the Leica; it featured interchangeable Zeiss lenses that coupled to the camera using a bayonet mount rather than a screw thread; and it was considerably heavier than the Leica. However, the biggest difference was in the shutter. The Contax shutter moved vertically and was made up of metal blinds, in contrast to the horizontally running cloth blinds of the Leica. The Zeiss Ikon shutter recalled the Contessa-Nettel shutter; although innovative, it was prone to jamming, for which the Contax quickly gained a reputation. The camera's back removed completely, which made it easier to load than the Leica. Loading the Leica involved removing the baseplate and undertaking a fiddly process, with the potential for the film to be improperly secured to the take-up spool, leading to an unexposed roll of film.

Like the Leica, the Contax was advertised as a system camera with a range of lenses and accessories all designed to make the camera usable across a wide range of subjects and applications, such as copying work and

RIGHT **The Contax I was introduced with a range of accessories to ensure that the camera appealed to as wide a market as possible. This advertising brochure from c.1936 shows a Contax I mounted on a copying stand.**

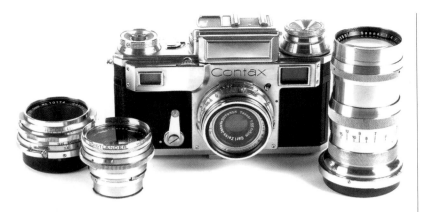

photomicrography. The lenses were designed by Ludwig Bertele (see page 85), who had previously worked for Ernemann and had designed the f/2 Ernostar. For many photographers, the Contax lenses were superior to their equivalent Leica lenses. Bertele's designs reduced the number of air-to-glass surfaces. This ensured that the light was transmitted with fewer imperfections through the lens to the film. In the years before lens coating, which further aided the transmission of light, became widespread, this had significant advantages for contrast and reduced lens flare. In 1935, Bertele introduced the Zeiss Sonnar f/2.8 180 mm lens, which was available for the 1936 Olympic Games held in Berlin.

The Contax was advertised from the outset as "The Universal Camera of today and tomorrow." The company noted the key features of the camera as: all-metal construction, including the shutter; speeds from ⅕₅ to ¹⁄₁₀₀₀ of a second; a rangefinder coupled to the lens for accurate focusing; automatic film transport to avoid double exposures; easy film loading; available for use with any 35 mm film and a wide range of Zeiss lenses. The camera sold for £24 10s (around $2,345 today), including an f/3.5 50 mm Tessar lens. The Leica II, which was the direct competitor for the Contax, sold for £22 ($2,030 today), including an f/3.5 50 mm Elmar lens.

A review of the Contax printed in the *British Journal Photographic Almanac* for 1933, which also carried a review for the Leica II, was positive: "beautifully made and finished, this little camera may be said to represent the very last word in miniature de luxe camera construction."

New models, the Contax II and Contax III, were introduced in 1936 to compete with new Leica models. The II, which was manufactured until 1942, featured an extended shutter-speed range and the III, also only made until 1942, when the war stopped production of both models, had a built-in selenium-cell exposure meter. The new models featured rounded corners and came in a chrome finish, with updated controls and fittings. The *British Journal Photographic Almanac* for 1937 noted that the II featured "radical constructional improvements which make for great ease in manipulation." The price was increased significantly to £40 10s for the II and £53 for the III. The last Contax model, the IIIa, was made in 1961. By then, the

advantages of the single-lens reflex had become apparent and SLRs began to dominate the market.

The market for the Contax camera, especially the models II and III, lay with professional photographers, photojournalists and those working in industry. Robert Capa (see page 98) and Margaret Bourke-White both used the Contax. Eliot Elisofen used a Contax III extensively when he was on assignment in the Second World War, during which the *Life* magazine photographers George Silk and Carl Mydans also carried several Contax II bodies with them. The Leica, although popular during the war, was given a good run by the Contax, which was often preferred because of its Zeiss lenses and wide apertures. These gave it the edge when shooting in difficult or low-light conditions. The mechanics of the camera, despite the shutter's propensity to jam on the earlier models, were also more robust.

For the amateur, the Retina camera introduced by Kodak AG in 1934 was a more affordable option. It was designed by Dr. August Nagel, who had previously worked for Contessa-Nettel and had then joined Zeiss Ikon AG before leaving in 1928 to set up his own company. By 1939, the Retina had sold some 266,000 units. In 1937 the first Canon rangefinder camera was marketed in Europe, a forerunner of the competition Zeiss Ikon could expect after the war.

The Contax II and III cameras were reintroduced after the Second World War as the IIa and IIIa, with updated specifications, but by then they faced stiff competition from Japanese-made rangefinder cameras modeled on the Leica.

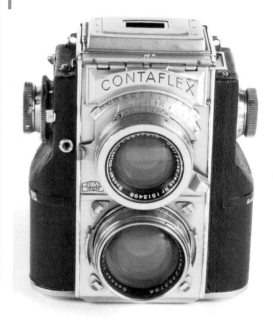

THE TWIN-LENS CONTAFLEX

A number of Zeiss Ikon's other cameras incorporated design or mechanical elements from the Contax range. The Super Nettel and Nettax cameras, for example, were essentially Contax shutter units with folding fronts. The Tenax II featured a rapid film advance lever. The most significant development was the introduction of the twin-lens Contaflex in 1935. The camera was essentially a streamlined Contax body with a viewing lens mounted above it. But it was far more than that: it was the first camera to have a fully built-in exposure meter. Although a masterpiece of Zeiss Ikon engineering and design, the camera was very heavy and its lens mount was not compatible with Contax lenses. Priced at £64 (around $6,100 today) and above, it saw only limited demand.

ROBERT CAPA

Perhaps the greatest of all Contax users was Robert Capa (1913–1954) — and of all the images he took using the camera, perhaps the best remembered are 11 surviving images taken on Omaha Beach during the D-day landings in 1944 for *Life* magazine. Armed with little more than two Contax II cameras with fixed 50 mm lenses and his Rollei and Speed Graphic packed in oilskin bags, Capa was among the first wave of troops to arrive on the beach that June day. His famous maxim was: "If your photographs aren't good enough, you're not close enough," and on Omaha Beach he couldn't have been closer to the action. Over a 90-minute period he took 106 photographs — the most famous of which was of a young soldier under fire, half submerged in the water. Shortly after taking this image, while Capa was trying to change the film, his Contax jammed and he found himself panicking and heading for a landing craft that was taking wounded men back to the ships. Suddenly he found himself covered in feathers from dead soldiers' life jackets as the landing craft was shot away. Capa made it safely back to the mother ship before returning to England to send his film to the magazine's London headquarters — where subsequently almost all the images were accidentally destroyed in the darkroom.

Despite being offered various other assignments over the years, Capa was drawn to conflicts and was known for earlier photographs of the Spanish Civil War and the second Sino-Japanese War, as well as later coverage of the 1948 Arab–Israeli War. He was on assignment in South East Asia in 1954, photographing the First Indochina War, when he stepped on a landmine. He was found by fellow photographers John Mecklin and Jim Lucas with his left leg blown off and serious chest wounds, his left hand still clutching his Contax II. He died in a field hospital shortly after.

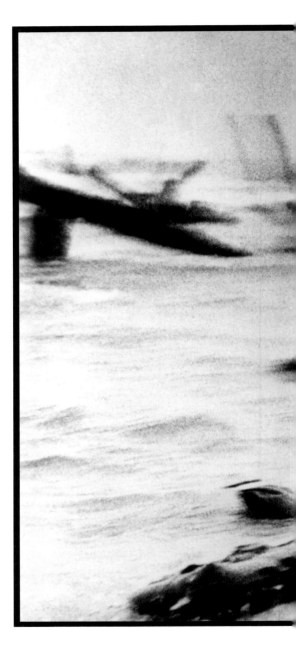

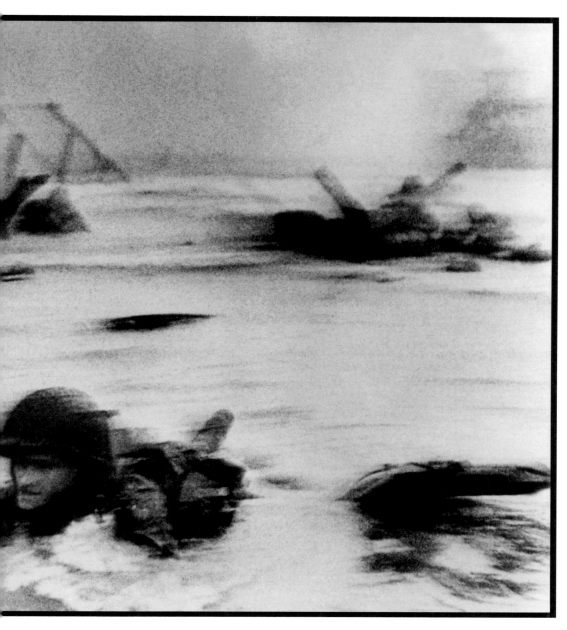

ABOVE **A frame from Robert Capa's D-Day landings film, June 6, 1944. Of four rolls of 35 mm sent back to** Life **magazine, only 11 frames survived an accident during processing.**

The Voigtländer Prominent

PRODUCED: **1933** | COUNTRY: **Germany** | MANUFACTURER: **Voigtländer**

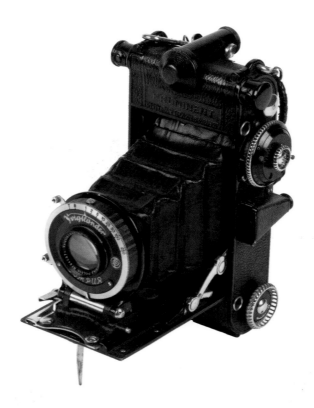

ABOVE **The Voigtländer Prominent camera of 1933.**

THE standard style of roll-film camera that was popular from the late 1890s until the 1950s had a baseboard that dropped from the body of the camera, along which the lens board was pulled. In more complex cameras of this type, opening the camera automatically pulled down the lens board into position via mechanical struts. The lens was connected to the back of the camera with light-tight bellows. Manufacturers generally produced a variety of models, from simple versions to better-quality ones with improved lens and shutter combinations, and across a range of film sizes. Beyond this there was little that could be done to reduce the potential for technical failures resulting from user error.

The Prominent, which was introduced in 1933, was an attempt by the German Voigtländer company to bring together some improvements to the general design. The camera was sprung so that when a button on the side was pressed, the baseboard opened out and brought with it the lens section, which was locked into position by struts, ready for taking photographs. A rangefinder

was automatically coupled to the lens via a series of mechanical linkages. The focusing distance could be set in advance and the camera was ready for making the exposure. An extinction light meter, a simple but reasonably effective exposure meter, was fitted to the camera side. The camera produced eight exposures of 2¼ × 3⅜ inches (60 × 90 mm) on film, but a metal mask could be fitted in the film plane to allow 16 1¾ × 2¼ inch (45 × 60 mm) exposures.

The *British Journal Photographic Almanac*, reviewing the camera in 1934, noted: "The Voigtländer designers have excelled themselves in providing many new features in a camera of remarkable portability considering the facilities it provides." The camera sold for £26 5s ($2,345 today) with a Voigtländer Heliar f/4.5 lens.

Although the camera offered many technical improvements, the different controls and fittings protruding from the body made it aesthetically unappealing and it did not sell well. Meanwhile, Voigtländer's existing range of roll-film cameras remained popular and it was clear the market was not yet ready for the refinements the Prominent offered. By the end of the decade the Kodak Super Six-20 (see page 124) incorporated more automation at a moderate price and in a body that was better designed, which made it more attractive than the Prominent.

Voigtländer revived the name after the Second World War for a range of high-quality 35 mm cameras that were much more successful.

BELOW Frances "Alice" Griffiths, photographed by her cousin Elsie "Iris" Wright using her father Arthur's Midg quarter-plate camera, the first in the "Cottingley Fairies" series.

THE COTTINGLEY FAIRIES

Folding cameras like the Prominent were popular and sold well to the mass amateur market, which made them ideal for younger people to use. On display at the National Media Museum in Bradford, England, are a folding-plate and a falling-plate camera. The two cameras were used to fool everyone from Sir Arthur Conan Doyle to Kodak experts. In 1917 two British girls — Elsie Wright and Frances Griffiths — borrowed Elsie's father's camera to create a series of images of themselves appearing to play with "fairies" at the bottom of the garden — the fairies were in fact paper illustrations propped up using twigs and hat pins. Thanks to a 1920 article written by the Sherlock Holmes author and featured in the *Strand Magazine*, the fairies became a national sensation, with the girls claiming they were real until 1983, when Elsie revealed how they were really made in a BBC program.

23 The Coronet Midget

PRODUCED: **1934** | COUNTRY: **UK** | MANUFACTURER: **Coronet Camera Company**

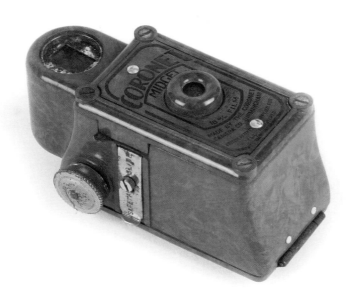

ABOVE **A cheap plastic camera produced in a range of colors for the general market.**

THE Coronet Camera Company was established by Frederick Pettifer in Birmingham, England, around 1926 to produce a range of cheap cameras for the mass market. By May 1927, the company was selling a large range of simple, low-cost cameras, along with accessories and film that had been purchased and relabeled with the Coronet name.

The *British Journal Photographic Almanac* reported in 1934: "Realising the vast market which exists for snapshot cameras of very low price, the Coronet Camera Co. have produced a series of models very suitable for this market and of excellent construction at their prices. While low price has been a chief consideration the construction is very good and the cameras are undoubtedly capable of giving very good results and long service." The company's production was mostly confined to box cameras and simple folding roll-film cameras. By 1933, the company was claiming an audited net sale of 510,000 cameras and it advertised: "We believe that this figure is greater than all the combined total sales of all British owned and controlled camera companies."

NOT JUST A NOVELTY OR A TOY

The Coronet Midget was announced around 1934 as "The World's Smallest Camera for Fine Photography." It was made from molded plastic in a range of colors and sold for 5s 6d (around $27 today). The company's advertisement in the 1936 *British Journal Photographic Almanac* described the camera optimistically as "Not as long as a cigarette … In every way a REAL Camera and not just a novelty or toy." Technically, the camera was simple, with a Taylor, Taylor and Hobson single meniscus f/10 lens that focused from 60 inches (5 feet/1.5 m) to infinity and a shutter that gave a speed of ⅟₃₀ second. It used tiny spools of paper-backed 16 mm film and weighed 2½ ounces (71 g). The company produced a small range of accessories including a Morocco leatherette carry case lined with colored silk to match the camera and a viewer to magnify the resulting images.

The camera was a departure for the Coronet Camera Company, which had generally made and assembled its own cameras from cardboard and metal, buying in lenses and some of the camera fittings. The Midget was made from Bakelite, to which the lens and shutter mechanism and fittings were added. The camera was initially available in black, walnut, green and rose Bakelite, and around 1937 a blue model was added. These were the official colors but disparities in the manufacturing process meant that there were different intensities of color. During the course of the camera's manufacture up to 1939 there were variations in the types of fittings attached to the plastic bodies.

BELOW **The Coronet Midget camera of 1934 was made from Bakelite in a range of colors.**

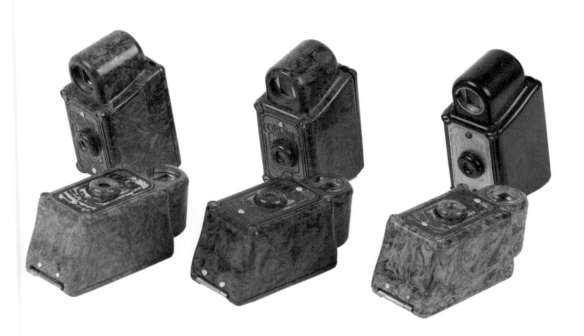

AN AFFORDABLE OPTION

The Midget was one of a number of cameras that reflected changes in the materials used for camera manufacture, particularly at the lower end of the market. The first British camera with an all-plastic body was the Amalgamated Photographic Manufacturers' Ltd. Rajar No. 6 camera, patented in 1929. It was mainly used as a promotional camera given away in return for coupons, most commonly from cigarette manufacturers. The camera was cheap to produce and had a special spool that allowed only the manufacturer's own film to be used, thereby ensuring ongoing sales and profits. Kodak Ltd. introduced a similar camera in 1930 made from brown Bakelite plastic, the Hawkette, which was also used as a gift in return for coupons. Between 1930 and 1932 some 34,920 Hawkette cameras were given away.

Elsewhere, Soho Ltd. made the Soho model B, Pilot, Cadet and Tuon cameras in plastic or, in the company's own words, "Synthetic Moulded Materials," between 1930 and 1933. Kodak also sold plastic-bodied cameras, including the Baby Brownie and the Baby Brownie Special, both of which were designed by Walter Dorwin Teague.

The Coronet Midget showed what was possible and what the public would accept, as well as being a commercial success. The Coronet Camera Company introduced the miniature Vogue camera, made in streamlined brown Bakelite, in 1936; after the war, the company tried to recreate the success of the Midget with the Cameo in 1947. The British Purma Special camera, made from black plastic, appeared in 1937, taking 12 pictures on 127 roll film and featuring a distinctive shutter; this returned in a new form after the war. The Midget continued to be listed and sold until 1940.

ABOVE **Three plastic-body cameras. From left to right: the Soho Pilot (c.1930), the Soho Cadet (c.1930) and the Rajar No. 6 (1929).**

STYLE MATTERS

The use of Bakelite plastic in cameras during the late 1920s and into the 1930s reflected the need for cheaper materials to ensure that cameras could remain affordable at a time of austerity.

But it also allowed for more stylish cameras to be made, with streamlined and decorative features that reflected the age and would not have been possible with the metal, wood and leather bodies common to most cameras of the period. After the Second World War, as new techniques of molding were developed and new plastic materials were produced, plastic became increasingly used in camera production by numerous manufacturers in Europe and the United States as it lent itself to mass-production. Kodak was among the most successful with its British-made Brownie 127 (pictured left), of which some 3 or 4 million units were made between 1952 and 1967, and more stylish cameras such as the Brownie Vecta designed by Kenneth Grange, the British industrial designer, in 1963.

The Canon Hansa

PRODUCED: **1935** | COUNTRY: **Japan** | MANUFACTURER: **Canon**

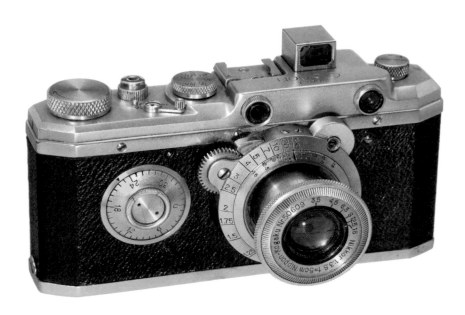

ABOVE **The first production camera from one of the major photographic companies of the 20th and 21st centuries.**

FROM its beginning in November 1933, when Seiki Kogaku Kenkyujo (Seiki KK), or the Precision Optical Instruments Laboratory, was founded in Japan, its successor, Canon, has grown to become one of the two largest quality camera manufacturers in the world. Canon and Nikon have dominated the market for professional and amateur single-lens reflex cameras since the 1970s, first as film cameras and more recently with their digital models.

The founders of Seiki KK, Goro Yoshida, Saburo Uchida and Takeo Maeda were three photography enthusiasts who were determined to build the first Japanese 35 mm camera, with the intention of rivaling the Leica and Contax rangefinder cameras. These two German-made product series were prohibitively expensive at around Yen 420, when the average graduate salary was around Yen 70 per month. Yoshida established the company in November 1933 in a modest Tokyo appartment.

Born in Hiroshima, Goro Yoshida moved to Tokyo to become an apprentice repairer of movie cameras and projectors. In the late 1920s he frequently traveled to Shanghai on business. A story, possibly apocryphal, relates that Yoshida was inspired to make quality cameras by an American buisnessman he met in Shangai, who suggested to him that a country that already made successful aircraft and battleships ought to be able to make good cameras too, without having to source parts overseas.

The first design produced by the company was the Kwanon, named after the many-armed Buddhist goddess of mercy. Yoshida designed the camera after he had taken apart and studied a Leica II camera. When asked about his motive in doing this, Yoshida explained: "I just disassembled the camera without any specific plan, but simply to take a look at each part. I found there were no special items like diamonds inside the camera. The parts were made from brass, aluminum, iron and rubber. I was surprised that when these inexpensive materials were put together into a camera, it demanded an exorbitant price. This made me angry."

It is uncertain whether the original Kwanon was actually put into production, although it was advertised between July and September 1934, and a purported prototype was sold at auction in 2006. The first Canon would come the following year and required a collaborative effort. In the fall of 1934, the German Leitz company took out a Japanese patent for its method of coupling the Leica's lenses to its rangefinder, and Seiki KK responded by asking Nippon Kogaku to design a new lens mount system for its own cameras. Nippon Kogaku was already a well-established optical equipment manufacturer with a history dating back to 1917; in 1948 it would introduce its own camera, the Nikon. In the 1930s, the company was looking to diversify its mostly military production with optical products for civilian use, and the request from Seiki KK was timely. The collaboration between the two companies resulted in the Canon Hansa camera, fitted with Nippon Kogaku's Nikkor f/3.5 50 mm lens.

THE FIRST ASIAN 35 MM CAMERA

The Canon Hansa camera was produced in 1935 and introduced to the market in February 1936. As well as the lens and the lens mount, Nippon Kogaku designed the viewfider optics and the rangefinder mechanism. Seiki KK assembled the camera and made the body and the shutter, which was of the focal-plane type. Seiki KK changed the camera's name from Kwanon to Canon; the "Hansa" trademark belonged to the company in charge of Seiki KK's sales and marketing, Omiya Shashin Yohin Co., Ltd. The camera was sold for Yen 250, which included a case. By 1938, Seiki KK was advertising the Hansa Canon in Britain as it attempted to develop an export market for the camera.

A series of new models, the S, J, NS, and JS, were released through 1939, until the Second World War interrupted production in 1941. In addition, from July 1937 the Seiki KK company worked on its own lenses. Yoshizo Furukawa, the company's first optical engineer, developed some lenses on a trial basis and a series of Canon lenses was introduced under the Serenar trade name.

The prewar rangefinder Canon camera models did not sell in large numbers but they were important as they showed that Japan was able to make a 35 mm rangefinder camera and lenses that could potentially compete with Leica and Contax, even if they were cruder in their construction than their German counterparts.

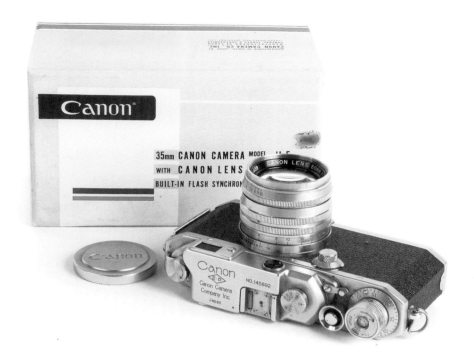

POSTWAR PRODUCTION

When the Second World War ended on August 15, 1945, Seiki was able to give consideration to restarting production. The factory had escaped major damage, but due to the lack of raw materials and the unstable conditions in the aftermath of war, company president Takeshi Mitarai decided not to proceed straight away, declaring: "Since I am at a loss about what to do, I will shut down the plants and disband the company immediately. But, remember to come back as soon as I call you back for restoration." In the months following the end of the war, the Allied occupation forces showed interest in Japanese cameras, which encouraged Seiki to submit an application for permission to produce consumer goods. This was granted on October 1, 1945. The first postwar models launched by the company were the Canon J and J-II, which were made using remaining stocks of prewar camera parts. Around 560 examples were made. In October 1946, the first all-new model, the S-II, was introduced, which sold some 15,000–18,000 units. In 1947, Seiki KK changed its name to Canon Camera Company Ltd.; the company was fully back in business.

With the resumption of production in 1946, the business model that Seiki KK had established with its Canon cameras was adopted more widely. European cameras were taken apart and assessed, and Japanese companies worked out how to manufacture them more cheaply. Its prewar experience gave Canon a headstart in developing its own camera range.

GROWTH OF THE JAPANESE CAMERA INDUSTRY

Nippon Kodak introduced its own rangefinder camera in 1948, which it based, in part, on the German Contax camera. The lens mount was almost a direct copy, meaning that most lenses were interchangeable. The quality of Japanese optics was increasingly recognized and the Canon and Nikon cameras were sought out by photographers traveling to cover the war in Korea. Photojournalists such as David Douglas Duncan used Nikkor lenses on their Leica cameras, and later would also buy Nikon cameras as confidence in their reliability grew.

Around this time, other Japanese manufacturers also entered the market — Chiyoca, Honor, Leotax, Minolta, Nicca, Tanack, Tower and Yashica — with designs mainly based on the Leica. Japanese cameras' reputation for quality was gaining ground.

The move within the Japanese camera industry from simply copying European camera designs to developing their own and advancing them technically, principally with SLR cameras such as the Nikon F and Pentax Spotmatic (see pages 160 and 172), was key. Japanese camera manufacturers were now well-placed to exploit a market that was ready for an easy-to-use, competitively priced design of proven quality. By establishing sales organizations or partnerships with companies in other countries to sell and market their products, Japanese companies soon went on to dominate global camera sales.

EDDIE ADAMS

Pulitzer Prize–winning photographer Eddie Adams (1933–2004, pictured left) was a Leica user, but he also used the Canon F1 camera, launched in 1971. It is likely he was carrying a Canon model on February 1, 1968, while walking along the streets of Saigon. He was on assignment for Associated Press and was on his way back from trying to cover a battle between the South Vietnamese and the Vietcong guerillas in the city. After seeing a man dragged from a building, Adams followed and, instinctively reaching for his camera, captured the moment police chief General Nguyen Ngoc Loan executed the Vietcong prisoner Nguyen Van Lem, just 5 feet (1.5 m) away from where Adams stood. Shot at $\frac{1}{500}$ sec with a 35 mm lens, the photo appears to show the exact moment the prisoner is shot, before the bullet has left his head. This powerful photograph won Adams the Pulitzer Prize, but more importantly had a huge impact on American public opinion of the war.

25 The Kine Exakta

PRODUCED: **1936** | COUNTRY: **Germany** | MANUFACTURER: **Ihagee**

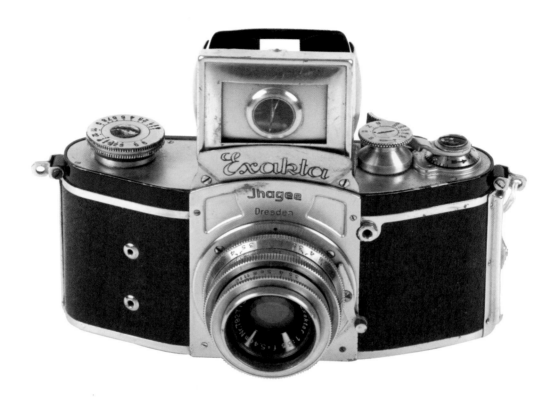

ABOVE **The first
commercially successful
35 mm single-lens reflex
(SLR) camera.**

THE first 35 mm single-lens reflex (SLR) that achieved commercial
success was the Kine Exakta, made by the German firm Ihagee from 1936.
During the 1930s the popularity of 35 mm film grew as emulsions became
more sensitive and finer-grained, which made greater enlargements possible.
A particular attraction for amateurs was that 35 mm film was also more
economical to use.

The Ihagee company had a history of camera manufacture going back
to 1912. Although founded by Johan Steenbergen, a Dutchman, the new
company located itself in Dresden, at that time the centre of the German
camera industry. The firm made a large array of cameras that enjoyed
considerable commercial success, but it was the Exakta range that really
made its name.

THE VP EXAKTA

Production of the 127 roll-film VP Exakta camera began in 1932 and the camera was presented to the public at the Leipzig fair in February 1933. Trapezoid in shape, it fitted the hands easily and inside was a mirror set at 45 degrees to reflect the subject into the viewfinder. The use of 127 roll film, which gave a 1%6 × 2%6 inch (40 × 65 mm) negative (as opposed to the larger 120 roll film, which could give 2⁷⁄₁₆ × 2⁷⁄₁₆ inch/60 × 60 mm or 2⁷⁄₁₆ × 3½ inch/60 × 90 mm negatives), allowed a very compact camera.

The VP Exakta was supported by a range of lenses and accessories. Further models were introduced and the range continued to be produced up to 1939. All the tooling was lost during the Second World War and production of the range was never restarted.

The success of the VP Exakta suggested that a similar, smaller-format camera using 35 mm film might also be a success. The designer of both the VP Exakta and the Kine Exakta was the Ihagee engineer Karl Nüchterlein. He had completed an apprenticeship as a mechanic at the Seidel and Naumann typewriter factory before joining the Ihagee camera works in 1923.

BELOW **The VP Exakta A (1933–1938), the precursor to the 1936 Kine Exakta.**

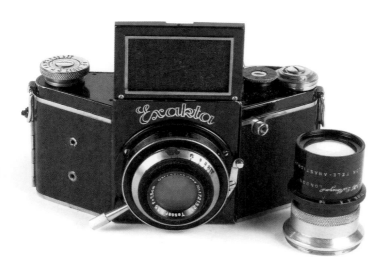

SOVIET PROTOTYPE

The Kine Exakta was, arguably, not the first 35 mm SLR camera. The Soviet Union produced a prototype camera called the Cnopm (Sport, pictured right) in 1934. The camera did not enter the market until 1937 and even then in a very limited way; it is reasonable to give credit technically and commercially to Ihagee's Kine Exakta camera.

A 35 MM SLR SUCCESS

In 1936, the Kine Exakta was introduced at the Leipzig Fair. The camera was the first SLR to use 35 mm film. Leica and Contax users were sceptical that a 35 mm SLR could successfully compete against a rangefinder camera, but the Kine Exakta proved otherwise. In part, its success was due to a carefully designed and engineered optical viewing system that incorporated a plano-convex magnifying lens to enlarge the small viewfinder image. The camera was typically used at waist-level, and a pop-up viewing hood, which acted as a shade, incorporated a magnifying lens, allowing a closer view of the image so that it could be properly focused. The viewing hood could also serve as a sports finder.

Although 35 mm film was increasingly accepted and used, the number of exposures for most purchased cassettes was considerably in excess of those obtained on roll film. Ihagee incorporated a small cutting knife so that a strip of exposed film could be cut off in a darkroom and processed. The remaining film could then continue to be used. Film was advanced using a lever, which was much quicker to use than the knobs featured on other camera models.

The camera was an immediate success. It was reviewed in the *British Journal Photographic Almanac* for 1934, which noted the simplicity of operation: "The film-winding key not only resets the focal-plane shutter after each exposure, but also puts down the mirror which has sprung upwards just before the exposure has been made. Thus for each picture all that is necessary is to focus by means of the big milled ring on the lens and to press the release of the shutter." It summed up the camera: "This combination of original features renders the camera a most attractive and practical instrument." It sold for £18 ($1,720 today) with an f/3.5 Zeiss Tessar or £14 with an f/3.5 Exakta lens.

EAST AND WEST

The Ihagee company, which made the Exakta camera, was founded in Dresden, Germany, in 1912. With the arrival of the Russians in the city on May 8, 1945, Dresden became part of the German Democratic Republic, or East Germany. By 1958, the company was effectively under state control. It was eventually incorporated into the Pentacon company, which made the Praktica range of cameras, and independent manufacture ended in 1970. A separate West German Ihagee company opened in 1959, and showed the Exakta Real at Photokina in 1963.

POSTWAR IMPROVEMENTS

The original Kine Exakta was followed up by further models, to which incremental improvements were added. Production of the Kine Exakta was interrupted by the war but resumed from 1948 in Dresden, by then part of East Germany. In 1950, the Exakta Varex camera was introduced, bringing with it a major improvement to the camera: it was fitted with a pentaprism, which meant that instead of images being inverted from left to right, they were displayed the right way around and at eye level to the photographer.

The prewar Kine Exakta was popular but it was the postwar Exakta Varex that truly captured the public imagination. An Exakta Varex had a starring role alongside James Stewart and Grace Kelly in Alfred Hitchcock's 1954 film *Rear Window.* The Exakta Varex also featured in a 1992 film, *The Public Eye,* which was inspired, in part, by the New York photographer Weegee, and in *The Last Emperor* (1987) and *Extremely Loud & Incredibly Close* (2011).

The Exakta was developed further with a lower-cost range, the Exa, and models were produced until the 1970s. The 35 mm Exakta was very popular during the 1950s and 1960s, with users ranging from amateurs to universities and businesses. The range of accessories and lenses and the fact that the camera provided reflex, through-the-lens viewing made it superior to the rangefinder camera for many applications. For all its advantages, however, the Exakta and other European cameras were challenged by the growth of the Japanese camera industry, which from the 1950s produced SLRs with better-quality manufacturing and at competitive prices. The Exakta ultimately fell victim to Japanese competition.

JOSEF KOUDELKA

The most important photographer to use the Kine Exakta was not a movie star but a Czechoslovakian engineer, Josef Koudelka. In early 1968, he decided to give up his job and to work full-time as a photographer — taking commissions from theater magazines and regularly photographing gypsies, a subject he would return to throughout his career. It was a timely moment: that very summer, on August 21, the Soviet Union and its Warsaw Pact allies invaded the country.

When the Soviet tanks rolled in, Koudelka began to photograph what he saw: Russian soldiers, small acts of defiance at the invasion, protests and increasing violence. He was not familiar with the word "photojournalism" or magazines like Life, and captured the events he was a part of with the somewhat antiquated Exakta. He would buy rolls of motion-picture film cheaply from a friend, cut it into strips and load it in to numerous cassettes so he could shoot almost continuously as the days unfolded, only stopping to run home and reload. In total he took 5,000 photographs in Prague during the first week of the invasion, many of which placed him in extremely dangerous circumstances. His pictures, which were smuggled out of the country and published in The Sunday Times magazine — credited to a "Prague Photographer" to protect his identity — won him the 1969 Robert Capa Gold Medal Award. It was because of these photographs that he was able to join the Magnum agency and secure a visa to leave Czechoslovakia to live in London and later Paris. He returned to his homeland in 1991 and in 2008 his Prague photographs were exhibited there as part of a 40th anniversary commemoration of the invasion.

RIGHT Josef Koudelka, Prague, Czechoslovakia, August 1968, during the invasion by Warsaw Pact troops. This image was taken near the radio headquarters.

The Minox

PRODUCED: **1937** | COUNTRY: **Latvia** | MANUFACTURER: **Valsts Elektrotehniska Fabrika**

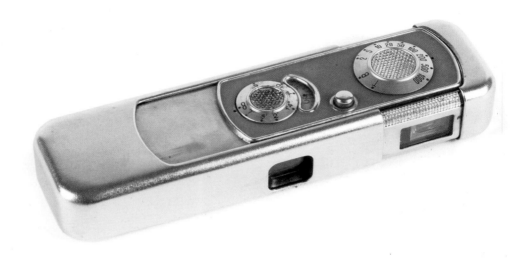

ABOVE **Small and compact, the archetypal spy camera was originally intended for amateur photographers.**

THE Minox camera was a small metal-body camera designed to take 50 exposures, each negative ⁵⁄₁₆ × ⁷⁄₁₆ inches (8 × 11 mm), on ⅜ inch (9.5 mm) unperforated film held within a special cartridge. Although sold to the public, it was quickly adopted for serious spying and also found fame as a spy camera in various films, including the James Bond series.

The idea for a subminiature camera was conceived by Walter Zapp as early as 1922, when he started working as a photographer. He was obsessed with the idea of constructing a miniaturized camera, one that "should be so small as to vanish in a clenched fist." With financial support from his friend Richard Jürgens, he developed plans for a very simple camera. A wooden model of this design dating from 1934, sized ½ × 1⅛ × 3 inches (13 × 28 × 75 mm), still exists. Jürgens and Zapp had founded a partnership in 1932, the former providing financial support and Zapp the technical expertise. By August 1935, the production drawings for the mechanics had been completed. The optics were calculated by Professor Schulz of Vienna, and Hans Eppner, a precision mechanic, handmade the components of the silver-plated prototype.

Test photographs made using the camera received an enthusiastic response and the first patents were granted in 1936. A contract for the manufacture of the camera was signed on October 6, 1936, with Valsts Elektrotehniska Fabrika (VEF) in Riga, Latvia, a government-owned manufacturer of electrical power equipment, and the first batch of 20 Minox cameras was produced in the spring of 1937.

A SUPPORTING ROLE

In the movies, the Minox camera found a supporting role. The actor James Stewart used a Minox in the 1948 film *Call Northside 777*. Stewart's character, a crusading journalist, tracks down and photographs documents supporting an imprisoned man's claim of innocence.

Stewart uses his Minox A camera, carefully setting the exposure and focus while adjusting the lighting to secure a good negative. George Lazenby, as James Bond 007, used a Minox in *On Her Majesty's Secret Service*. The camera also featured in numerous television programand books, including Len Deighton's *The Ipcress File*, the film of which starred Michael Caine.

THE MINIATURE MASTERPIECE

In order to sell the cameras, the company realized it needed to be located in the main markets of Europe and North America, and so it established sales offices in London and New York. A British advertisement in *The Miniature Camera Magazine* from Minox Ltd. noted: "Small enough to seem a toy — nevertheless an apparatus of the finest precision." A review of the camera in the same publication from October 1939 appeared just after the camera had been imported into the UK. The reviewer commented: "It is no exaggeration to say that the Minox is an exceptionally clever and interesting camera — revolutionary in many respects, daring in design, but certainly efficient in performance. And it is not German!"

The Minox camera was built to a very high standard of precision engineering, as its small size demanded. It gained a reputation for reliability and, because of its fixed-aperture f/3.5 lens and short focal length of only 15 mm, as well as a focusing scale from 8 inches (20 cm) to infinity, it gave very sharp images. Exposure was controlled by varying the shutter speed. Once an exposure had been made the film was advanced by pushing the ends of the camera together and then pulling them back out again. This movement brought the next film frame into place and reset the shutter, ready for the next exposure. The camera's body was finished in stainless steel, with rounded corners. Other than the focus adjustment, shutter speed dial and shutter release button, it was smooth and sleek.

The Miniature Camera Magazine review noted that the Minox camera "can be whipped out of the pocket in a moment and a picture taken before anybody knows what you are doing." VEF also supplied special processing equipment to develop the subminiature film, together with a special enlarger. The camera sold for £20 4s 3d in 1939 ($1,720 today) and the review summed up the camera: "The Minox combines high efficiency with extreme simplicity of operation right from the taking of the picture to the finishing of the print. Certainly one of the most remarkable outfits it has ever been our privilege to try."

THE PERFECT SPY CAMERA

At the outbreak of the Second World War the Minox camera attracted the attention of intelligence agencies in the United States, Britain and Germany. The British intelligence service bought all available Minox cameras in late 1939. The Office of Strategic Services (OSS), a U.S. intelligence organization, ordered 25 of them in 1942.

Unobtrusive and easily hidden, the Minox was ideally suited for covert use. It was also simple to use and capable of giving good negatives that could be enlarged to a reasonable size. A range of accessories facilitated its use for document copying. The camera was used by the British MP John Moore-Brabazon (see page 83) inside the chamber of the House of Commons when he photographed a packed Commons chamber being addressed by Prime Minister Neville Chamberlain on either April 9 or May 7, 1940. It was the first time that a photograph had been taken inside the chamber when the Commons was sitting and, of course, was not permitted.

More covert Minox users included Heinz Felfe, the German double agent who was arrested on spying charges in 1961 and found to have a dozen Minox films hidden in his case. While employed by West German intelligence, he had photographed thousands of documents over an 11-year period for the Russians. In 1977, Christopher John Boyce, an employee of the TRW Corporation in the United States, copied secret documents relating to satellite reconnaissance programs. The FBI was able to match tiny irregularities in the frame edge of the negatives with a Minox B camera found in the room of his associate. Boyce was convicted of espionage and served 24 years in jail.

With the resumption of Minox production after the war, new models were introduced — the A in 1948, the B in 1958 and the C in 1969, to each of which were added new features, such as built-in exposure metering and, later, automatic exposure. The $\frac{5}{16} \times \frac{7}{16}$ inch (8×11 mm) negative was always a limitation, something the company recognized in 1974 when it introduced the first Minox 35 mm cameras, using a standard 35 mm cassette and giving a standard 35 mm negative. The Minox 35 EL was the first electronic compact camera manufactured in large volumes. New models appeared with increasing automation as electronics were incorporated until the range was discontinued in 2004. A less successful Minox range using 110 cartridges was introduced in 1976.

The Minox company was acquired by Leica in 1996, but a management buyout on August 25, 2001, returned Minox to independent ownership. Walter Zapp died in Switzerland in 2003.

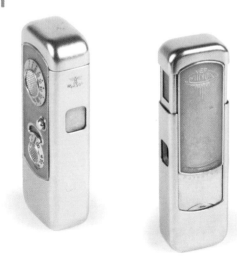

CHANGING SIDES

From 1938 to 1942, when the factory was taken over by the invading German Army, some 17,500 Minox cameras had been produced. Between 1942 and 1945, Minox cameras were first marked with the German eagle and then, after Soviet forces captured Riga from the Germans, engraved "Made in USSR." After 1945, the Minox factory reopened in West Germany and production recommenced, continuing to the present day, with the modern camera clearly recognizable as the descendent of the original Riga-made Minox.

27 The Compass

PRODUCED: **1938** | COUNTRY: **Switzerland** |
MANUFACTURER: **LeCoultre & Cie/Compass Cameras Ltd.**

ABOVE **A feature-packed camera designed by a British eccentric and built by a Swiss watchmaker.**

THE Compass camera was introduced to the market in March 1937. A miniature camera, it packed in so many features that it required a Swiss watchmaker, LeCoultre & Cie, to make it. The camera was designed by the notorious Noel Pemberton Billing, who was a product of his time: a true English eccentric, with a flair for self-publicity, right-wing patriotic politics that resulted in several court appearances, and an extensive knowledge of engineering that, he claimed, resulted in over 2,000 patents.

A TRUE ENGLISH ECCENTRIC

Noel Pemberton Billing was born in 1881 in Hampstead, London. He attended public school before taking a job in the City, then traveled to Durban, South Africa, where he participated in the Anglo-Boer War. The experience left him with a lifelong interest in munitions, and he designed a gun carriage and other items of military equipment.

He later returned to Britain and trained as a barrister. An inveterate over-achiever, he engaged in many pursuits throughout his professional life, including theater management, playwriting, editing the *Hampstead Social Review*, making furniture, farming and building dairies. He also had a keen interest in aeronautics. He built, and crashed, a glider and then built an aerodrome at South Fambridge, where he constructed a light monoplane that attracted the interest of Howard Wright, an aircraft engineer. In 1912

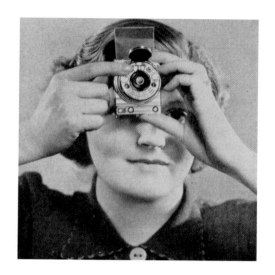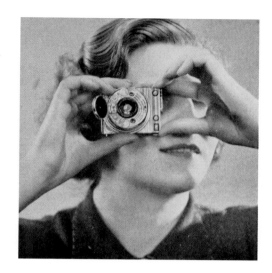

he acquired his flying license within 24 hours (winning a £500 bet along the way) and in 1914 his first flying boat, the Supermarine PB1, was displayed at the Olympia Aero Show. He developed the PB9, a single-seater fighting airplane regarded as the ancestor of the iconic Spitfire aircraft.

Billing was gradually drawn to politics, being elected Member of Parliament for East Hertfordshire in 1916. In June 1917, he founded the Vigilante Society to promote purity in public life, which became a front for its founders' extreme right-wing views and prejudices. Billing's involvement culminated in a sensational libel case of 1918 prosecuted by the actress Maud Allan over her role in Oscar Wilde's *Salomé*. The case hinged on Billing's claim that the German secret service had a Black Book containing the names of 47,000 members of the British establishment who were sexual deviants and that the country was in a state of decadence. Billing eventually won the case.

He resigned as an MP in 1921 and was never re-elected, despite standing on several occasions. He continued inventing and returned to commentating on aeronautical matters. He died on November 11, 1948, in Burnham-on-Crouch, Essex, England, where he had been a keen sailor.

Politics and eccentricities aside, Billing was undoubtedly an accomplished and innovative engineer and designer. The list of his patents covers a bewildering range of objects: a machine for making and packing "self-lighting" cigarettes; a wind-up gramophone; a motion-picture apparatus synchronized with a gramophone; a golf practicing device; a petrol-powered automatic gun; a cloth-measuring device; a pencil hat calculated "as you write"; a two-sided stove; a Durotofin, a type of helicopter; and a miniature camera — the Compass.

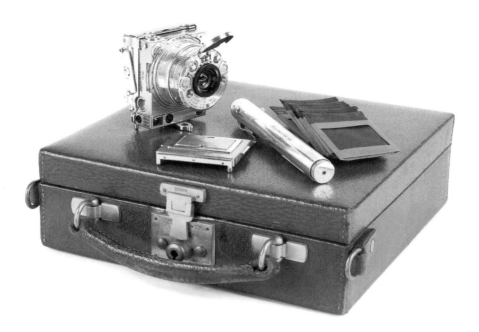

A FIRST-CLASS CAMERA

The Compass camera was the outcome of a bet to design a first-class camera small enough to fit in a cigarette packet. Billing designed it within a fortnight and then improved it over a period of six years. British patents for the camera were granted in 1935 and 1936, and construction of the more than 290-part camera was put into the hands of the renowned Swiss watchmaker LeCoultre & Cie. The camera was not marketed until full-scale production could be started and it was officially launched in March 1937 at a cost of £30. The Compass made negatives of standard 35 mm size on special cut film or using a roll-film back. It was only 2¾ × 2¼ × 1¼ inches (70 × 60 × 32 mm) when closed. Fewer than 3,700 cameras were made before the Compass stopped being advertised in 1941, although production had almost certainly ceased some time before this. Two models were made: the Compass I, of perhaps no more than 140 examples, was recalled and upgraded, free of charge, to the Compass II. The camera was sold in London, Switzerland and New York and was made with a variety of non-English engravings.

The Compass II was intended to be a complete system of photography with every feature possible being built into the camera. Additional accessories such as a tripod and roll-film back were made available as extras. Compass Cameras Ltd. offered a comprehensive developing and printing service.

A review in the 1938 *British Journal Photographic Almanac* noted the principal selling point of the camera: "It embodies as an integral part of its construction almost all the accessories which normally are carried separately." These included filters, a rangefinder, extinction-type exposure meter, stereoscopic and panoramic head, plus a shutter with 22 speeds, from ⅟₅₀₀ to 4½ seconds.

THE PHANTOM PHOTOGRAPHIC UNIT

Pemberton Billing also developed one further camera: The Phantom Photographic Unit was one of the last engineering projects he worked on before his death. It had clear antecedents in the Compass camera, which he had taken to its logical conclusion, with all aspects of the camera being built into a single box. The Phantom camera, although larger than the Compass, was of a similar design and layout.

The Phantom was designed between 1944 and 1946 and was made by W. Rollason & Sons of Finchley, London, an optical and precision-engineering firm. It was intended to be manufactured and sold complete for £25 ($1,250 today) in 1948. Yet the prototype was never fully finished and the camera was never advertised. It was designed as a combined carrying case, camera and developing set, with storage for film and paper, a contact printer and an enlarger/projector, and it came with a battery storage compartment. The rationale behind the camera was that a photographer could travel with a completely self-contained outfit with which he could expose the negative or transparency, process the film, produce contact prints or transparencies, and project the transparencies. The case doubled as a light-tight changing box.

The only known prototype was made by hand by Rollason and it was intended that die-castings for the production model would be manufactured by the Zenith Carburettor Co. Ltd. The camera featured a simple Taylor, Taylor and Hobson f/3.5 50 mm lens and took five images approximately $^{15}/_{16} \times ^{3}/_{4}$ inches (24 × 18 mm) on circular sheet film. The coupled rangefinder appears to have been similar to that of the Compass. An extinction-type light meter was built into the camera, which allowed the correct aperture to be set on the camera. A "time" setting allowed the camera and lens to be used as a projector/enlarger with the addition of a lamphouse.

The bottom part of the outer case was a battery compartment and the batteries were connected in a series/parallel combination, depending on whether the contact printer or projector lamphouses were to be used. The aluminum case was part of the circuit. With Billing's death, the camera lost its financial backing and it never entered production.

28 The Kodak Super Six-20

PRODUCED: **1938** | COUNTRY: **U.S.A.** | MANUFACTURER: **Eastman Kodak Company**

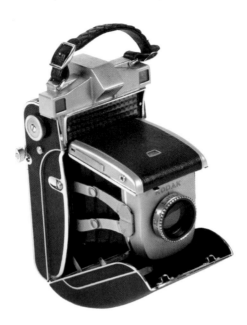

ABOVE **The world's first camera featuring automatic exposure control.**

FROM the 1880s, camera designers increasingly gave consideration to automating the technical side of photography. Inexperienced amateurs often struggled with the chemistry and mechanics of photography. By simplifying or automating these aspects, or both, camera designers aimed to give the photographer greater certainty of capturing the subject. As better, more sensitive photographic emulsions were developed, manufacturers also looked for ways to make light-measuring more precise and the processing of films more consistent.

There were two main approaches to making cameras more user-friendly. The first was to simplify the camera as much as possible and then to standardize everything — the focus, shutter and aperture — and so leave the photographer with the task of simply pointing the camera and pressing the shutter-release button. This approach was best exemplified by the original Kodak and Brownie cameras and their competitors.

The second was to try to incorporate devices such as rangefinders to aid focusing or an extinction meter to aid exposure, or a clockwork motor to help advance film to the next exposure. Automation was intended to remove from the photographer the need to control the camera directly. In some cases, these controls were linked directly to the camera. So, for example, mechanical linkages could be added to devices such as rangefinders to focus the camera lens. In reality, these were aids to successful photography but did not make it foolproof.

THE FIRST FULLY AUTOMATIC EXPOSURE CONTROL

During the 1930s a number of cameras began to incorporate electric light meters into their bodies. None were directly linked to the camera's operation, so the photographer had to take a meter reading and then manually set the camera. The Kodak Super Six-20 camera, introduced in August 1938, was the first camera to offer fully automatic exposure control. A large selenium photoelectric cell on the front of the camera above the lens directly controlled the camera diaphragm aperture, which opened or closed in response to the amount of light entering the cell.

Previously, exposure measurement had largely been managed with visual (or extinction) meters, where the photographer exposed a piece of photographic paper to light for a set period, compared the resultant tint to a standard tint and then calculated the exposure required. Photoelectric meters offered a more accurate and faster method of determining exposure. The discovery of selenium and its property of variable conductivity based on the amount of light falling on it was the foundation for a new type of photoelectric cell that could be used for photography. After an initial flurry of activity in the 1880s and 1890s, interest waned, and it was not until 1931 that the first photoelectric meter to be sold on any scale was introduced — the first Weston Universal 617 meter of 1932 used the direct output of the selenium cell, and a variety of other meters were introduced by other manufacturers. It was this design of meter that was incorporated into the Kodak Super Six-20 camera.

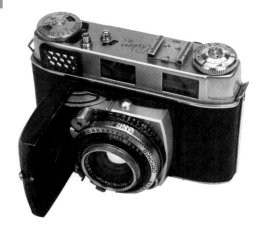

LIGHT METER DEVELOPMENT

After the Second World War, particularly from the 1950s, more sensitive photoelectric cells were developed, which allowed for smaller light meters and the ability to incorporate cells directly into the camera, as in the Super Six-20. By 1956 at least 12 cameras incorporated meters inside them, including some of Kodak's Retina range (an example of which is pictured left). Soon after this, camera manufacturers began to link the meter to the camera mechanism, usually via a matched needle that would set the correct exposure.

DESIGN DREAM TEAM

The Kodak Super Six-20 was designed by Joseph Mihalyi and styled by the well known industrial designer Walter Dorwin Teague. Mihalyi had arrived in the United States from Hungary in 1907 and, after working in the optical and scientific instrument industry, he was recruited by the Eastman Kodak Company in 1923 as a camera and photographic equipment designer.

Mihalyi designed a number of important cameras for the Kodak company, including the Bantam Special (1936), in collaboration with Teague; the Ektra (1941), a 35 mm rangefinder camera that became important as supplies from Germany became scarce; and the Medalist (1941), a 620 roll-film camera with coupled rangefinder. His skills were also put to use with a design of rangefinder that was used in anti-aircraft sighting systems. Mihalyi was also responsible for creating the 828 film format, which was introduced in 1936 and represented a more efficient use of 35 mm film stock.

Walter Dorwin Teague began working for Eastman Kodak Company on January 1, 1928, and continued to act as an advisor until his death in 1960. He was a well known industrial designer and worked on a number of popular and successful Kodak cameras that were initially influenced by the art deco style, including the Gift Kodak camera (1928), the Baby Brownie (1934), the Bantam Special (1936) and the Brownie Hawkeye (1950). Teague's influence also expanded into the design of Kodak's displays and retail spaces. In 1934 the company created an entire styling division, and Teague's role became advisory. Teague was later to design Land's Polaroid 95 camera — the first model of another landmark camera product series..

The combination of Mihalyi's mechanical expertise and Teague's awareness of design made their cameras commercially successful. The Bantam Special was a very popular camera and the Baby Brownie, with its sleek lines made from molded black plastic, sold many tens of thousands.

BELOW **The Baby Brownie camera designed by Teague and sold 1934–1941 (U.S.) and 1948–1952 (UK).**

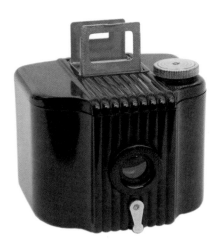

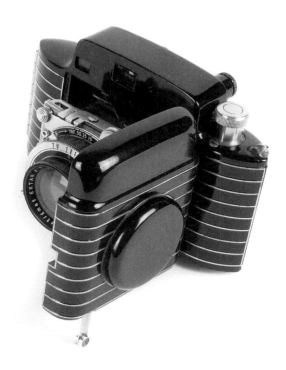

ABOVE **The Kodak Bantam Special camera of 1936, with sleek, streamlined design.**

THE BOOMERANG

The Super Six-20 was, however, less successful. The streamlined black and matte chrome finish suited the age and the concept of an automatic camera was a great selling point, but the camera was difficult to manufacture and it was susceptible to damage. Teague's clamshell design was not original and had been used on several cameras in the late 19th and early 20th centuries, but those had been simpler to produce. On the Super Six-20 the two clamshell parts required precise engineering and were delicate. The camera was opened by pressing a button on the side, which released the two halves of the clamshell, pulling out the lens. Once locked into position the camera was ready for use. The selenium cell reacted to the light entering it and moved a needle that was locked by pressure on the shutter release. A spring-loaded sensor, connected to the aperture control, moved until it was stopped by the needle and the shutter fired, making the exposure. The camera was fully automatic for shutter speeds between $\frac{1}{25}$ and $\frac{1}{200}$ second.

In 1938 the camera was expensive at $225 (around $2,800 today), which was more than a Leica camera at the time. Just 719 examples of the camera — nicknamed "the boomerang" to reflect the regularity with which it was returned to the company for repair — were made. Manufacture was discontinued in August 1944.

And yet the Super Six-20 camera was significant as the first attempt to produce an automatic camera. It was not until the 1970s, when electronics had evolved and the integrated circuit was introduced, that true automation was realized, with cameras that left almost nothing to chance.

29 The Kodak Matchbox

PRODUCED: **1944** | COUNTRY: **U.S.A.** | MANUFACTURER: **Eastman Kodak Company**

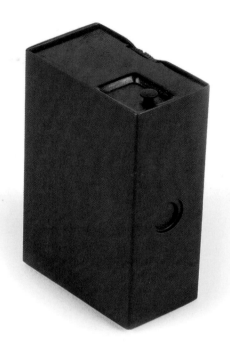

ABOVE **A spy camera developed for the American Office of Strategic Services and made for covert use during the Second World War.**

THE Minox camera had found success as a spy camera, despite originally being intended as a small camera for amateur photographers. From the mid-1930s, and particularly during the Second World War, spying agencies in various countries set about designing cameras specifically for covert use.

In Germany, a camera a little larger than a matchbox was designed and made just before the German invasion of Poland in 1939. The camera was heavy and one side of it was painted to resemble the popular Haushaltsware brand of matches. Another matchbox camera, again from Germany, probably dates from around the same time and is known as the Independence Safety Match camera after the matchbox it is contained within. The user made an exposure by pushing the inner box forward, which released a flap shutter in one of its short ends. The camera used 16 mm film.

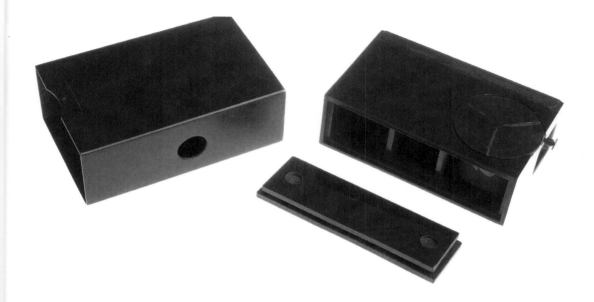

A SPECIAL COMMISSION

The Eastman Kodak Company had a close relationship with the United States Armed Forces and much of their optical and photographic research was centered on Kodak Park, Eastman Kodak's manufacturing base in Rochester, New York. So it was only natural that after the United States entered the war in 1941, Kodak would be approached to work on various secret projects. These related mainly to optical work, but in 1943 or early 1944 the Eastman Kodak Company was approached by the Office of Strategic Services with a request to develop a small matchbox-sized camera that could be used by American and European agents and by members of the resistance movements without detection. The contract was taken on "reluctantly" by the company and the camera was referred to as Camera-X. It was developed by Kodak employee Frank Bobb.

Bobb developed a plain metal box — the size of a standard matchbox — within which it could be hidden. The simple camera had a single f/5 1 inch (25 mm) fixed-focus lens that ensured sharp images from 8 feet (2.5 m) to infinity. The shutter gave a single speed of ¹⁄₅₀ second plus Time. It used readily available standard 16 mm film loaded into 30-exposure cassettes, giving a negative of ½ × ½ inch (12.5 × 12.5 mm). A miniature darkroom was also produced, consisting of chemicals in tablet form so that film could be developed in a single solution in a standard glass. The processing kit included a chamois for drying film, together with a mixing stick and other accessories. A close-up stand for document copying was also made. Two batches of the camera, each of 500, were made during 1944–1945.

The official OSS handbook for the camera described its application: "Matchbox is an extremely accurate camera for general or documentary photography. It can be easily concealed and operated in one hand. There are innumerable means of camouflage or concealment. The camera can be requisitioned with labels like a Swedish or Japanese matchbox, or it can be requested plain for camouflage by the operator."

The camera was designed for use by untrained personnel and it was intended to be used from the hip. The photographs produced by it were to be supplied to underground newspapers, as well as being used for military intelligence purposes.

The project remained secret until after the war had ended. In 1947, reports of the Matchbox camera began to be circulated.

Because of its very nature, the photographs made by the Kodak Matchbox camera are unknown, but a number of the cameras have turned up in remarkably good condition, which suggests that not all of the 1,000 cameras made actually saw use in the field.

BELOW **The Mast Concealable camera was the same size as a matchbox. It never went beyond the prototype.**

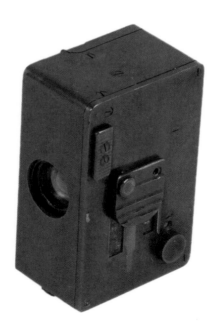

OTHER CONCEALABLES

The idea of a matchbox camera — at a time when far more people smoked and used matches to light open fires and kitchen stoves than today — was one that was continued during the Cold War. A Japanese copy of the Kodak camera exists, and a prototype camera called the Concealable that was also the size of a matchbox was made by the Mast Development Company. The same company received a contract from the American government for a camera that was small enough to be concealed in a packet of cigarettes. The so-called Lucky Strike camera of 1950 was the result. Only two prototypes were made and it never entered into production for field use. The camera was accompanied by a light meter concealed in a matchbox. Likewise, the prototype Concealable matchbox camera never entered production.

LEFT **The "Lucky Strike" camera with light meter in the form of a matchbox.**

A TEENY TINY CAMERA

The Kodak Matchbox was not the smallest camera that the Kodak company made. In 1921, Sir Edwin Lutyens was commissioned to create a doll's house for Queen Mary, as a showcase for the best of British arts and crafts — and to raise money for charity. Kodak Ltd. created a ⅛ scale working model of a 2C Brownie box camera. Technicians also made photographs with it. A second camera was made, a scale model of a No. 3A Autographic Kodak camera. The box camera stayed with Kodak and the better-quality folding camera was included with the doll's house when it went on public display at the 1924 British Empire Exhibition. The house and its contents can still be seen at Windsor Castle.

The Pacemaker Speed Graphic

PRODUCED: **1947** | COUNTRY: **U.S.A.** | MANUFACTURER: **Graflex Inc.**

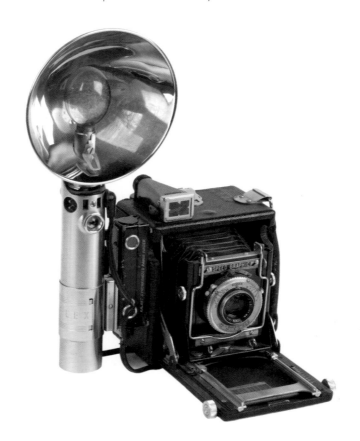

ABOVE **The camera most closely associated with press photography during the 1950s. It captured iconic images and became synonymous with the New York press photographer Weegee.**

THE Speed Graphic camera was made by Folmer & Schwing Manufacturing Company, which dated back to a partnership between William F. Folmer and William E. Schwing in 1887. The company manufactured gas lamps before moving on to making bicycles and cycling accessories. By 1897 it had begun the manufacture of cameras. The Graflex reflex, a single-lens reflex (SLR) camera with a focal-plane shutter that was introduced around 1902, was one of its first products and became very successful. In 1905 the company was purchased by George Eastman and moved to Rochester, New York. In 1907 it was incorporated into the Eastman Kodak Company as a division of the main company, known at first as Folmer-Graflex Corporation, then simply Graflex, Inc. It remained part of Eastman Kodak until 1926, when it reverted to independent ownership, which it retained until 1956, eventually becoming part of the Singer Corporation in 1968.

THE SPEED GRAPHIC

The company's most famous product was the Speed Graphic. This camera was a hand camera with a drop baseboard and a focal-plane shutter that gave fast shutter speeds up to $\frac{1}{1000}$ second. It was introduced in 1912. Although the company had produced some similar designs under the Graphic name, it was the Speed Graphic series of cameras (which included the 1947 Pacemaker model) that became the mainstay of the American press photographer. It remained in production in various formats and models until the Graflex company was dissolved in 1973, by which time the 35 mm SLR was ubiquitous.

The Speed Graphic was made in a wide range of plate sizes from 2¼ × 3¼ inches to 3¼ × 4¼ inches and 5 × 4 inches (57 × 83 mm, 83 × 108 mm and 127 × 102 mm). The rear-mounted focal-plane shutter meant that the camera could use a wide range of lenses mounted onto the lens panel. Although the camera was widely used by press photographers, it was slow to operate, particularly when compared with cameras such as the Leica and Contax. However, the large format gave it an advantage and the speed of operation could be increased by using a Grafmatic film holder, which gave six exposures on a film pack, or with a roll-film holder mounted on the camera instead of using plates.

Throughout its long history the basic design of the camera changed very little. There were, of course, modifications, particularly through the 1950s and 1960s as the camera's appearance was modernized, and there were some technical changes to the way the camera worked, but a photographer of 1912 would recognize the Super Graphic and Pacemaker Graphic cameras of the early 1970s as being basically the same.

BELOW **Company brochures promoting the Speed Graphic and Graflex cameras.**

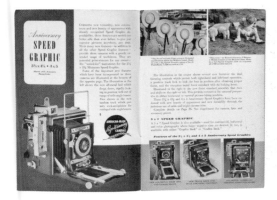

PULITZER PRIZE WINNER

The Speed Graphic was used by a number of well known photographers and produced photographs that are widely remembered. One of the longest users of the Speed Graphic camera was the New York City street photographer Louis Mendes, who used the camera for more than 40 years. Between 1942 and 1954 all the Pulitzer Prizes for photography were taken with Speed Graphic cameras, including the iconic image *Raising the Flag on Iwo Jima* by Joe Rosenthal.

During the Second World War, the Speed Graphic was widely used by military personnel and photographers embedded with servicing soldiers, such as Morris Engel. Well known female American war correspondents to use the camera included Peggy Diggins, Lee Miller and Dickey Chapelle.

Photo-historian Beaumont Newhall described Sam Shere's widely published photograph of the 1937 Hindenburg disaster (also taken on a Speed Graphic) as "the world's most famous news photograph ever taken." Shere described how he captured the famous picture: "I had two shots in my big Speed Graphic but I didn't even have time to get it up to my eye. I literally 'shot' from the hip — it was over so fast there was nothing else to do."

The last Pulitzer Prize–winning photograph from a Speed Graphic, showing the dramatic on-stage assassination of the Japanese politician Otoya Yamaguchi, was taken in 1961 by Yasushi Nagao. The camera continued to be used long after it might reasonably have been considered obsolete. In 2004 American photojournalist David Burnett used his Speed Graphic to cover John Kerry's presidential campaign.

RIGHT **Peggy Diggins using her Speed Graphic, September 1943.**

The Pacemaker Speed Graphic

RAISING THE FLAG ON IWO JIMA

This iconic image by photographer Joe Rosenthal of U.S. Marines raising the American flag on Iwo Jima in 1945 became a symbol of American victory in the Pacific. Telegraphed around the world, the photograph hit the newsstands on February 25, 1945, and it was widely used on news magazine covers. The photo earned Rosenthal a Pulitzer Prize in 1945, with the committee praising him for "depicting one of the war's great moments." Even after the war's end Rosenthal's *Raising the Flag on Iwo Jima* became an enduring icon. It was used as the model for the United States Marine Corps War Memorial,

at Arlington, and the United States Postal Service used the picture on a postage stamp. It inspired Thomas E. Franklin's photograph, *Ground Zero Spirit*, which shows firefighters raising the flag by the ruins of the World Trade Center in 2001.

Joseph Rosenthal (1911–2006) was born in Washington, D.C. and started photography as a hobby before becoming a reporter and photographer for the *San Francisco News* in 1932. His poor eyesight meant he was unable to serve in the U.S. Army. He joined Associated Press (AP), which gave him access to photograph the war. He left AP in 1945 and eventually joined the *San Francisco Chronicle*, retiring in 1981.

ABOVE **A man drinking from a bottle near a movie theater marquee that reads: "Is Paris Burning?" In the background is a sign for Woolworth's Luncheonette and "King of Slims"; a hand in the foreground holds a cigarette. Arthur Fellig (Weegee), New York, 1966.**

RIGHT **Forensic scientists take the fingerprints of murdered store owner Joseph Gallichio, as he lies on the roof beside his cage of racing pigeons. Neighbors watch the proceedings from their rooftop at 12 East 106th Street. Arthur Fellig (Weegee), New York, 14 August 1941.**

CAPTURING THE NAKED CITY

The most famous user of the Speed Graphic was the New York–based news photographer Arthur Fellig, better known as Weegee. In the words of William McCleery in Weegee's autobiographical *Naked City*: "He will take his camera and ride off in search of new evidence that his city, even in her most drunken and disorderly and pathetic moments, is beautiful." During an intense period from the mid-1930s to the mid-1940s Weegee vividly captured dramatic and often lurid photographs of New York crimes and news events.

The Speed Graphic captured these for him on plates. A large flashgun allowed him to operate at night and, at the same time, added a harsh and dramatic lighting to his subjects. He wrote in his 1945 book *Naked City*: "The only camera I use is a 4 × 5 Speed Graphic with a Kodak Ektar lens in a Supermatic Shutter. All-American made. The film I use is Kodak Super-Panchro Press B. I always use a flashbulb for my pictures which are mostly taken at night."

Fellig carved out a job for himself by spending two years at the Manhattan Police Headquarters waiting for stories to come in. When they did he would go to the scene, despite not having any police card or credentials. Whether he was attending car accidents, building fires, murder scenes, gangster stings or other human-interest stories, it was his camera that made it possible for him to take the shots the newspapers would pay for. "If you are puzzled about the kind of camera to buy," he said, "get a Speed Graphic … for two reasons … it is a good camera, and moreover … with a camera like that the cops will assume that you belong on the scene and will let you get behind police lines."

The Hasselblad

PRODUCED: **1948** | COUNTRY: **Sweden** | MANUFACTURER: **Victor Hasselblad AB**

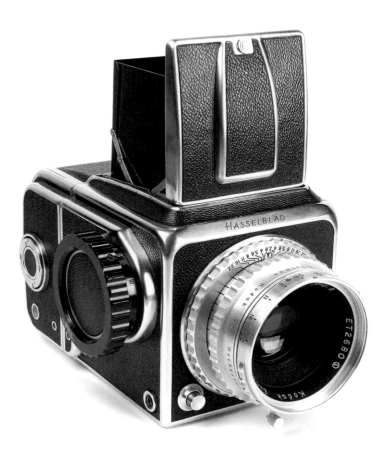

ABOVE **The Hasselblad 1600F camera, with a Kodak Ektar f/2.8 80 mm lens.**

THE Hasselblad's enduring reputation as the ultimate professional camera reflects both the quality of the design of the camera, its Kodak and Zeiss lenses and, much like the Leica, a certain mystique that it has acquired since its introduction in 1948.

The F.W. Hasselblad business was established in 1849 as a trading company and soon began importing photographic goods into Sweden and selling cameras made by others under its own brand name. A photographic division, Hasselblads Fotografiska AB, was established in 1908, acting as a photographic distributor for Eastman Kodak Co. In 1940, the firm was approached by the Swedish government to produce a surveillance camera and the HK7 became the Hasselblad company's first camera, with some 240 units being made.

A STREAMLINED DESIGN

Victor Hasselblad, the head of the firm from 1942, aimed to make high-quality cameras for the civilian market. In 1945 design work began on what was at first called the Rossex; this eventually evolved into the Hasselblad. The camera was similar to several German prewar models such as the Primarflex, but featured the innovation of fully interchangeable film backs that permitted different types of film to be used quickly and without waste. Although Victor Hasselblad was responsible for the mechanical design, Sixten Sason, a respected industrial designer, was brought in to style the look of the camera. Sason, who had designed the first Saab car, produced a streamlined camera with no sharp corners that was comfortable to use whether it was on a tripod or handheld.

The Hasselblad 1600F was launched in 1948. It was well reviewed and some 2,859 units were made. The first model was not fully effective — the shutter mechanism being unreliable — and a new model, the Hasselblad 1000F, with a slightly slower top shutter speed of $1/1000$ second, was introduced in 1952. The new camera included other technical refinements and a greater range of lenses, resulting in some 10,396 units being made. The introduction of the Hasselblad 500C in 1957 marked a significant change for the company. This became Hasselblad's basic model for the next 60 years and versions of it remained in production until 2013. More importantly for the company, from 1960 the camera became profitable.

Hasselblad continued to develop new models, each one building on its predecessors, with sales rising rapidly to 76,700 for the 500C and 243,000 for the CM. A range of film backs, viewing accessories and specially designed lenses from respected German lens makers such as Carl Zeiss and Schneider superseded the original Eastman Kodak Company Ektar lenses. It remained the leading professional medium-format camera, with new ranges of camera in different formats, built-in exposure metering systems, autofocus lenses and digital backs all closely made to Sason's original design. With the advent of digital technology, which Hasselblad initially ignored, it lost its market share.

THE SWINGING SIXTIES

Terence Donovan (1936–1996), along with David Bailey and Brian Duffy, helped to define the Swinging Sixties in London. The three photographers became celebrities in their own right, and all three at some time used a Hasselblad. Donovan concentrated on fashion photography and portraiture during the 1960s and early 1970s for publications such as *Harper's Bazaar* and *Vogue*. He moved on to making documentary films, music videos and some 3,000 television commercials. Toward the end of his life, Donovan returned to photography, one of his last commissions being to photograph 20 of Britain's leading men for the men's style magazine *GQ*. His collection of cameras and photographic equipment was sold by Christie's in 1997.

A PROFESSIONAL PHOTOGRAPHER'S FAVORITE

From its launch, but particularly with the introduction of the 500C, the Hasselblad became popular with professional photographers, both within the studio and on location. The 2¼ × 2¼ inch (60 × 60 mm) format gave better-quality negatives than 35 mm, particularly for editorial or fashion work, and the single-lens design offered advantages over the Rolleiflex and more traditional view cameras. The British fashion and portrait photographers Terence Donovan, John French, Tim Graham and Norman Parkinson used the camera from the 1960s. Some news photographers also made use of the camera, with *Life* magazine photographer Ralph Crane and *Daily News* photographer Frank Hurley taking advantage of the availability of long telephoto lenses and of the medium format. In the United States, Richard Avedon and Irving Penn were among many who used the camera. The camera also appeared in the film *Blow-Up*, used by David Hemmings who played a fashion photographer loosely modeled on David Bailey.

The documentary photographer Mary Ellen Mark favors the camera, preferring the square format to the standard rectangle of the 35 mm frame. She describes it as "a beautiful shape," although she says, "You have to work hard to break the format of the square."

WHERE NO CAMERA HAD GONE BEFORE

The Hasselblad camera received its greatest exposure as the principal camera used on NASA space missions. The first Hasselblad to be taken into space was the 500C, on the Project Mercury mission of 1962 and again in 1963. They were also taken aboard the Gemini spaceflights of 1965 and 1966. The camera's reliability ensured that it continued to be selected but, in addition, there was the fact that it had interchangeable lenses and film magazines — the latter were specially enlarged to reduce the number of reloads needed. The cameras were specially modified by the factory and NASA technicians to facilitate their use in the cramped conditions of the space vessel while wearing spacesuits; for example, the reflex mirror was replaced with an eye-level finder and larger controls that would be easier to use with gloved hands were fitted.

Hasselblad EL electric cameras were used on *Apollo* 8 in 1968, the first manned voyage to orbit the moon. That mission produced one of the most iconic photographs ever made. *Earthrise*, also known as "NASA image AS8-14-2383," was taken by astronaut William Anders from lunar orbit on December 24 using a modified Hasselblad 500EL with an electric film drive. The camera had a simple sighting ring and was loaded with a 70 mm film magazine containing custom Ektachrome film developed by Eastman Kodak. The image was taken at ½₅₀ second with an aperture of f/11.

Earthrise has been described as "the most influential environmental photograph ever taken." It showed, for the first time, the beauty of Earth in the infinity of space, diminutive beyond the horizon of the barren moon. It was this image that gave rise to the concept of "Spaceship Earth."

On *Apollo 11*, three Hasselblad 500EL cameras were used. A Hasselblad EL Data Camera (HDC) was extensively modified for use on the moon's surface, with a special Zeiss Biogon f/5.6 60 mm lens and film magazines for 150–200 exposures. All subsequent NASA missions had the cameras on board and NASA's Space Shuttle continued to use Hasselblad models. Twelve Hasselblad cameras remain on the lunar surface.

ABOVE *Earthrise*, William Anders, 1968, taken during the *Apollo 8* mission.

32 The Polaroid Land Model 95

PRODUCED: **1948** | COUNTRY: **U.S.A.** | MANUFACTURER: **Polaroid Corporation**

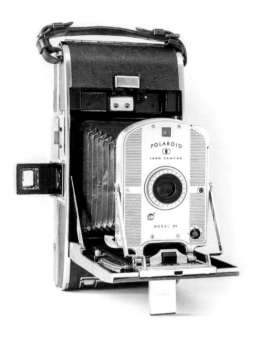

ABOVE **The first true instant-picture camera, which introduced a whole new way of making photographs.**

FEW inventions can be credited to one individual, but Edwin Land's invention of instant photography is one such example. The idea of processing and producing a photograph in the camera had a long history, back to the announcement of photography itself. Henry Fox Talbot proposed, in September 1839, a method by which an image could be processed inside a daguerreotype camera. Antoine Claudet, the scientist and photographer, expounded a similar idea in 1841. These never amounted to anything and the first camera to incorporate internal processing was Frederick Scott Archer's camera of 1853. This was essentially a darkroom into which the photographer inserted his hands and manipulated his wet-collodion plate in chemical baths. A yellow glass allowed him to see what was happening inside the camera box.

The introduction of dry plates during the 1870s and then the arrival of celluloid roll film removed the need for immediate processing from a chemical perspective. Where there was a commercial need for immediate photographs, such as at the seaside or fairs, the ferrotype, or tintype, process was used. Portraits of visitors could be taken and within three or four minutes a finished photograph on a metal plate could be presented to the subject in a paper mount. This style of "instant" picture-taking remained popular well into the 1970s and continues to be used in less-developed parts of the world.

AN INSTANT SUCCESS

It was Dr Edwin Land who established a truly instant process. Land was a successful inventor and businessman who formed the Polaroid Corporation in 1937 to manufacture and market his polarizing sheets and objects that utilized them. Land was inspired to develop an instant photography process in 1943 while on a family holiday during which his daughter, Jennifer, asked why she could not see the holiday photographs immediately. He set to work on the problem and later claimed to have grasped all the details of the process in no more than an hour.

Polaroid instant photography was demonstrated to the Optical Society of America on February 21, 1947, and the first camera went on sale in Boston, Massachusetts, on November 26, 1948. The Polaroid Land model 95 camera was an upright oversized folding camera of a design that would have been familiar to many photographers. It was developed specifically to take the Polaroid Land picture roll, which produced a positive photograph in one minute. The most important part of the camera was the back, which incorporated rollers to burst a special pod of viscous processing reagent and distribute it evenly onto the print. The reagent combined both a developer and a fixer. Once the processing was complete, a flap in the back of the camera was opened and the black-and-white 3¼ × 4¼ inch (82 × 108 mm) finished print was peeled away from the negative strip.

In 1950 a new type of Polaroid material was introduced. New cameras followed in 1952, including the Model 110 Pathfinder, for professional use. By the time the Model 95 camera was discontinued in 1953, around 900,000 had been sold; in 1956 the one millionth Polaroid camera was purchased.

ABOVE **Polaroid Land Automatic 100 camera**

THE DUBRONI

There were many cameras patented during the 19th century that made use of the camera interior to hold chemicals and to allow processing. The most successful of this type was the Dubroni camera (pictured left), which was patented in Britain in 1864 by G.J. Bourdin. Inside the small wooden camera was a ceramic lining into which chemicals could be poured and washed over the glass plate. The top of the camera had a hole into which a pipette could be inserted so that the chemicals could be introduced without admitting light and spoiling the plate. The Dubroni was popular and was produced in a range of sizes.

THE IMMEDIATE IMAGE

For commercial photographers, the Polaroid provided an instant check on a photoshoot, after which the final images would be taken with conventional film or transparency materials. It also opened up new markets where an instant photograph could be taken, produced and sold. Many professional photographers attended dinners or social events and circulated tables taking Polaroid photographs and then selling them immediately. Polaroid supported this by providing special cutters, folders and keyring frames in which to present the photographs.

One photographer would become known for his use of Polaroid cameras to shoot subjects on a much grander scale. Ansel Adams, who met Edwin Land at an optics conference, was also heavily involved in the development of Polaroid's cameras and films. Three decades after they met Adams recalled the brown, poor-quality image Land took of him on a big 8 × 10 inch (203 × 254 mm) camera in his laboratory. "It was a one-minute picture," he said, "and that excited me to no end." In 1948 the American photographer became a consultant for the company, testing new cameras and films as well as using the camera as a tool for his own landscape work in Yosemite and elsewhere. He wrote in his autobiography: "Many of my most successful photographs from the 1950s onward have been made on Polaroid film. One look at the tonal quality of the print I have achieved should convince the uninitiated of the truly superior quality of Polaroid film."

Ansel Adams was also an environmentalist, closely associated with the Sierra Club. He was particularly known for his stunning landscape photographs, usually taken on large-format cameras. From 1961 Adams used a new type of Polaroid film called Type 55, capable of making a positive print and a reusable large-format negative. One of his favorite images, *El Capitan, Sunrise, Winter, Yosemite National Park, California,* 1968, was shot on Polaroid film.

Adams's friend, the photographer Minor White, also used the early Polaroid cameras, drawn to them not by the camera's usefulness, but by the idea of "the immediate image." He explained why: "In the newer Polaroid Land process the immediate image is back in photography (after a lapse of about three-quarters of a century) and exposure explodes into picture so fast the crack is practically audible.... With the Polaroid system, it is true that I can compare photograph with scene; but this only serves to make me realise with lightning clarity what a tremendous transformation has taken place. A forceful change is present with any ordinary photograph: when the result is a photograph that has found itself, the transformation is truly remarkable."

ADVANCES IN FILM

In 1959 a new high-speed Polaroid film of 3000 ASA was introduced that allowed photographs to be made in low light. The following year the first of the Polaroid Electric Eye cameras was introduced, the Model 900, which was fully automatic. A major step forward came in 1963 when Polaroid introduced the Polacolor Land film which, for the first time, gave a color photograph after 50 seconds of development. The Polaroid Land Automatic 100 camera had an electronic shutter that supported automatic exposure control, and was the first to use a Polaroid film pack rather than the Polaroid rolls. Packs were simply dropped into the camera, ready for exposure. After taking a picture, a paper tab was pulled, drawing the negative material through rollers and into contact with the positive sheet and spreading the chemical reagent. Black-and-white photographs were produced within 15 seconds and color in one minute.

The Polaroid remained the dominant instant process, despite attempts from Eastman Kodak Company, Fuji and Agfa to enter the market. The advent of affordable digital photography from the mid-1990s took away many of the advantages of instant Polaroid photography for both professional and amateur photographers and Polaroid discovered that the market for its products was diminishing rapidly. The company's fortunes went into a dramatic decline as it failed to diversify its business. By the end of 2008 it had withdrawn from the instant film market altogether.

PHOTOGRAPHY LIBERATED

The Polaroid completed a process that George Eastman had started for the amateur — the removal of the need for any knowledge about photography, or for others to intervene in the production of a photograph. The Polaroid did away with a visit to a local drugstore to have a film processed and printed, meaning that no third party would have to see the photos taken. Inevitably, perhaps, this allowed couples to take pictures of each other in the bedroom and outside undertaking activities that they would not usually have photographed. Surviving Polaroid photographs from the 1950s, 1960s and 1970s show that a surprising amount of nudity was captured. The immediacy of the Polaroid photograph liberated people to capture new subject matter that had hitherto remained largely private.

The View-Master Personal Stereo Camera

PRODUCED: **1952** | COUNTRY: **U.S.A.** | MANUFACTURER: **Sawyer's**

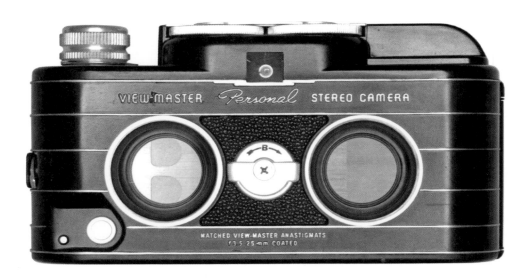

ABOVE **A serious camera for adults and a popular toy for children, View-Master was a phenomenal global success that continues today.**

VIEW-MASTER cameras, viewers and stereo reels were originally conceived of as educational tools to show adults, as well as children, the world around them. Stereoscopy and the ability to represent subjects in 3-D had a history stretching back to the 1850s, but despite periodic popular revivals in the 1890s and 1930s, it had always been a niche area of photography. In the 1930s William Gruber, a photographer, and Harold Graves saw the opportunity to produce high-quality color stereoscopic transparencies that could be sold cheaply, supported by a simple viewer. They formed a partnership and the View-Master, invented by Gruber, was marketed by Graves through Sawyer's (a photo-finishing, postcard and greeting card company run by Edwin and Fred Mayer), was born in 1938. The viewer and picture reels were launched at the 1939 New York World's Fair.

SEE PICTURES "COME TO LIFE"

Unlike traditional stereographs, which had a stereoscopic pair of images mounted on a single card, the View-Master reel had seven stereo pairs on a circular cardboard disk (known as a reel). Each was in full color, making use of Kodachrome color transparency film, introduced by Eastman Kodak Company in 1935. The bright, strong colors were attractive and the seven subjects allowed for a story or travelogue to be told, supported by text on the reel packet. View-Master reels were sold individually from 1939 to 1950.

The Model A viewer, produced between 1938 and 1944, was made from Kodak Tenite plastic and cost $1.50 ($13 today). The United States' involvement in the Second World War from 1941 interrupted the development of the View-Master for the consumer. The country's military was a keen advocate of it and commissioned reels of 3-D images of enemy aircraft and landmarks to aid with artillery spotting and aircraft identification. Many millions of reels were purchased, together with thousands of Model B viewers. The View-Master Model B viewer was produced between 1944 and 1947, and a British version was made in Salford, England.

At the end of the war, production returned to service public demand. A Model C viewer was produced between 1946 and 1955. It was made from Bakelite and, unlike earlier models, which opened up like a clamshell in order for the reel to be inserted, it was the first to have a slot into which the reels were placed for viewing; a design that continues to the present day. It sold for $2 ($17 today). The expansion of the range of subjects covered in reels was a priority. Although single reels continued to be sold, the company began grouping titles into packets sold by subject.

Around 1952 the company introduced the View-Master Personal Stereo Camera, made for Sawyer's by the Stereocraft Engineering Co. This model allowed photographers to make their own stereo pairs of photographs for use in View-Master viewers. It made 69 pairs, each $15/32 \times 33/64$ inches (12 × 13 mm), but had limited success and was discontinued in 1955. In 1961, Regula-Kamerawerk King in West Germany made a second View-Master camera. A projector was also marketed, into which reels could be dropped for projecting onto a screen.

BELOW **A pair of images taken using the View-Master Personal Stereo Camera.**

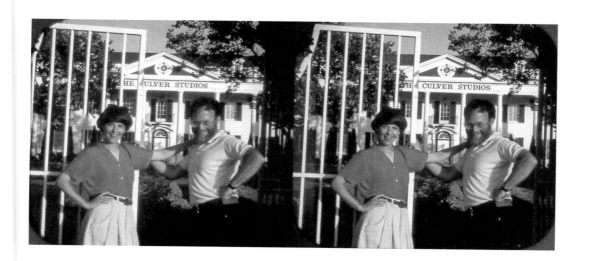

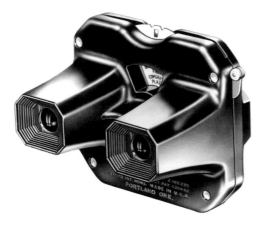

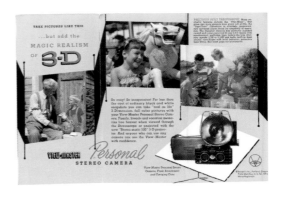

A WIDER APPEAL

A key turning point for the View-Master's continued success came when Sawyer's acquired their main competitor, the Tru-Vue company, in 1951. This firm produced stereo views on 35 mm film strips and held a valuable license with Walt Disney Studios. This supported the expansion of View-Master reels, from travel views to reels and packets showing stills of Disney characters, the newly built Disneyland theme park and the studio's live-action feature films and television shows. The relationship continues to the present day. By 1957, most of the View-Master production had been moved to three-reel packets that could be retailed for a higher price than the individual reels.

In 1966, Sawyer's became a subsidiary of the General Aniline & Film (GAF) Corporation. The change in ownership further pushed the company's reel packets away from Sawyer's traditional travel and scenic subjects into areas with a wider popular appeal from other media: motion pictures, television, sports and, in particular, entertainment for children. On a technical level, the company moved away from the strong colors of Kodachrome to a new type of Eastman Kodak transparency film that made use of the simpler E6 processing chemistry. The greater ease in making reels was compromised by the lower quality of the new film stock, which was not so durable, gave less saturated colors and showed increased film grain. The majority of reels were made in the United States or Belgium, along with small numbers made in India, Australia, Austria and France.

View-Master was sold by GAF in 1981 to a group of investors headed by Arnold Thaler for just over $20 million and it was reconstituted as the View-Master International Group. Despite being nearly 50 years old, View-Master viewers and reels remained popular among children. The company changed hands again in 1984 and 1989. In 1997, it merged with the Mattel company and was placed in its preschool division, marketed under the Fisher-Price brand. Since 1939, some 100 million viewers have been sold and more than 1.5 billion reels have been made.

AN IDEAL WORLD

Sawyer's commissioned photographers throughout the world to record the sights, landscapes, animals and flora they encountered. Their work depicted an idealized view of the world, optimistic and bright, that was commensurate with the new postwar era. View-Master remained popular throughout the 1950s to the 1980s; although the two Personal cameras sold in relatively small numbers, many millions of homes had a viewer and reels.

PRODUCED: **1954** | COUNTRY: **Germany** | MANUFACTURER: **Leitz**

ABOVE **The Leica M3 camera with a Summicron f/2 50 mm lens.**

THE rangefinder Leica camera introduced in 1925 (see page 88) had undergone various minor design changes by the 1950s and new features had been incorporated. Yet it continued to be clearly recognizable as the descendent of the original model. The rangefinder camera was becoming increasingly dated, thanks to the growth of the single-lens reflex (SLR) camera, which offered the advantage of showing the photographer in the viewfinder exactly what was being photographed, irrespective of which lens was mounted on the camera body. Despite this, the Leica had a strong and loyal following among photographers: it was unobtrusive and had a quiet shutter that made it better placed for discreet shooting.

M IS FOR MESSSUCHER

In 1954 the Leitz company introduced the Leica M3 at the international Photokina trade fair in Cologne. The M stood for *Messsucher*, the German term for a combined rangefinder and viewfinder. It was the first significant departure from the original Leica camera. Although work on a new camera design had started in the mid-1930s, Leitz was not able to realize it in a commercial product until after the postwar reconstruction of Germany was well under way and the growth of potential export markets would ensure financial success.

The Leitz company pooled its finest talent into developing the new camera. Chief designer Willi Stein worked with Ludwig Leitz on the rangefinder, while the viewfinder optics were designed by Heinrich Schneider and Willi Keiner. Hugo Wehrenfennig was responsible for the lens mounting, which was a key difference from previous models. The new camera offered a bayonet mounting rather than a screw fitting, allowing the lens to be removed and replaced more quickly. The camera's shutter speeds were all on one dial and the film was advanced by a lever rather than a knob. The viewfinder incorporated bright lines, which were automatically selected, depending on which lens was on the camera, to show the frames for 50 mm, 90 mm and 135 mm lenses. A hinged back was brought in to ease the process of film loading, although the film continued to be inserted from below. The screw-mount cameras were discontinued in 1960. In Britain, the Leica M3, with a standard Elmar f/3.5 50 mm lens, sold for £140 ($4,375 today).

The Focal Press, in its series of camera guides, noted that the M-series of cameras "incorporates many features for increased versatility and convenient operation, especially for general, press, and professional photography" and the *British Journal of Photography* reported that the Leica M3 "meets the most stringent demands that professionals and serious amateurs can make on modern photographic equipment."

By the time the camera's production ended in 1966, over 220,000 Leica M3s had been produced and the M-series, which included the MP, M2 and M1 alongside several specialty models, was well established. The introduction of the M4 in 1967 set the path for a continued sequence of cameras up to the M8, Leica's first rangefinder digital camera in 2006, the M9 of 2009 and the M of 2012.

Like the original rangefinder series, the Leica M3 was conceived as part of a system of photography and a full roster of accessories and lenses was introduced to support the camera.

BELOW **A Leica M3 camera with a standard lens, a wide–angle lens and two telephoto lenses.**

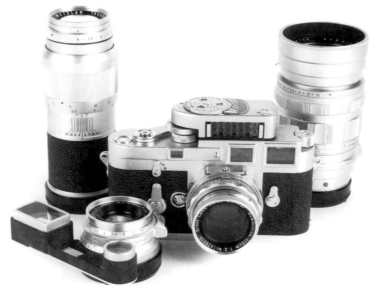

IN THE HANDS OF THE GREATS

The advantages of the Leica screw-lens series were continued with the Leica M3, with the added benefits of a camera better designed for immediate use. As a result, a number of photographers who had used earlier models of Leica switched to the M3. Of these, Henri Cartier-Bresson is perhaps the best known. The photographer Martine Franck, Cartier-Bresson's second wife, also favored the Leica M3. Cartier-Bresson was a long-time Leica user, although, as he said: "It is an illusion that photos are made with the camera … they are made with the eye, heart and head." Tony Ray-Jones, who documented the British way of life, was a Leica user, producing a body of work that was to be a major influence on his near contemporary, Martin Parr. In the United States it was the favorite of street photographers and the pioneering color photographer William Eggleston.

BELOW **Elliott Erwitt (b. 1928), self-portrait with dog, Ireland, 1970. Erwitt is a Leica user and known for his quirky, frequently humorous photographs. He has made a particular specialty of photographing dogs.**

Leitz recognized the value of presenting cameras to well known people and regularly gave cameras with distinctive serial numbers to famous photographers or individuals. Queen Elizabeth II was given a Leica M3 camera with the serial number 919,000; she took pictures with it on a regular basis and was photographed using it as recently as 1982.

By the early 1970s the rangefinder camera was in decline as the SLR became the camera of choice for serious photographers and as simpler cameras with varying degrees of automation were adopted by amateurs. The Leica rangefinder cameras remained sought after, but Leica's SLR series, introduced in 1965, were cumbersome and failed to gain wide recognition.

From the 1990s, rangefinders experienced something of a resurgence, with the introduction of a small number of digital models and a renewed interest in retro photography. The Epson R-D1, announced in March 2004 and discontinued in 2007, was the first digital rangefinder camera, and other models followed. Electronic automation and digital technology had overtaken the advantages of the traditional rangefinder camera.

ON THE STREETS

Photography moved out of the studio and onto the streets from the 1890s, and by the 1950s street photography was fully established as a genre in its own right. Two of the best-known exponents were Garry Winogrand (1928–1984) and Joel Meyerowitz (b. 1938). Winogrand's street photographs of the 1960s portrayed a vast spectrum of American life, somehow capturing both the hope and the anxiety that arose from the social changes of the decade. One leading critic, John Szarkowski, called him the central photographer of his generation. He mainly used the Leica M4. As one of his students recalled: "As we walked out of the building, he wrapped the Leica's leather strap around his hand, checked the light, quickly adjusted the shutter speed and f/stop. He looked ready to pounce. We stepped outside and he was on." Winogrand famously professed that he was uninterested in making photos that would succeed: he photographed in order to see what the things that interested him looked like as photographs. In the early 1960s Winogrand loaned a Leica camera to his friend Joel Meyerowitz one afternoon. According to Meyerowitz, he was converted. "I saw how if you want to be a street photographer and you want to be invisible, that's the camera you have to have," he said. While influenced by Henri Cartier-Bresson and Eugène Atget, Meyerowitz boldly struck out in his own direction by adopting color film at a time when black-and-white was predominant. "I saw in the 35 mm color a kind of quality of description that 35 mm black-and-white didn't have." The quiet and unobtrusive Leica continued to be the camera of choice for street photographers long after the introduction of first-rate SLRs, perhaps in part because its viewfinder allows the photographer to see what is about to enter the frame and thus anticipate the next shot.

CAPTURING WAR

It was in the sphere of war photography that the Leica M3 really came into its own and achieved a reputation for reliability and quality that has remained with this product series to the present day. From the *Daily Express'* Terry Fincher and *Life* magazine's Larry Burrows and Carl Mydans, to Pulitzer Prize–winner Eddie Adams and news and portrait photographer Michael Ward, photojournalists covering conflicts in the second half of the 20th century were often carrying a Leica M3. For one man, however, there was a special model made only for him. David Duncan Douglas (b. 1916) was probably unique in having Leitz design a camera specifically for him, the Leica M3-D. In 1955, the company built him four of these cameras, which he used during his coverage of the Korean and Vietnam wars and for other documentary work. The cameras included a special Leicavit rapid winder and other modifications. Douglas' combat career started when he was sent to the South Pacific on assignment during the Second World War. He was hired by *Life* magazine and documented conflicts in Turkey, Eastern Europe, Africa and the Middle East. But he was best known for his work in Korea and Vietnam. Douglas was a close friend of Pablo Picasso and the artist was the subject of seven of his books, with all the photographs being taken on a Leica M3-D. As recently as 2012 one of the four cameras — Leica M3-D 2 — was sold for £1.2 million (nearly $2 million) at auction.

LEFT **David Duncan Douglas (b. 1916). This image was used on the front cover of** *Life* **magazine on October 27, 1967, which ran a feature "Inside the Cone of Fire at Con Thien: David Douglas Duncan Photographs the Marines."**

The Rolleiflex 3.5F

PRODUCED: **1958–1960** | COUNTRY: **Germany** | MANUFACTURER: **Franke & Heidecke**

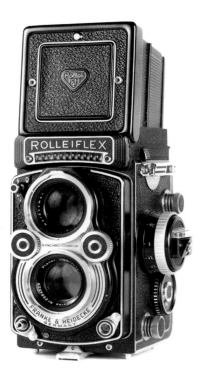

ABOVE **The Rolleiflex 3.5F, the ultimate incarnation of this product series.**

TRADITIONALLY, most cameras had only one lens, which was used to expose the film or plate, usually with a separate viewfinder to help direct the camera at the subject. The single-lens reflex (SLR) camera used the same lens for both viewing the subject and taking the picture. There were two further general camera configurations: stereoscopic cameras often had two lenses mounted horizontally, which made two images simultaneously, and the twin-lens reflex (TLR) camera employed two lenses, usually mounted vertically, with one to view the subject and one to take the photograph.

TWO LENSES ARE BETTER THAN ONE

The idea of using a second lens, similar to the taking lens and focused by the same mechanism, went back to 1862 and a camera shown by Lieutenant-Colonel Shakespear at the International Exhibition. In 1873, Frederick York designed a two-lens stereoscopic camera with an additional lens for focusing that he used to photograph animals at London Zoo. One of the more successful was Marion and Company's Academy camera, which was sold from 1881. Further designs appeared throughout the 1880s and

THE TRAILBLAZER

The success of the Rolleiflex led to other manufacturers copying the design. Voigtländer produced a cheap TLR, the Brillant, Zeiss Ikon produced the Ikoflex, and Franke & Heidecke introduced the Rolleicord range in 1933 as a less expensive alternative to the Rolleiflex.

In 1931 a 1⁹⁄₁₆ × 1⁹⁄₁₆ inch (40 × 40 mm) model using 127 roll film, the Baby Rolleiflex, appeared. Zeiss Ikon introduced the twin lens 35 mm Contaflex in 1935, which offered interchangeable lenses. Other manufacturers added the advantages of TLR to standard cameras by providing a removable focusing lens coupled to the taking lens of existing cameras.

1890s, including Ross' Portable Divided camera of 1890, and Newman and Guardia's Twin Lens camera of 1895, both of which achieved some success. For plate use the TLR camera offered little advantage over the SLR and the design gradually fell from favor in the period up to the First World War.

In December 1928, the German manufacturer Franke & Heidecke introduced its Rolleiflex TLR camera. The camera used 117 roll film, which gave 2¼ × 2¼ inch (60 × 60 mm) negatives, and the metal body allowed for a compact design; it was a quarter the size of the pre-1914 TLR cameras. The two lenses, the lower one for making the exposure and the upper one for viewing the subject, were mounted close together. The camera was immediately successful. The design offered the photographer the ability to view the subject while the exposure was being made. It was the first time this feature had been available in a mass-produced form. The front-mounted Compur shutter into which the taking lens was set was more compact than the focal-plane shutters of the SLRs. The original Rolleiflex sold for £16 7s 6d (around $1,330 today) with a Zeiss Tessar f/4.5 lens.

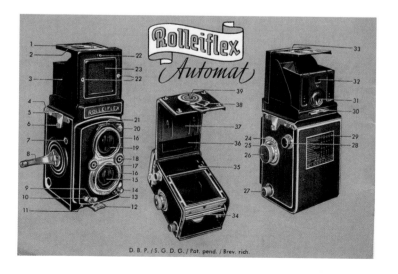

D. B. P. / S. G. D. G. / Pat. pend. / Brev. rich.

ABOVE (Top) Ross' Portable Divided camera, 1890. (Bottom) Marion's Academy camera, 1881.

LEFT The Rolleiflex Automat camera described in its instruction booklet.

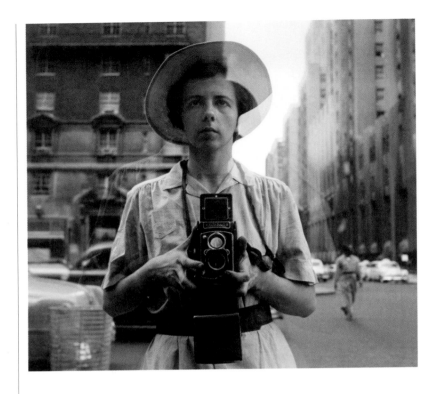

A PRESS FAVORITE

The Rolleiflex was the most popular TLR camera of the 20th century. It was widely adopted by press photographers, for whom the large viewfinder and ability to see their subject, even while the exposure was being made, allowed a level of certainty that a shot had been secured. The large negative size, compared with 35 mm, meant that the quality of the shots was better, too, particularly for the illustrated press, which would frequently use photographs across a full page. The design's main disadvantage was that the lenses couldn't be changed, as both the viewing and taking lens were fixed to the body. The twin-lens 35 mm Contaflex camera (see page 97) offered interchangeable lenses, but at a significant cost.

After the Second World War, the TLR returned. In Britain, the Microcord of 1952 was a close copy of the Rolleicord and cheap imitations of the design were introduced by Kodak, with the Kodak Reflex and Brownie Reflex.

The Rolleiflex reigned supreme. A wide-angle model (1961) with a 55 mm lens and a telephoto model (1959) with a 135 mm lens appeared, offering photographers alternative focal-length lenses. The standard range with the 75 mm or 80 mm lens was developed throughout the 1950s, with the Rolleiflex 3.5F (1958) and 2.8F (1960) models appearing — the ultimate incarnations of the product series. Both offered a coupled light meter and a whole range of refinements to the camera body, with high-quality Zeiss or Schneider taking lenses. They were supported, as previous models had been,

by a range of accessories, from flash guns to plate backs and close-up lenses, turning what was, in reality, a limited design into a more versatile camera. The 2.8F sold some 82,800 and the 3.5F around 81,500 units.

The roster of photographers who used the Rolleiflex TLR is a long one and includes many key figures from the world of press and fashion photography: Richard Avedon, Danny Lyon, David Bailey, Cecil Beaton, Werner Bischof, Édouard Boubat, Margaret Bourke-White, Robert Capa, John Chillingworth, Imogen Cunningham, Bruce Davidson, Toni Frissell, Robert Doisneau, Zoltan Glass, John Gutmann, Ernst Haas, Fritz Henle, Charles Hewitt, Nina Leen, Haywood Magee, Leo Matiz, Lee Miller, Carl Mydans, Lennart Nilsson, Gordon Parks, Irving Penn, Bert Stern, Earl Theissen, Weegee (Arthur Fellig), Walker Evans and Helmut Newton.

Imogen Cunningham bought the first of three Rolleiflex cameras she owned in 1945, and she used them increasingly for the rest of her life. Some of Cunningham's self-portraits show her using the most picturesque of all Rolleiflex accessories, the binocular focusing hood. Walter Evans carried six Rolleis at one stage in his career: two each of standard, wide and telephoto. Fritz Henle was known as Mr. Rollei, working in almost every genre of photography, mostly using a Rolleiflex. Life magazine published more than 50 picture stories and five front covers by the Henle. Many photographers have found the Rolleiflex's square focusing screen an ideal tool for composition.

By the 1960s, the TLR design was increasingly obsolete when compared with the SLR, which offered interchangeable lenses and a more compact camera body. The Mamiya Professional C of 1957 gave the ability to change lenses and continued to be produced in various forms until 1994. The Rolleiflex TLR was made until the mid-1970s, but even Franke & Heidecke could see that it needed a new design if it was to survive. In 1966, the company introduced the SL66, a medium-format SLR camera; a 35 mm SLR range followed. Today, the Rolleiflex TLR is still made in limited numbers, largely for collectors.

VIVIAN MAIER

The discovery of Vivian Maier's vast collection of prints, negatives and undeveloped rolls of film in an auction house in 2007, two years before her death, took the street photography world by storm. While working as a nanny and caregiver in New York and Chicago, Maier (pictured opposite) amassed an incredible body of photographic work in her spare time — unbeknown to the families she worked for and her friends. Until 1952 she used a relatively modest Kodak Brownie box camera, but that year she purchased an expensive Rolleiflex and her work reflected that change.

Maier's nondescript appearance combined with the unobtrusiveness of the waist-level Rolleiflex allowed her to make startlingly forceful photographs of people on urban streets. She also took numerous self-portraits, often capturing her reflection in store windows, as though trying to become part of the world she was photographing. Over her lifetime she worked with a number of Rolleiflex cameras, including the Rolleiflex Automat, 2.8C, 3.5T and 3.5F. The discovery of her work has prompted much speculation and even a documentary film about Maier, whose best images recall the work of Helen Levitt, Lisette Model and Diane Arbus.

The Nikon F

PRODUCED: **1959–1974** | COUNTRY: **Japan** | MANUFACTURER: **Nippon Kogaku**

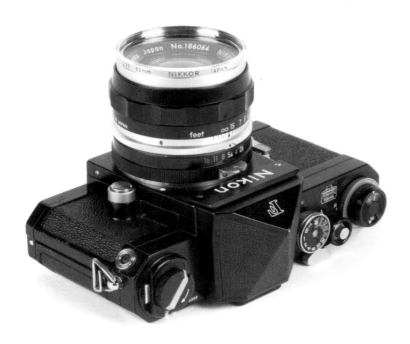

ABOVE **The Nikon F became the archetypal photojournalist's camera. It remains one of the most influential cameras of the 20th century and did more to build the reputation of the Japanese camera industry than any other model.**

THE Nippon Kogaku company of Tokyo was founded in 1917, making optical instruments and, during wartime, military instruments such as binoculars, rangefinders and periscope sights. After the Second World War, the company returned to civilian production and looked for new markets that it could enter. Camera making was an obvious choice, as the company was experienced with optical design and had made photographic lenses, including some for Canon, in the 1930s. It set about designing the camera that would become the Nikon I, which appeared in 1948. The company changed its name to Nikon Corporation in 1988.

EVOLUTION AND REVOLUTION

The Nikon F was introduced in April 1959 by Nippon Kogaku. It built on the technical advances of the German 1936 Kine Exakta (see page 110), the first true 35 mm single-lens reflex (SLR) camera; the Contax S, with a built-in pentaprism; the Japanese Asahi Optical Company's Asahiflex IIb (1954), with an instant-return mirror; and the original Pentax SLR (1957). The camera was a major departure from Nippon Kogaku's previous models.

The Nikon F was designed by Masahiko Fuketa and was the company's first SLR camera. It was to supersede the Nikon rangefinder cameras that had originated back in 1948. The camera was based on the Nikon SP rangefinder camera, to which was added a mirror box, pentaprism and bayonet lens mount. These were not straightforward additions: they required a complete rethinking of how the camera was constructed, which Nippon Kogaku used to its full advantage. The camera was made up of 918 parts and the "F" designation came from the "f" in the word reflex. The Nikon F set a new standard for SLR camera design for the next 30 years that was widely adopted by other makers. It continues to influence the SLR's digital successor, the digital single-lens reflex (DSLR). The Nikon F was a key factor in reinforcing the dominance of the Japanese camera industry over German competition, in particular the Zeiss Ikon company, which had been at the forefront of quality camera manufacture since 1926.

The Nikon F was manufactured to a high standard: the eye-level viewfinder gave a 100 percent view. The camera came with a range of accessories, including a 4-frames-per-second motor drive, and it was immediately available with lenses from 21 mm to 500 mm. The Nikkor lenses, in particular, were recognized as being of exceptional quality.

The original camera featured a simple eye-level pentaprism viewfinder, which, from 1962, could be replaced with a Photomic finder; this incorporated an exposure meter that linked to the camera's shutter-speed dial and the lens aperture ring. This was not a true through-the-lens (TTL) meter, as the light was measured through the finder. The Photomic T (1965) changed this and the 1968 Photomic FTn gave 60 percent center-weight TTL metering, which became the standard for Nikon cameras until the rise of the digital camera.

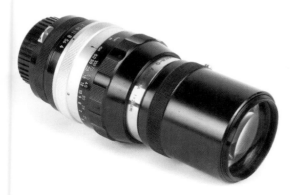

ADVANCED TECHNOLOGY

The Nikon F included a number of important firsts. It was the first Japanese SLR to come with a full range of lenses and accessories — a System — from its introduction. It was also the first SLR that could have an electric motor winder attached to it, offering up to 4 frames per second. The shutter curtain was made of titanium foil rather than the traditional cloth. It had a 100 percent viewfinder and it was the first Japanese SLR with interchangeable focusing screens, both of which made it particularly useful for the professional photographer.

LENS LEGACY

A defining feature of Nikon's subsequent camera designs, which few other manufacturers attempted, was to ensure that all Nikkor lenses had an identical mount. The Nikon F introduced a three-claw bayonet mount so that lenses would fit subsequent models — a principle that continues to the present day. A Nikkor lens for the original Nikon F will still fit a modern Nikon digital camera. Accessories such as a 250-exposure back made the camera suitable for more specialized uses in industry and by the military.

BUILT TO LAST

The Nikon F was very robust, with a metal body. The mechanics of the shutter and film advance quickly gained a reputation for reliability; in the United States it became known as "the hockey puck." The excellent Nikkor optics ensured that the camera found favor with photojournalists covering the Vietnam War. David Duncan Douglas (who was presented with the 200,000th Nikon F in 1965 in recognition of his support), W. Eugene Smith and Alfred Eisenstaedt all used the Nikon F. Don McCullin's Nikon F took a direct hit from a sniper's AK-47 bullet in Cambodia in 1970 and saved his life. The Nikon F and Nikkor lenses were standard equipment at *National Geographic* and at *Life* magazine from 1960, where almost every photographer was a Nikon user. Bert Stern shot Marilyn Monroe with a Nikon F in 1962 just before her death; Terence Donovan and David Bailey through the 1960s, among many others, also favored the camera. Elsewhere, it was used on the NASA space program with a 250-exposure back to record the launches of the Mercury, Gemini and Apollo space programs; one Nikon FTn was even taken on *Apollo 15* to the moon. The partnership continues, with Nikon digital cameras being used on NASA's current programs.

The Nikon F reinforced its reputation and established itself as a modern design icon through its starring roles in films such as *Blow-Up*, with David Hemmings as a fashion photographer in London; *Apocalypse Now*, with Dennis Hopper as a photojournalist; and, later, with Clint Eastwood as a *National Geographic* photographer in *The Bridges of Madison County*.

Hugely popular, between 1959 and May 1974, when production ended, 862,600 Nikon F cameras had been made, with only minor mechanical changes improving the original design until the Nikon F2 was launched in 1971. The Nikon F was widely adopted by professional photographers, especially in the United States, and it is a testament to the camera's manufacturing quality and reputation that many are still in regular use today.

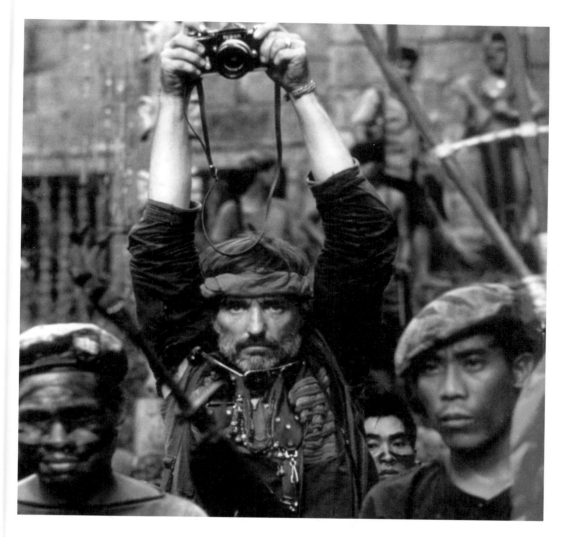

The Nikon F was less well known in Europe, other than to those photographers who had been covering the Asian conflicts. The introduction of the Nikon F2, which was widely marketed and sold well, changed this. The F2 and subsequent Nikon film camera models continued to enhance the company's reputation for quality and design and were seen as the standard professional camera throughout the 1970s and 1980s. The "F" designation continued to be used up until the F6, which was introduced in 2004.

From the 1990s camera design increasingly used printed circuits and from the 2000s, digital technology. Nikon's D1 — "D" for digital — camera was introduced in 1999 to compete with Canon's EOS digital range, which edged ahead in popularity. Practically, there is little to distinguish the two product series beyond personal preference and photographers tend to fall evenly between the two camps.

DON McCULLIN

Don McCullin would prefer to be known as a photographer rather than a war photographer, but the subject of conflict has breathed life and death into his work since the first of his photographs was published in 1959. Raised in a rough North London neighborhood, McCullin never set out to be a photographer, but after returning from National Service in the RAF with a Rolleicord, he submitted images of a notorious gang he hung around with to The Observer newspaper, which published them. He went on to work for the The Sunday Times magazine covering conflict zones for 18 years. He was the first photojournalist to be awarded a CBE, in 1993, and continues to be regarded as one of the best photojournalists of the 20th century.

His work has a strong leaning toward highlighting the victims of atrocities: the weak, the grieving, the defeated, the dying. One of his most famous images shows a Turkish woman who has just learned the news of her husband's death in Cyprus in 1964. She wrings her hands while her son looks on in tears. "In my photography I always lean towards the underprivileged because that's where I came from," McCullin told the Financial Times in 2013. "When I went to the wars I attempted to go and stand by those who were being trodden on."

McCullin has been shot at by the Khmer Rouge, thrown in jail in Uganda, and broken his arm in five places jumping from a roof in El Salvador. He admits to running out in front of firing guns to get the photograph he wanted and thinking he could outrun bullets. The results are unforgettable. "I try to bring into my photography energy and power," said McCullin, who came out of war-reporting retirement to visit Syria for five days in 2012. "I want it to talk to you. I don't want you to say, 'Oh, that's nice' and move on."

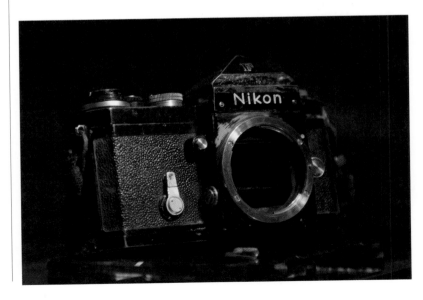

RIGHT Thanks to its robustness and reliability, the Nikon F was very popular with photo-journalists. For Don McCullin (b. 1935), the metal body of "the hockey puck" was even solid enough to stop a sniper's bullet. The damage caused when the bullet hit is clearly seen on the camera.

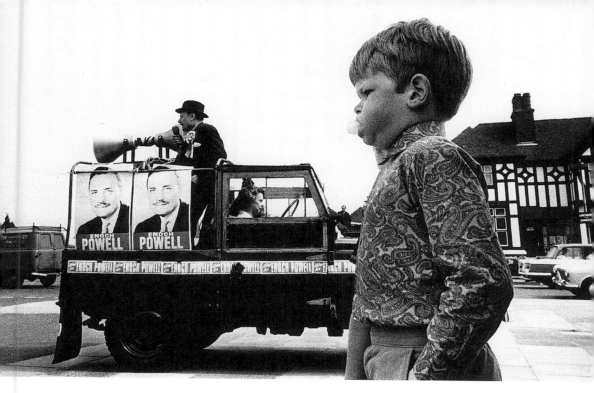

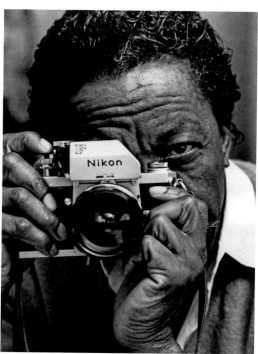

ABOVE Controversial
British conservative
politician Enoch Powell
campaigning during the
1970 general election.
Taken for *The Observer* by
Paul Hill, using a Nikon F
with a 28 mm Nikkor lens.

LEFT Gordon Parks
pictured with his Nikon F,
by Bruce Davidson, 1970.

The Topcon RE Super

PRODUCED: **1963–1971** | COUNTRY: **Japan** | MANUFACTURER: **Tokyo Kogaku KK**

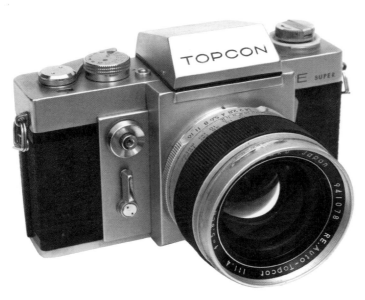

ABOVE **The first camera to feature full through-the-lens (TTL) light metering.**

DURING the 1950s camera manufacturers were paying increasing attention to automated picture taking. Attempts had been made to automate camera focusing through mechanical methods, with limited effect; it was not until the 1980s that this was achieved, using sonar and infrared. Automatic wind-on of film was achieved in the early 20th century using clockwork motors. The fail-safe loading of film came about through drop-in film cartridges at the same time, although it was not until the 126 and 110 Instamatic cartridges of 1963 and 1972, and later the APS cartridge, that they saw widespread use. This left exposure. A number of cameras had extinction light meters and, later, electric-cell light meters added to them; these needed to be manually set on the camera. The short-lived 1939 Kodak Super Six-20 camera (see page 124) had a mechanical linkage from the light meter to the camera's aperture control.

After the Second World War, the photoelectric light meter grew in popularity, with the American-made Weston meter and West German Gossen Sixtomat being particularly popular. By the 1950s, thanks to new methods of manufacturing and the introduction of photocells with greater outputs than previously, it was possible to reduce the size of the meter dramatically. They could be fitted onto the accessory shoe of a camera or built into the camera body. The postwar Contax IIIa continued to host a

built-in meter, but compared with its prewar predecessor the camera was smaller and the meter far less obtrusive. By 1956, there were at least 12 cameras with built-in meters on the market. Manufacturers began to seek ways to link these meters directly to the camera shutter or aperture, most frequently using a matched-needle system. This required the photographer to move a pointer so that it matched the light-measuring needle. The pointer mechanism then set the aperture on the camera.

A TECHNOLOGICAL FIRST

The ground-breaking Topcon RE Super was introduced by Tokyo Kogaku KK in 1963. It featured through-the-lens (TTL) exposure metering, measuring the light at full aperture so that the photographer did not have to set the aperture first and then look through a darkened viewfinder. The light cells were set behind the lens, in contrast to the Nikon F camera, which, since 1962, had used a Photomic head mounted on top of the camera to measure light, resulting in a bulky add-on to the camera. Tokyo Kogaku KK had designed the meter in a joint effort with Toshiba Electric, which was a major shareholder in the company. The Topcon RE Super was supported by a choice of good-quality lenses and accessories, making it suitable for professional and industrial use. The Super D camera, as the Topcon RE Super was known in the United States, was also adopted as an official camera of the United States Navy.

TTL metering enabled improved exposure accuracy, especially for close-up macro photography using bellows or extension rings, and in telephotography with long lenses. The full-aperture meter was innovative, at a time when many cameras from other manufacturers could only achieve stop-down metering. To realize this, Topcon RE lenses had an aperture simulator that relayed the preset aperture to the exposure meter at full aperture. This allowed the retention of a bright viewfinder image while determining the correct exposure. The meter also worked independently of the pentaprism finder and therefore allowed for different viewfinder configurations.

To achieve these, the light meter cell was incorporated into the camera's reflex finder mirror behind narrow slits in the mirror surface. The slits let a limited amount of light through to the cadmium sulphide (CdS) cell just behind the mirror. CdS cells had only been introduced in the late 1950s and made use of the fact that the electrical resistance of CdS falls when it is exposed to light. They required a small battery, but the cells were significantly smaller than the selenium versions and far more sensitive, making them ideally suited for use within cameras.

The Topcon RE Super remained in production until 1971. By then, most other SLR manufacturers had introduced TTL metering into their 35mm cameras and, for some manufacturers, into their professional medium-format cameras. Although the Topcon RE Super's metering system was overshadowed by the Pentax Spotmatic camera (see page 172), the camera was successful. It was an important technological first, removing from the photographer one of the common causes of failure.

38 The Kodak Instamatic

PRODUCED: **1963** | COUNTRY: **U.S.A.** | MANUFACTURER: **Eastman Kodak Company**

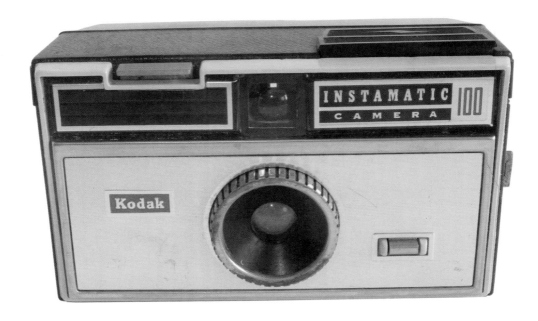

ABOVE **A camera that launched a revolutionary new film cartridge in an effort to make photography fail-safe, much as the Brownie had done in 1900, and became Kodak's most successful camera ever.**

THE Instamatic range of cameras was launched with a new drop-in cartridge film, the Kodapak cartridge, also known as the 126 cartridge, in 1963. It was designed chiefly by Dean M. Peterson (1931–2004), who was later to undertake important work on the fully automated cameras of the 1980s. The Instamatic 50 appeared in the UK in February 1963, followed about a month later by the first U.S. model, the 100.

A range of further models followed, all using the same cartridge. In March came models 300, 400 and 700. Each camera had a plastic-molded body with the basic controls of shutter-release button and film advance set into the top. They had provision for flash photography and the later models had automatic exposure. The model 400 had a low-light indicator in the viewfinder window and clockwork film advance. Unlike the traditional box cameras, many of which had been updated and restyled during the 1950s using plastic injection-molded bodies, the Instamatic range of cameras was compact. The Kodapak used a 1⅜ inch (35 mm) wide film producing 1⅛ × 1⅛ inch (28 × 28 mm) negatives; the roll films used in box cameras were at least twice the size.

OPERATION EASY LOAD

The idea of a drop-in cartridge was not a new one; there were cameras that used them dating from the 1890s and early 20th century, including the popular Ticka camera (see page 66). Roll film was more popular and Kodak's range of cameras from the mid-1890s successfully made use of it. Yet roll film was not without problems and amateurs frequently experienced difficulty loading films correctly, resulting in blank films. The 1950s saw a boom in camera sales and amateur picture taking was increasingly moving to color photography. Due to competition from Japan, with its high-quality 35 mm film cameras, Eastman Kodak turned its attention to securing the amateur market. In the late 1950s Kodak initiated its "Project 13," code-named "Easy Load," to design a camera system — both camera and film — that would, in effect, be a 35 mm general purpose camera that was simple to use and capable of producing good results. This was completed in 1961.

ABOVE **The Kodak 126 Cartridge.**

Kodak had previously used the 126 film designation for a roll-film format introduced in 1906 and withdrawn in 1949. For the cartridge, the 126 designation indicated that the negative was 1 inch (26 mm) square, using Eastman Kodak's common 1xx film numbering system. The negative area was actually $1\frac{1}{8} \times 1\frac{1}{8}$ inches (28 × 28 mm), but was usually reduced to approximately $1\frac{1}{16} \times 1\frac{1}{16}$ inches (26.5 × 26.5 mm) by masking during printing or mounting as slides.

The camera and cartridge both made use of postwar plastic injection-molding techniques. The cartridge simply dropped into the back of the camera and would only fit one way. The cartridge design formed a light-tight seal between the camera and itself. New fine-grain and faster film emulsions allowed the smaller negative size to be enlarged without any noticeable loss of quality and the cartridge eliminated all the handling problems associated with traditional roll film. On top of this, the plastic camera bodies and high-quality acrylic lenses could be mass-produced.

LOAD IT, YOU'LL LOVE IT

The introduction of the Instamatic was marked by an extensive print and television advertisement campaign that highlighted the benefits of the camera. The advertisements portrayed, and were mainly targeted at, younger people. They featured color photographs and highlighted the camera's major selling point — the ease of loading: "People used to hate to load their camera … Just drop in the film and shoot … Load it, you'll love it."

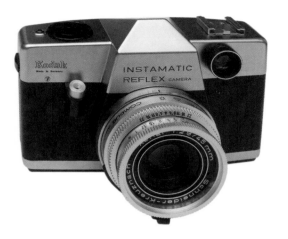 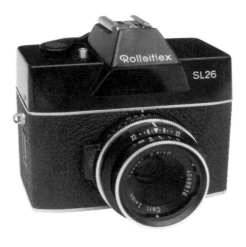

PHOTOGRAPHY SIMPLIFIED

The Instamatic was phenomenally successful and by 1970 at least 50 million had been sold. It replaced in a stroke the traditional box camera, which had not evolved significantly since the introduction of the original Kodak in 1888 and the Brownie in 1900. The success of the Instamatic had similar effects to that of the Brownie camera: photography was simplified and cameras became smaller and easier to use, with the resulting pictures less formal and more immediate.

Kodak's camera range expanded to models that included automatic exposure. The aluminum-bodied Instamatic 800/804 boasted a rangefinder and a selenium light meter; film advance was automatic, powered by clockwork. At the top of the range, the German-made Instamatic Reflex SLR could accept a range of lenses designed for the upmarket Kodak Retina series. Kodak licensed other manufacturers to produce cameras taking 126 cartridges, including Agfa, Bell and Howell, Canon, Olympus, Minolta, Ricoh, Rollei and Zeiss Ikon, many of which offered more features — at a higher price — than the Instamatic range. The Rollei SL26, for example, featured interchangeable lenses, through-the-lens metering and a rangefinder; it cost $300 (£176 9s 6d) (around $3,435/£2,200 today). Although it was the most expensive camera made for the format, some 28,570 units were made between 1968 and 1973.

In 1970 the Instamatic series was revised to accomodate a new flash technology. Unlike the old AG flash bulbs or flash cubes, the new Magicube used a mechanically triggered detonator, which eliminated the need for a battery. Instamatics with provision for the Magicube had an "X" in their model designation.

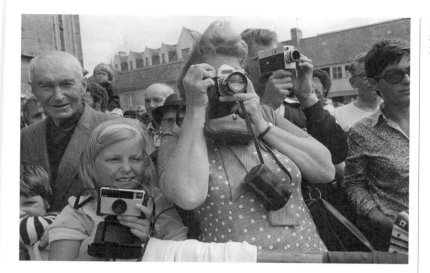

The 126 cartridge had been extremely successful, and the Instamatics were Kodak's most successful camera range, with an estimated 70 million sold, perhaps 100 million in total from all its manufacturers. They were replaced by the Pocket Instamatic range in 1972. On December 31, 1999, Eastman Kodak Company discontinued the manufacture of the 126 cartridge, which by that time was only being made in Gold color negative format. The company explained that "sales of film in this format have declined at a rate of 30 per cent annually for some time. Far less than one per cent of our film sales are in the 126 format." The last remaining company still making the film, Ferrania, ended production in 2007 and few photofinishers are in a position to process it.

The lead designer for the Instamatic program, Dean Peterson, left Eastman Kodak Company in 1968 and made important contributions elsewhere, including for Honeywell, and for Nimslo on its 3-D camera. His work on the Instamatic was recognized in 1975 when he received a fellowship from the Society for Imaging Science and Technology for outstanding achievements in imaging science and engineering.

A PERSONAL MOMENT

One of the American photographer Annie Leibovitz's best-known portraits is of a naked John Lennon and Yoko Ono curled up against each other, taken just hours before Lennon's assassination. One of the photographs she made at the session appeared on the front cover of *Rolling Stone* magazine in January 1971. What is less known is that Leibovitz photographed Lennon with his own Kodak Instamatic camera in New York in 1970.

39　The Pentax Spotmatic

PRODUCED: **1964** | COUNTRY: **Japan** | MANUFACTURER: **Asahi Optical Company**

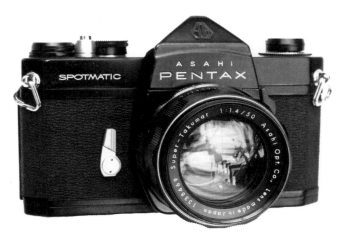

ABOVE **Pentax Spotmatic
camera with an f/1.4 50
mm lens.**

THE Nikon F camera of 1959 (see page 160) was a hugely influential piece
of technology and in many ways set the course of camera design for the
next 40 years. The one area in which it did not lead was in the incorporation
of through-the-lens (TTL) metering. In this respect, both the Topcon RE Super
(1963, see page 166) and the Asahi Optical Company's Pentax Spotmatic
camera (1964) were the innovators.

The Asahi Optical Company (AOC) had been established in 1919 as a
lens and optical manufacturer. After the Second World War, it resumed the
manufacture of binoculars. With the encouragement of occupying forces,
it began to diversify its production with the introduction of photographic
equipment. The AOC differentiated itself from its competitors by designing
a 35 mm reflex camera rather than copying traditional rangefinder cameras.

The first camera designed and made by the AOC was the Asahiflex,
which it introduced in 1952. The camera was partly based on the prewar
German Praktiflex. In 1954 the company introduced the Asahiflex IIb,
which had an instant-return mirror so that the photographer lost the
subject in the viewfinder for only a fraction of a second while the exposure
was being made. This was a considerable innovation and one that Nikon
was quick to incorporate in the Nikon F.

The Asahiflex developed into the Asahi Pentax camera, which was
promoted from late 1957 with magazine advertisements just showing
the camera's back; it was introduced in 1958. The camera was a completely
new design and incorporated a pentaprism for right-way-around viewing.
Like the Nikon F, the shape and design were not to change for the next
40 years. New models developed the design until the introduction of the
Pentax Spotmatic in 1964.

CREATING THE COMPUTER CAMERA

The prototype of the Pentax Spotmatic was shown at Photokina in 1960. For the first time, the built-in photoelectric cell was not directed at the subject, but at the ground-glass focusing screen, providing very accurate metering. The principal advantage it offered was that changing a lens or adding extension tubes or filters would not require any adjustment as it was only the light entering the camera that was being measured. The CdS cell was accurate and quick. Turning the prototype into a commercial product took longer than envisaged and it was not until the end of 1964 that the Pentax Spotmatic was shown to the press. Preproduction models were made available to a number of photographers at the Tokyo Olympics, which were taking place the same year, and the camera was presented to the public at New York IPEX in 1965. The metering was slightly problematic and comprised two fixed photoelectric cells on either side of the pentaprism. It worked with the aperture stopped down, activated when a switch was pressed, powered by a small battery. This method of discontinuous metering was subsequently improved.

The camera body was smooth and sleek, with minimal clutter, and made use of Asahi Optical Company Takumar screw-mounting lenses. Some 16 lenses were available for the Spotmatic, ranging from the wide-angle 17 mm to a 1,000 mm telephoto. A wide range of accessories was also made. The introduction of the Electro Spotmatic series in 1971 brought more extensive use of electronics to the camera; in particular, the automatic setting of the camera shutter based on the aperture and film speed set. Automatic aperture-priority exposure was a novelty.

By 1971, the Asahi Optical Company was claiming the camera as "the world's best selling," and advertised it as "The Computer Camera," because it included electronics that controlled the exposure.

BELOW **The Pentax S camera was introduced in 1958. Along with a family of other models, it was a precursor to the Spotmatic camera of 1964.**

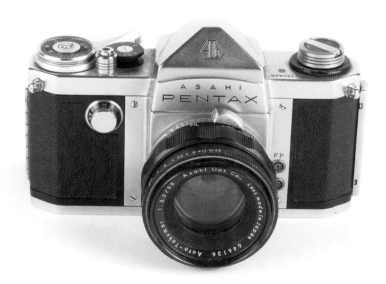

SLR SUCCESS STORY

In mid-1975, the Asahi Optical Company abandoned the screw-mount lenses that had achieved such a good reputation and introduced a bayonet-fit lens. During its production the Pentax Spotmatic was one of the biggest successes in the history of 35 mm single-lens reflex(SLR) camera production, with some 4 million cameras manufactured.

Sebastião Salgado, the social documentary photographer, got his first camera in 1970, and it was a Pentax Spotmatic. His wife Lélia bought the camera for him, with a 50 mm lens. Salgado recalled: "It was the first time I had looked inside a camera; for me, it was incredible." The couple bought 35 mm and 200 mm lenses and he quickly taught himself how to take pictures. The camera accompanied him on his first African trip and he soon decided to abandon a career as an economist and become a photographer. He moved on to other models of camera, especially the Leica. Salgado established himself as a photojournalist and "concerned" documentary photographer, producing in-depth bodies of work on subjects including the gold mines of Brazil, migrant workers around the world and coffee-plantation workers. A recent project, *Genesis*, shot digitally, consists of a series of photographs of landscapes and wildlife, and human communities that continue to live in accordance with their traditions and cultures.

Other photographers quickly picked up the Spotmatic. The society portrait photographer Cecil Beaton used it to take pictures in Andy Warhol's studio The Factory in New York in 1969. The camera's reputation for durability has meant that many well known photographers started with a second-hand Pentax Spotmatic. The portrait photographer Alastair Thain's first camera was a Pentax Spotmatic, as it was for contemporary photographer Nadav Kandar. It was also seen in the hands of celebrities with an interest in photography, including members of The Beatles (as pictured opposite).

DOING THE JOB WITH EASE

An IBM engineer who developed timing systems for the 1964 Winter Olympics named Fred Springer-Miller handled the camera while attending the Tokyo summer games. In his review of the camera, which appeared the following year, he noted: "For me the most important item was a trim and compact Pentax Spotmatic which I tried out at the athletic events ... Using the Spotmatic I could compose, shoot and, when necessary, meter in one smooth operation without ever having to look away from my picture ... Working with the Spotmatic during the Olympics was both fun and challenging ... And for me, the Spotmatic helped to do the job with ease."

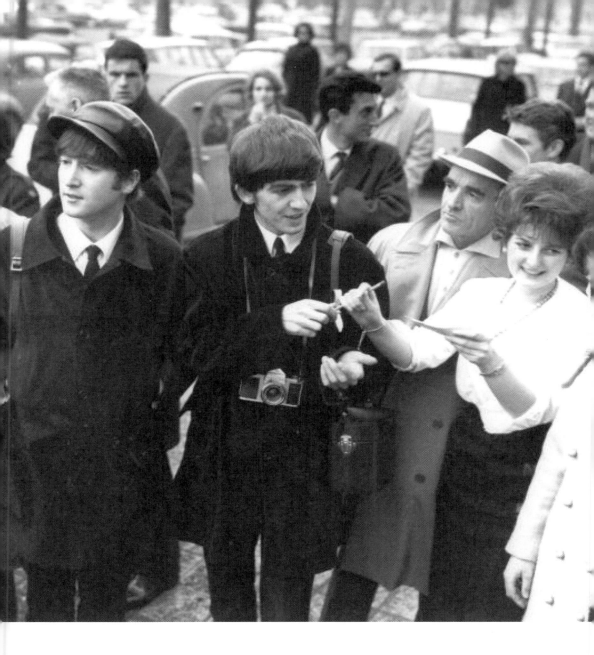

ABOVE **Beatles John Lennon and George Harrison, who carries an Asahi Pentax S-series camera, sign autographs in the Champs-Élysées during a visit to Paris, January 1964.**

40 The Olympus OM-1

PRODUCED: **1972** | COUNTRY: **Japan** | MANUFACTURER: **Olympus Optical Co., Ltd.**

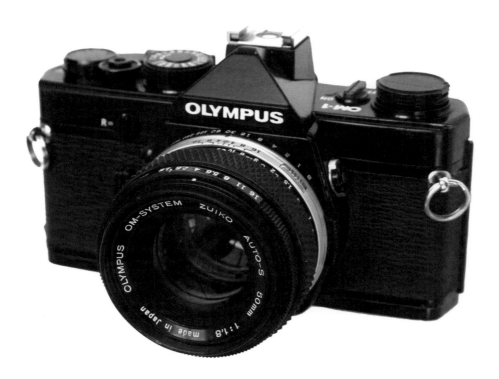

ABOVE **The camera that started the trend for full-featured compact SLR cameras.**

BY THE early 1970s, the 35 mm single-lens reflex (SLR) camera was widely accepted as the standard general-purpose camera for serious, experienced photographers. Any detractors of 35 mm film had by then accepted its convenience and quality. For many applications the SLR was the default camera for professionals, particularly for reportage and journalism, as well as for amateurs. Medium- and large-format cameras continued to remain popular for advertising, product and fine-art photography.

The typical 35 mm SLR cameras, such as the Nikon F, Canon F, Leitz's Leicaflex and the Zeiss Ikon Contarex ranges, were heavy and relatively bulky. Although there were smaller models such as the Pentax and Minolta ranges, they did not have the wide popular following of the major brands. The Olympus OM-1, originally called the M-1, which was presented at Photokina in Cologne in 1972, changed that.

TOWARD A COMPACT SLR

The OM-1 camera was designed by a team led by Yoshihisa Maitani. Born in 1933, he had an early interest in photography and, after studying mechanical engineering at university, he joined Olympus Optical Co., Ltd. in 1956. Maitani was involved in the development of many cameras that became landmarks, including the half-frame Olympus Pen camera (1959), the Pen F (1963), the OM-1 (1972) and, later, the compact XA (1979).

The commercial success of the half-frame Pen camera (which produced negatives of $^{15}/_{16}$ × $^{11}/_{16}$ inches/24 × 18 mm — half the usual size, meaning twice as many could be made on a standard 35mm film) had convinced Olympus that there was a market for a compact 35mm SLR. Olympus had already developed a 35 mm SLR when the Pen boom was at its height — it had completed research and design and was close to starting production. But it clashed with the Pen F project, on which the company opted to concentrate in order to capitalize on its reputation as a manufacturer of half-frame cameras. As Maitani noted: "I realised that the real reason why I couldn't get enthusiastic about conventional SLRs was the problem of their weight and size. This is a major difference of 35 mm SLR cameras compared with the Leica. The half-size camera that I made was also the result of my efforts to create a smaller camera." Maitani also resolved to "make a camera that would give Olympus the opportunity to display all of its products, including endoscopes and microscopes. In short, I was going to create a full-featured system SLR."

Despite the resistance of the sales department, which did not believe a compact full-frame 35 mm SLR would be viable, in December 1967 Maitani was given the go-ahead to create the new camera. He completely rethought the mechanics of the camera in order to fit everything into a small size. A prototype called the MDN was displayed at an Olympus camera show, with the aim of prompting people to think about what made a full-featured system SLR.

ABOVE **Olympus advertising brochure for the OM range of cameras, c.1974.**

OPTICAL EXPERTS

Olympus Optical Co., Ltd. dates back to 1919 and initially specialized in microscopes. It started making 2¼ × 2¼ inch (60 × 60 mm) format cameras in 1936, but it was not until 1948 that it made a 35 mm Leica-copy camera. In addition to still photography products, Olympus' range included motion-picture cameras and many other kinds of optical equipment, such as laser measuring devices. They also made tape recorders. In fact, cameras constituted only half the firm's manufacturing output. Olympus continues to be a major player in the development of medical optical instruments such as endoscopes.

In the meantime, in 1971 Olympus launched the Olympus FTL, which was aimed at overseas markets for the first time. It was an SLR with a 42 mm Praktica lens mount. Six lenses were available, ranging from 28 mm to 200 mm. The FTL was not a success and remained available for a very short time. It was overtaken by the introduction of the OM-1 the following year, but it represented an important transition between Olympus' half-frame range of cameras and the OM-1.

The M-1, later renamed the OM-1 after Leica complained that the original designation was too close to its own M-series name, appeared at Photokina in 1972. Of the original M-1 designation, 5,000 cameras were made. The factory had the capacity to produce about 60,000–70,000 cameras per month and the production camera was the fully specified 35 mm SLR that Maitani had envisaged. Accompanied by a range of 30 Olympus Zuiko lenses and 286 accessories that would make it compatible with Olympus microscopes, endoscopes and other optical equipment, it quickly found a market. Olympus' advertising emphasized the bright viewfinder and the quality of the lenses, quoting A.L.M. Sowerby, a former editor of *Amateur Photographer* magazine: "The Olympus OM1 is fitted with probably the best lens I have ever tested." It was priced at £215 (around $4,060 today) with an f/1.8 50 mm lens.

RIGHT **An advertisement for the Olympus OM-1 that emphasized the quiet shutter mechanism.**

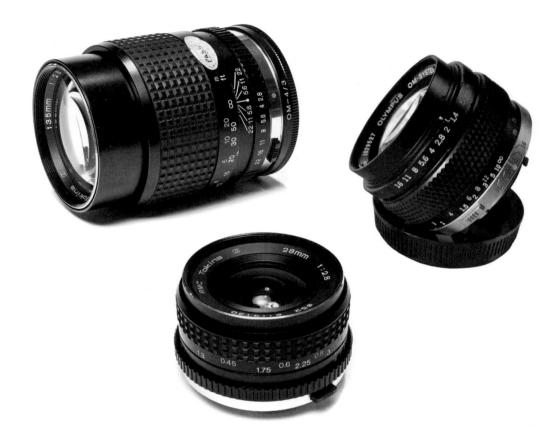

ABOVE **Olympus
OM-series lenses.**

A SERIOUS CAMERA

In Britain, Olympus Camera initiated an advertising campaign to promote
the OM-1 as a serious new camera and worked with photographers such
as Patrick Lichfield, Duffy, David Bailey, Terence Donovan and Don McCullin
— all of whom maintained a long relationship with Olympus — to
showcase the OM-1's capabilities. Photographer Barry Lategan's affiliation
with Olympus cameras stemmed from an early association with his
contemporaries working with Olympus and he noted: "Olympus cameras
have been the tools of my trade since the 1970s." The actor Peter Sellers,
who was also an accomplished photographer, appeared in advertising
alongside pictures he had taken and was quoted as saying: "I reckon it's
the best camera I have ever owned."

An early user of the Olympus OM-1 was the photojournalist Don
McCullin. Olympus arranged an event for photographers on the Côte
d'Azur, to which McCullin was invited, and when he eventually arrived,
late, he told Maitani that he had been able to capture his amazing battlefield
photographs in Vietnam and various other war zones because his camera
was lightweight. Maitani explained: "He wanted to thank us for that. My
eyes filled with tears when he told us that the OM SLRs had lifted a weight
from the shoulders of photographers everywhere.

DENNIS STOCK

A 1955 issue of Life magazine featured a photo story about an up-and-coming young actor by the name of James Dean. He was pictured in New York, shoulders hunched, cigarette in mouth, his large overcoat protecting him from a rainy Times Square, and then in his hometown of Fairmount, Indiana. The trip home was to be Dean's last — he died in a car crash a year later. The photographer behind the story was New Yorker Dennis Stock (1928–2010), who met the actor in Los Angeles at the home of Rebel Without a Cause director Nicholas Ray in 1954.

"I liked him sometimes, but not all the time," Stock said of James Dean in a 2005 interview with the Sarasota Herald-Tribune. "But he was like family after a while. We really bonded in Indiana. Not in New York, where he was distracted a lot. He was an insomniac and didn't get a lot of sleep and was a pain in the ass to work with." The story

of those days spent together has been made into a 2014 film titled Life. Prior to photographing celebrities, Stock had served in the United States Army and then was an apprentice to Albanian-American photographer Gjon Mili. He had been one of 10 winners of Life magazine's $15,000 contest for young photographers for a picture essay in 1951 — among the other winners were Robert Frank, Elliott Erwitt and Ruth Orkin — which led to his becoming an associate and then full member of the Magnum photo agency.

As time passed Stock's photographic interests turned to the environment, in a move that he said was not an easy one to make. His photography concentrated on the natural landscape and he shot almost exclusively in color, referring to himself as a "color essayist." He produced a series of books of his color work. Two of these, New England Memories and Provence Memories, were shot in Kodachrome using Olympus OM-1 and OM-4 bodies.

He really understood the significance of our efforts to create compact, lightweight cameras."

David Bailey, too, used his Olympus cameras and Zuiko lenses for commercial work and he later appeared in a series of television advertisements for the compact Olympus Trip camera that ended with the now classic line: "David Bailey, who's he?" Bailey himself noted: "I have favourite cameras: the twin lens Rollei 2.8, the Olympus OM-1 and the Leica M7. Those are cameras I like to use." Bailey later returned to promote Olympus' more recent digital offerings.

The Olympus OM-1 was produced until 1979. New models were introduced throughout the 1970s including the OM-2 in 1976, the OM-10 in 1978, and the OM-1N and OM-2N, both in 1979. These all added additional features to the camera body without affecting the overall concept. Further models appeared throughout the 1980s, including the OM-4Ti in 1986.

The OM range of cameras, with its supporting array of lenses, found a ready market with professionals needing a quality 35 mm SLR, as well as with serious amateur photographers. It also made other manufacturers rethink their own camera ranges and during the 1970s, Canon, Nikon and other Japanese companies introduced smaller and lighter models in addition to their standard professional cameras. Like the OM series, these were intended to overcome the three problems of size, weight and shutter noise or shock.

In 2003 Olympus Optical Co., Ltd. announced the discontinuation of the OM-3Ti and OM-4 Ti BLACK bodies (the only models still in production at that time). However, the company would continue to make and sell OM System lenses and accessories until the end of March 2003. Nearly 30 years after the basic designs were completed, Olympus claimed that it was struggling to source parts for the camera system. Yet the imaging technologies developed for the OM System would continue to be utilized in new forms by the company, in the development of new imaging and photographic products. The OM-1 had acted as catalyst for a change in camera design.

41　The Pocket Instamatic

PRODUCED: **1972** | COUNTRY: **U.S.A.** | MANUFACTURER: **Eastman Kodak Company**

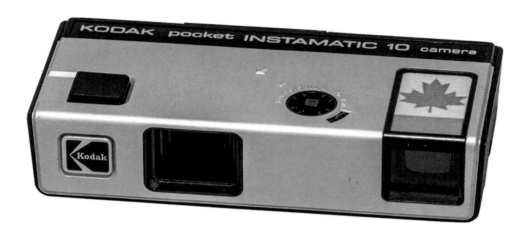

ABOVE **Kodak Pocket
Instamatic 10, made
between May 1973 and
September 1976. This
example shows a Canadian
flag; one of various special-
edition models released.**

EASTMAN Kodak Company's 126 Kodapak cartridge of 1963 had shown
the commercial potential of a simple drop-in, foolproof method of
loading a camera. With the development of finer-grained films, new film
manufacturing methods and processing technology, the company saw an
opportunity to refine the 126 cartridge into something even smaller and,
at the same time, to attract a younger market for its products.

POINT AND SHOOT

In 1972 it introduced the 110 cartridge, which made use of 16 mm film,
similar to that used in movie cameras, but with a single registration perforation.
The negative size was ½ × ¹¹/₁₆ inches (13 x 17 mm) and it was initially available
in 100 ASA. A more sensitive 400 ASA film was introduced later, which
allowed faster shutter speeds to be used, reducing the impact of camera shake.

A whole new range of cameras that used the 110 cartridge was launched.
The cameras were all small, reflecting the size of the 110 cartridge, which also
gave rise to the "Pocket" designation. Most of the cameras were little more
than box cameras, with few controls, and were intended to be point-and-
shoot devices. However, the Pocket Instamatic 60, at the top of the range,
featured automatic exposure and a rangefinder built into a tough stainless-
steel body. In 1978, a new range of 110 cartridge cameras called the Ektra
was introduced, which incorporated a sensing device that "read" the notches
on the cartridge and adjusted the camera for either the 100 or 400 film
speed, further reducing any margin for user error.

AN ADVANCED PHOTO SYSTEM

The 110 cartridge had shown the potential of increasing automation. In 1996 a new film format, the Advanced Photo System (APS), was introduced. It was jointly developed by Canon, Eastman Kodak, Fuji, Minolta and Nikon. The film cartridge was 30 percent smaller than conventional 35 mm cassettes and also more compact than the 110 cartridge, which had chambers for the exposed and unexposed film. The APS cassettes rewound the exposed film back into the cassette. Information could be recorded on a magnetic strip on the film, which special APS minilab processing units could read. APS permitted photographs to be taken in different formats, notably a panoramic format, on the same film. In addition to Eastman Kodak's Advantix film, compatible films were made by Fuji (Nexia), AgfaPhoto (Futura) and Konica (Centuria).

The cassette's small size allowed smaller cameras to be made, the Canon Ixus being one of the most successful. The Ixus kick-started interest in the new APS format, which strove to compete with 35 mm in terms of print quality. By early 1997, the Ixus represented 19 percent of all APS cameras sold. Sales were reported at over half a million and production was running at 60,000 a month, with Canon planning to open a third factory in Asia.

The Advanced Photo System was an attempt to improve photographic technology for amateurs, but it failed to enjoy the phenomenal success of the 126 or 110 cartridges. The impact of digital photography began to make rapid advances and quickly overtook the APS format. In the face of the digital competition it was ultimately short-lived, with several of the founding companies, including Eastman Kodak, discontinuing APS camera manufacture by 2004. Both Fuji and Kodak, the last two manufacturers of APS film, discontinued production in 2011.

A POCKETFUL OF MEMORIES

More than 25 million Pocket Instamatics were produced in under three years and the 110 format remained popular well into the 1990s. For many people, the Pocket Instamatic camera was their first introduction to photography.

Kodak print wallets holding the distinctive small color photographs were produced in tens of millions, showing summer holidays, birthdays and Christmas gatherings. They remain today as faded color prints.

PRODUCED: **1972** | COUNTRY: **U.S.A.** | MANUFACTURER: **Polaroid Corporation**

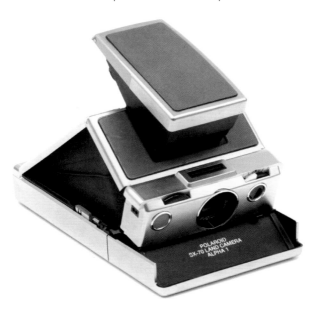

ABOVE **A stylish new instant-picture camera that was adopted by well known artists as a creative means of expression.**

INSTANT photography had been invented by Dr Edwin Land in 1943 and commercialized in 1948 with the first Polaroid camera, the Model 95 (see page 142). With the introduction of film packs and new chemistry, the Polaroid camera began to resurface in the 1960s.

The first of a low-priced series of Polaroid Land cameras, the Swinger went on general sale in 1966, after a prelaunch trial in the United States the previous year. The Swinger was sold for $19.95 ($140 today) — the first Polaroid to sell for under $50 — and this made it very popular, both as a direct purchase and as a gift. The name, with its connotations of fun, ensured the camera was popular among young people, in contrast to the previous Polaroid models, which had appealed to an older demographic. It was stylish, with a contemporary design in white molded plastic. The camera was also sold by a television advertisement complete with a catchy jingle, "Meet the Swinger," sung by Barry Manilow and featuring a young Ali MacGraw, who went on to have a successful film and television career. The Swinger featured an extinction exposure meter coupled to the aperture that showed the word "YES" in a window below the viewfinder when the exposure was set correctly. During the first three years of production the Swinger sold around 7 million units.

The success of the Swinger range foreshadowed the introduction of the Polaroid SX-70 in 1972. Land, ever the showman and innovator, realized that he needed to bring something revolutionary to the market in the same way that he had with the original Model 95 in 1948.

THE COST OF IN-AN-INSTANT PHOTOGRAPHY

The SX-70 was the camera Land had always wanted to make, giving real one-instant photography. His vision was a slim, pocket-sized camera that the user only needed to focus and that would produce a finished color photograph with no further intervention. As Land noted: "Don't undertake a project, unless it is manifestly important and nearly impossible." Although the camera was based on existing Polaroid technology, every aspect of it was developed specifically. A new optical system gave reflex viewing and later an ultrasound focusing system was added. The camera offered automatic exposure and focusing and required special flat batteries to power the mechanism. The film pack produced 10 prints, which were ejected straight from the camera, accompanied by a distinctive motor whine, and the image developed in daylight in front of the user's eyes. The film pack itself required new chemicals and ways of controlling development that went some way to explaining the massive cost of developing the camera and film technology.

The camera was designed by the industrial designers Henry Dreyfuss and Associates, who had worked with Land on previous cameras. When the SX-70 was launched in 1972, the Polaroid camera became something that was both functional and a design classic in its own right. The SX-70 system was reputed to have cost over $750 million ($4.2 billion today) to develop and it offered instant photography to a wide audience, for the first time, with no messy peeling or subsequent chemical coating. However, at a cost of $300 ($1,700 today) it was beyond the reach of most consumers.

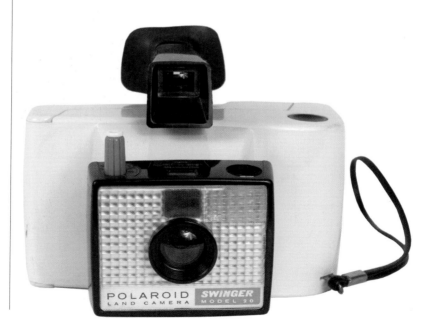

RIGHT **The Polaroid Land Swinger camera of 1966, which was designed to appeal to a younger market.**

Introduced to the public on October 26, 1972, during the first full year of production 415,000 units were made, although the company had hoped to sell 1 million. By mid-1974 it had sold 700,000 and initially the business was losing money on every camera and film pack it sold. The manufacture was beset by difficulties. The camera was complex and there were particular problems with the battery packs, which the company ultimately solved by manufacturing its own, designed by Land. However, by 1975, Land was able to announce to shareholders that "the SX-70 seems to be defying conventional marketing suppositions, as we planned that it should." The industrial designer Charles Eames was commissioned to produce a 20-minute film extolling the SX-70's scientific and humanitarian uses. The British actor Laurence Olivier agreed to do a television commercial for the camera — the first time he had done so, although he stipulated that the advertisement should not be shown in Britain. In 1974 a cheaper model was introduced and further models followed, each using the distinctive SX-70 film packs. In 1976 the company sold more than 6 million cameras. The SX-70 range of cameras was manufactured until 1981.

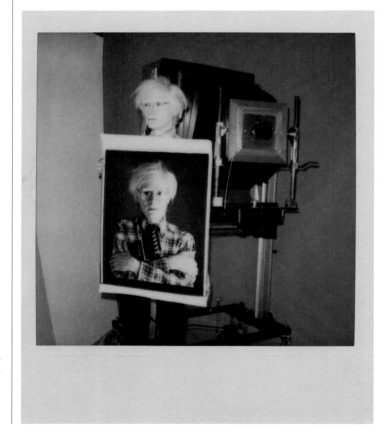

RIGHT **An SX-70 Polaroid photograph of artist Andy Warhol holding a large-format 20 × 24 inch (510 × 610 mm) Polaroid photograph of himself, standing in front of the camera used to take the large photograph, 1980.**

THE ART OF THE POLAROID

The camera attracted not only casual general users. Celebrities wanted to be seen with the futuristic clamshell design. Artists, too, were keen to use the distinctive photographs in their work. The pop artist Andy Warhol turned to Polaroid photography in the 1970s and the SX-70 was a perfect tool for him. He would frequently take up to 50 Polaroid photographs of a subject before producing a painting and a screen print. Warhol's interest in disposable celebrity culture and mass-produced art was ideally suited to the camera. He shot a vast archive of Polaroid portraits of himself, celebrities and friends, reveling in its immediacy, one time commenting: "Mr Land invented this great camera called a Polaroid. There is something about the camera that makes the person look just right. I take at least 200 pictures and then I choose. Sometimes I take half a picture and a lip from another picture. Sometimes it's hard, sometimes it's easy."

The British artist David Hockney also used the distinctive $3\frac{1}{16} \times 3\frac{1}{16}$ inch (78 × 78 mm) Polaroid image on a rectangular base to create photo-collages that he termed "joiners." Although critical of the ability of a photograph to show time, he realized that combining multiple Polaroids to form one image could add a depth that went beyond the whole. He noted: "I started making collage photographs because I realised you could make a different space, you're putting in time, and they began to be different and you got a different space. I got fascinated by that, actually, and spent a good few months just using, making complex Polaroid photographs, which are far more complex to make than they look."

Robert Mapplethorpe, the American photographer, used the Polaroid to produce explicit images that would not be able to pass through a processing lab — much as consumers had done with the early Polaroid models — but he also used them to develop his own photographic style. In the words of exhibition curator Sylvia Wolf: "This is where he learned to see photographically. The instant nature of the Polaroid is crucial. He was able to see, take a photo, then quickly adjust."

Helmut Newton, among others, elevated the SX-70 print into an art form — one that could be creatively manipulated as the image developed.

THE PHOTOGRAPHER'S MUSE

The Polaroid company also sponsored photographers and provided film stock in return for images taken with their cameras. The great American documentary photographer Walker Evans began to work with the SX-70 in 1973 and was given an unlimited supply of film by Polaroid. With the SX-70, the aging Evans returned to some of his key motifs and he claimed that "nobody should touch a Polaroid until he's over sixty," implying that only after years of work and struggle and experimentation, and developing one's judgment and vision, could the medium be pushed to its full potential. Using the SX-70, Evans stripped photography to its bare essentials: seeing and choosing. At his death in 1975 he left behind approximately 2,500 Polaroids.

After the death of his wife, photographer André Kertész allegedly found some relief from his grief when he began experimenting with a new camera — a Polaroid SX-70 given to him in 1979 by the Polaroid Corporation. It is said to have helped him beat depression from inside his New York apartment. He went on to produce a body of work using the SX-70 which was published in a book entitled *From My Window*. Many other photographers have made use of the SX-70 and its successors: Mary Ellen Mark, Lucas Samaras and Duane Michals, to name but a few.

The announcement by Polaroid in February 2008 that it would stop producing instant film for Polaroid cameras appeared to mark the end of an era that had started in 1948: without film to put in them, all Polaroid cameras would become obsolete, resigned to collectors' shelves. But it was not over just yet. In 2008, Dutch entrepreneurs Florian Kaps and André Bosman founded The Impossible Project when they bought the last factory in the world manufacturing Polaroid instant film in Enschede, the Netherlands. They also employed 10 of Polaroid's former staff, thus acquiring a wealth of expertise and knowledge about the instant-film production process. On March 22, 2010, the company announced that it would release two monochromatic films, PX100 and PX600, compatible with SX-70 and 600-type cameras. The Impossible Project estimates that there are 300 million Polaroid cameras in existence around the world: thanks to the company's efforts, their owners can continue to use them as Edwin Land intended. The company also refurbishes Polaroid cameras for resale and have created The Instant Lab, a piece of equipment that allows users to transform digital images from their iPhones into analog Polaroid prints. At the time of writing, the company was the only one in the world producing instant film for use with classic Polaroid cameras. While instant print materials are likely to remain principally a niche area used by artists and photographers solely for creative purposes, the popularity of smartphone apps such as Instagram demonstrates the enduring appeal of this distinctive photographic format.

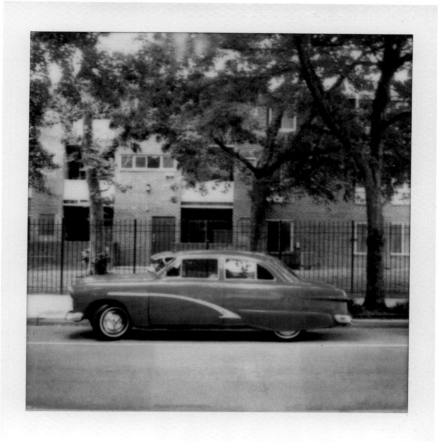

ABOVE A classic car parked
on First St NW in Truxton
Circle, Washington, DC,
Nathaniel Grann, August
19, 2013. The image was
taken with a Polaroid
SX-70 camera using The
Impossible Project PX70
Color Protection film.

43 The Konica C35 AF

PRODUCED: 1977 | COUNTRY: **Japan** |
MANUFACTURER: **Konishiroku Photo Industry Company**

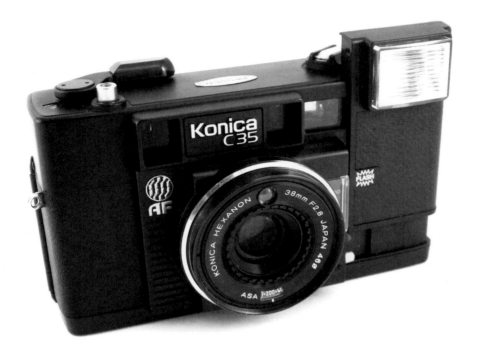

ABOVE **The Konica C35 AF camera, introduced in 1977. It is widely credited as the first autofocus compact camera.**

THE Japanese Konishiroku Photo Industry Company began life as a pharmaceutical retailer, Konishi-ya Rokubei Tenthat, which itself had origins back to 1873. It was Japan's oldest camera company until it merged with Minolta and ceased making cameras in 2006. The company introduced a range of cameras — the C35 — under the Konica name in 1968. These did much to influence the general design of what were termed "compact cameras."

Konishiroku was not the first company to make a compact camera; similar cameras included the Olympus Trip 35 (1967), which offered automatic exposure control. But with the compact C35 range it did bring together a number of features for the first time. The Konica series was innovative and was aimed at a market that wanted a camera capable of producing better results than a box camera and that used 35 mm film like single-lens reflex (SLR), but without the complexity. The slim design, simplicity and increased automation appealed to the public and the range proved extremely popular. Other manufacturers quickly brought out their

own competing models. Canon's AE-1 camera of 1976 introduced a central processing unit to the 35 mm SLR and the C35 did the same for the compact amateur camera. Many of the camera's other features, including an automatic exposure system to select the appropriate shutter speed and a built-in flash unit, were electronic.

The C35 AF was the only model with autofocus. The patented Honeywell Visitronic autofocus system was a "passive," dual-image comparator, which was linked to the lens focusing mechanism by an electromechanical system. In order to determine the focus, the passive system relied on five photo-electric sensors making a reading from the light being reflected from the subject. The difference in contrast in the subject at which the camera was pointed determined the best point of focus. By comparison, active systems relied on the camera generating a signal, such as sonar, and used that to focus the camera lens. The Konica C35 AF was the first camera to use the Honeywell system and by 1980 some 13 other cameras were making use of it. It worked reasonably well, but was less accurate in low light. The Konica C35 AF was expensive at $283 ($1,000 today) but sold well on the basis of the level of automation that it offered.

In 1979 Canon brought out the Canon 35 AF, or Sure Shot, in the United States to compete with the Konica and added further automation in the form of automatic film wind and rewind, easy loading, and an active infrared autofocus system. The Canon was the first modern auto-everything point-and-shoot 35 mm camera; it sold over 1 million units in the United States. However, if it hadn't been for the Konica C35 AF, it is unlikely that Canon would have introduced such a model in the form that it did.

The Konica C35 AF set the scene for the point-and-shoot compact camera, which became the predominant simple amateur camera design for 35 mm and APS film formats — in much the way that the box camera had been for roll film from 1900 until the 1950s. The general appearance was retained when simple digital point-and-shoot cameras were introduced in the 2000s.

For the amateur photographer, the Konica C35 AF removed the need to think about focusing the lens. It also provided a better-quality lens than was found on simpler fixed-focus cameras and did much to take the guesswork out of photography.

The Canon A-1

PRODUCED: **1978** | COUNTRY: **Japan** | MANUFACTURER: **Canon**

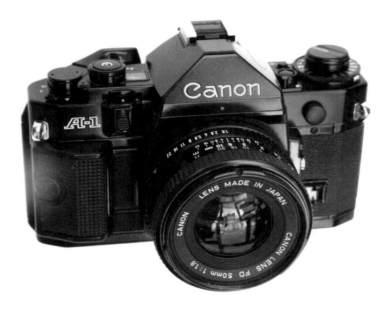

ABOVE **The first 35 mm SLR camera to offer fully programmed exposure control.**

DURING the 1970s the 35 mm single-lens reflex (SLR) reigned supreme. It was the dominant design of camera for the professional photographer working outside the studio and a popular choice for many amateurs looking for an all-purpose camera. Adding to its popularity was the fact that 35 mm format film was economical and available in a range of emulsion types — black-and-white, color print and transparency — and from numerous manufacturers. Over the course of the decade, the models available evolved from simple mechanical cameras to those that incorporated increasing levels of electronics, such as light meters, electronic shutters and automatic exposure.

A SPLIT MARKET

By 1974, SLR models that offered automatic exposure were divided into two main groups: those that allowed the user to set the shutter speed ("shutter priority"), with the aperture being set automatically, such as Canon, Konica, Miranda, Petri, Ricoh and Topcon; and those where the user set the aperture ("aperture priority"), with the shutter being set automatically, such as the Asahi Pentax, Chinon, Cosina, Fujica, Minolta, Nikkormat and Yashica. Neither approach offered any particular advantage: the manufacturer's decision depended largely on how easily they could adapt existing camera tooling in the factory to incorporate the electronics, whereas the photographer's choice between the two modes came down to personal preference.

Minolta's XD11 camera of 1977 became the first 35 mm SLR to offer both aperture-priority and shutter-priority modes. But the most significant model of the 1970s by far, in terms of computerization, was the Canon A-1 camera, introduced in April 1978, with a programmed auto-exposure mode.

A WORLD FIRST

In January 1974, Canon assigned 100 engineers to develop a new camera known only as "Model X." In April 1976, the new camera was unveiled, with its consumer designation Canon AE-1. The camera encompassed two new approaches. Firstly, it incorporated advanced technologies for its electronics and optics; secondly, the manufacturing process included computer-aided design and automation to support precision machining and assembly. The Canon AE-1 was the first 35 mm SLR with automatic exposure. It had shutter priority and through-the-lens (TTL) metering, controlled by a central processing unit (CPU).

ABOVE **The Canon AE-1 camera of 1976, which heralded a new approach to camera automation.**

Its successor, the Canon A-1, ushered in an era of programmed auto-exposure that became standard during the 1980s. The camera had five automatic exposure modes. The year following its release, a more powerful microprocessor was added, allowing the camera to offer both aperture- and shutter-priority modes. Other cameras were manufactured as part of the A-series, all using the same compact aluminum-alloy chassis and outer cosmetic acrylonitrile-butadiene-styrene (ABS) plastic panels. Since the models shared most major components, and all of them were fitted with an inexpensive horizontal cloth-curtain shutter, costs could be spread out over large production volumes.

BELOW **Canon FD lenses. This was Canon's standard lens mount from the F-1 camera of 1971, until it was superseded by the EOS system in 1987.**

The Canon A-1 was a remarkable success and it was made until 1985. It was reasonably priced and, along with the FD series of Canon lenses, attracted a loyal following among amateurs, with the higher-specified F-1 camera attracting a professional market. By the time the camera was replaced by the Canon T90 in 1985, it was showing its age and Canon took the opportunity to rethink and redesign its entire camera range.

THE AGE OF AUTO-EXPOSURE

The majority of camera manufacturers offered some form of programmed auto-exposure by the mid-1980s. Canon introduced further models, including the 1981 AE-1 Program and 1983 Canon T50. Leica's R4 reflex camera of 1981, Nikon's FG and FA of 1983, the Minolta X-700 of 1982 and the OM-2SP (Spot/Program) and Pentax Super Program of 1984, among many others, all brought the feature to their respective users. Only some of the cheaper brands, such as Cosina, Miranda and Zenit, and those companies that lacked the technical expertise or financial strength to develop new models, such as Rollei and Topcon, never introduced programmed models. For a number of these companies, the change from mechanics and electronics to computerization effectively forced them out of the camera market altogether.

45 The Sony Mavica

PRODUCED: **1981** | COUNTRY: **Japan** | MANUFACTURER: **Sony**

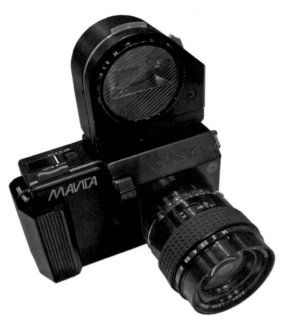

ABOVE **The Sony Mavica MVC FD series of cameras introduced in 1997 ßwere the commercially successful successors to the Mavica prototype of 1981.**

THE prototype of the Sony Mavica was unveiled in Tokyo on August 25, 1981. The name Mavica was derived from "magnetic video camera," and technically it was not a true digital camera: it used a charge-coupled device (CCD) sensor to produce an analog video signal from which still images could be made. But it was an important step toward fully digital cameras. Sony's press release recognized the impact that the camera would have, announcing that it had developed "a revolutionary video still camera, embodying fully the advantages of advanced electronic technology in magnetic recording, CCD and IC semiconductors ... This new video still camera represents an epoch-making innovation in the history of still photography."

The camera was a single-lens reflex (SLR) with interchangeable lenses and three lenses were available in a bayonet mount: an f/2 25 mm, an f/1.4 50 mm and a zoom f/1.4 16–65 mm. The CCD measured 570 × 490 pixels. The images were stored on a 2 inch video floppy disk called the Mavipak. Up to 50 color images could be stored on one Mavipak, each on its own single track, and could then be played back on a television or video monitor.

In the 1980s, a number of Mavica cameras that used the Mavipak were introduced, but the real breakthrough came with the Mavica MVC-FD5 in late 1997. This camera used the then ubiquitous 3½ inch floppy disk to record up to 55 images. It offered a 640 × 480 pixel CCD and variable

The introduction of the 3½ inch floppy disk helped to transform computing and proved crucial for the Mavica camera. Photographers could immediately insert the disk into a computer that accepted the new disk format and use the image files in desktop publishing software, or simply print them. Because the disks were standardized, they could be easily shared, making image-sharing faster and more convenient than ever before. It was an important milestone in the rise of digital photography. A side effect of this is that the traditional photo album is no longer the key part of family life that it was through much of the 19th and 20th centuries. From the mid-1850s, when photographs on paper became widespread, publishers began to sell photograph albums. The introduction of the carte de visite from c.1859 gave a further boost to the practice. These small cards were shared and collected, then stored in albums. Kodak and other photographic manufacturers sold albums to take photographs taken by their amateur cameras. Now, images are displayed on the camera or phone that made them or, increasingly, are shared via email and social media. Some 97 percent of all digital photographs never get printed on paper. Digital albums have replaced the physical, with severe implications for future historians.

shutter speed and an f/2.0 47mm lens. It retailed at around $600. The disk was a straightforward means of transferring images from the camera directly onto a personal computer and it became popular with estate agents, auction houses and insurers, for whom an instant image was required. Further models were introduced from 2000 that allowed images to be saved to a CD and to removable storage media.

ADVANCES IN MEDIA STORAGE

Despite the camera's popularity, the Mavica range was overtaken by changes in technology. New and better methods of storage and image transfer were developed, such as Flash memory and simple USB wire connectors that allowed images to be downloaded directly from a camera to a computer. The Mavica was bulky, as dictated by the size of the floppy disk; new digital cameras from other manufacturers that were smaller and had higher specifications quickly overtook it. The 3½ inch floppy disk was large, and once the floppy-disk drive itself was replaced by CD and DVD readers and writers in home and business computers, it became obsolete.

By 2001, Smartmedia had 50 percent of the digital camera market; by 2005, this had been superseded by SD/MMC (secure digital/multi-media card) memory, with other media such as CompactFlash remaining popular. These new methods of storage could hold a greater number of images and could be easily changed once they were full. Sony's floppy disk and the use of a CD within cameras were by now outdated technology.

Looking forward, the wireless technology that is now being increasingly added to both amateur and professional cameras may remove the need for any removable storage in cameras. Image files can be transferred directly to another device, or uploaded to cloud storage, with its unlimited storage capacity and potential to be accessed anywhere.

BELOW **The 3½ in floppy disk.**

The Fuji Quicksnap

PRODUCED: **1986** | COUNTRY: **Japan** | MANUFACTURER: **Fuji**

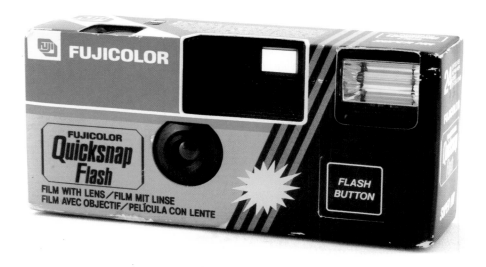

ABOVE **The Fuji
Quicksnap Flash
single-use camera, which
added a flash unit to the
original basic camera.**

FROM the first commercially made camera in 1839 until the rise of
mass-produced amateur cameras in the 1880s and 1890s, the camera
itself and its lenses had always represented a significant expense for the
photographer. Cameras were replaced only when necessary, and lenses
were reused when they could be. Although the cheapest amateur cameras,
such as the Kodak Brownie, were affordable to the working classes, they
still represented a cost and were something to be taken care of so that
they would last.

By the late 1980s, the simplification of camera design, the use of cheap
plastics and a globalized world economy meant that cameras could be made
and assembled in places with low labor costs. This meant that the unit cost
of producing a camera was lowered dramatically, so much so that in 1986
the Japanese company Fuji was able to introduce the first disposable camera.
It was named Utsurun-Desu, or "It takes pictures," to reassure prospective
customers that it was a proper camera. It sold for Yen 1,380. The concept
was an immediate success and the camera sold internationally as the
Quicksnap. In 1991 Japanese sales of disposable cameras were 50 million
and had risen to 60 million by 1992, with Fuji accounting for about 75
percent of the market. Fuji explained its success in 1993: "Some young
people use them because it's not fashionable now to carry a camera. It's a
reaction against the camera-and-glasses image of the Japanese tourist."

THE PHOTO-PAC

A precursor to the familiar single-use camera was the Photo-Pac camera of 1949. When A.D. Weir was caught out without a camera at a tourist spot where he would have liked to take photographs, he decided to make a cheap camera available to others in the same circumstances. His solution was a simple camera that could be rented from a nearby dealer. After the film had been exposed, the camera would be returned to Weir's company in Dallas and the film processed and printed. The idea itself was not new, but Weir's approach was to develop a very cheap camera by removing unnecessary parts and making it from cardboard. His Photo-Pac camera made eight exposures on 35 mm film and sold for $1.29 ($12.60 today). The idea won Weir a $50 Gadget Award in September 1949, but it failed to attract any success in the market.

The Eastman Kodak Company quickly followed suit in 1986 with its Kodak Fling, renamed the Kodak Fun Saver in 1988. The term "disposable" or "throwaway" was initially used, but with the rise of environmental awareness, companies began to market the cameras as "single-use" and more effort was made to recycle and reuse parts after the film had been processed.

The throwaway/disposable/single-use camera struck a chord with the general public. The cameras were cheap and could be left on tables at weddings for guests to take their own informal photographs, or they could be purchased on the spur of the moment when a camera had been left at home or in situations where there might be the worry of a more expensive camera being damaged by water or lost. By 1993, disposables were widely available, with Japan, for example, having 300,000 outlets, including station kiosks and vending machines. They were ideally suited for selling at supermarkets and visitor attractions such as zoos and theme parks.

As their success grew, Kodak, Fuji and Konica, among others, began, paradoxically, to introduce better-quality single-use cameras with a built-in flash, and for specific uses such as underwater photography. Some were designed to take particular types of photographs, including wide-angle, panoramas or black-and-white instead of standard color photographs. Polaroid even introduced cheap lines of instant cameras under the i-Zone brand which, although not single-use, were designed to compete head-on with single-use film cameras. Single-use cameras were cheap enough that

BELOW **The Polaroid i-Zone cameras were an attempt by Polaroid to compete with single-use cameras with a range of low-priced instant-picture cameras. The film they took was discontinued in 2006.**

they could be customized for companies and organizations, who could then give them away to their customers.

As makers of camera film, both Fuji and Konica were keen to emphasize that disposables expanded, rather than replaced, the existing camera market. They described their products as "film with lens," rather than cameras, and claimed they were attracting new groups of photographers, such as the elderly, who were put off by the uncertainty of loading film associated with conventional cameras and by the weight of them.

THE ADVENT OF DIGITAL

From 2001, the growth of digital cameras began to affect sales both of film and of single-use cameras. Single-use cameras were extremely profitable and so Kodak and Fuji adopted strategies to reverse this decline, with the result that sales of single-use cameras rose again in 2001–2002. The global value of the market for single-use cameras was estimated at $696 million ($0.9 billion today) in 2002, with Eastman Kodak's share of the market at 36 percent and Fuji's at 34 percent.

In the United States, 2003 saw the introduction of digital single-use cameras and, soon after, single-use camcorders. The American company, Pure Digital, developed and showed a prototype single-use digital camera in 2002. It was was mass-produced from 2004, when it went on sale at outlets including CVS drugstores and Disney World resorts. The camera sold for $19.99, against $4–$10 ($25 and $5–12 today) for a single-use film camera, and it offered a color preview screen and the ability to delete pictures. After it was returned to the manufacturer for processing, the user received prints and a photo CD of digital image files.

The growth of digital camera ownership and the advent of cell phones with built-in cameras removed the need for such devices, and although film-based single-use cameras continue to be popular, their digital counterparts have largely disappeared.

DISPOSABLE MEMORIES

The throwaway camera, because it is so cheap to buy, has created a new genre of "found" photography, based not on finding other people's photographs, but on leaving cameras in public places for people to take pictures. The camera is passed on to other members of the public before being returned for processing. A number of such projects have been developed, with the Disposable Memory Project being the most successful. Its concept is summed up simply: "We're leaving disposable cameras around the world, people are picking them up, taking a few photos and passing them on, eventually returning home — so we can tell their stories." Founded in 2008, in the three years that followed, more than 410 cameras were left in public places, and 30 returned. They have gone to 75 countries and traveled over 500,000 miles. The photographs are accompanied with stories and journeys, which the project exhibits on its website: http://disposablememoryproject.org

The Kodak Nikon DCS100

PRODUCED: **1991** | COUNTRY: **Japan/U.S.A.** | MANUFACTURER: **Eastman Kodak Company**

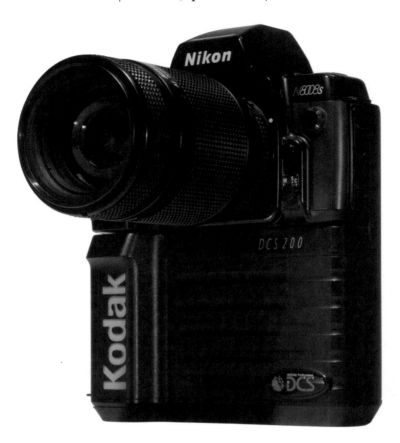

ABOVE **The Kodak DCS200 outfit, which comprised a Nikon F3 camera body coupled to its Digital Storage Unit.**

THE Kodak Professional Digital Camera System or DCS, known retrospectively as the DCS100, was the first commercially available digital single-lens reflex (DSLR) camera. Released by Eastman Kodak in May 1991, it comprised a Nikon F3 body with a customized camera back containing the digital image sensor.

Eastman Kodak Company has been credited with pioneering the digital camera in 1975 through the work of Steve Sasson; however, the company was slow in realizing the potential of digital technology. It was also wary of doing anything that might damage its highly profitable film and paper sales. The company considered the market for digital technology to be the professional sector rather than consumers, and it was with professionals in mind that it concentrated its efforts, although digital remained a very small part of its business compared with film.

COVERT USES

By 1987, Eastman Kodak had produced the first MP (megapixel) CCD (charge-coupled device) image capture device — the M1. The M1 was incorporated into a standard 35 mm camera body to create a portable digital camera. The camera was designed for covert use, with a hard drive for recording images concealed within a camera bag. Kodak developed further digital cameras, and by 1989 the company had moved to using Nikon F3 camera bodies on its digital cameras, all of which were intended for military or government surveillance. These cameras all had very small productions runs. The 1989 D-5000 or ECAM was developed by Kodak's Electronic Photography Division (EPD) and became the prototype of all modern professional digital single-lens reflex (DSLR) cameras. It used an autofocus Nikon camera body and was marketed to government customers.

At Photokina in fall 1990, a Kodak Still Video camera was shown publicly, with the digital DCS100 being shown privately. The Still Video camera was a Nikon F3 fitted with a still video back. Kodak's plan was to release the camera in 1991 at a price of $25,000 ($43,000); the target market was professional photojournalists.

A NEW DIGITAL SYSTEM

Ray H. DeMoulin, the president of Eastman Kodak, presented the new camera to the public at the Journées de l'Image Pro at Arles, France. By May 1991, Kodak's Professional Products Division was ready to announce the first Kodak Professional Digital Camera System at a New York City press conference.

Like the earlier prototypes, the DCS100 required a separate digital storage unit (DSU), carried in a shoulder bag, to accommodate batteries and image storage. A 200 megabyte hard-disk drive was eventualy offered as an extra. This could hold up to 156 uncompressed images, or up to 600 images compressed into a JPEG-compatible format. Captions and other image information could be entered using an external keyboard. Two different digital backs were available for the DCS100: the DM3 monochrome back and the DC3 color back. The latter used a custom array of color filters.

The camera came with a price tag of $30,000 ($51,000 today) and featured a 1.3 MP CCD (1,024 × 1,280 pixels). The system, which was packaged in a large plastic suitcase, consisted of a 200 MB external hard-disk drive with batteries, mono display and cables, and a control panel, and weighed 55 lb (25 kg). It was sold under the slogan "Convert to a new digital system without switching cameras," suggesting that the familiar Nikon F3 camera body would make the transition to digital easy. There were many variant models of the DCS100 — monochrome or color, some with different buffers. Versions with a keyboard and modem allowed images to be transmitted via a telephone line. A total of 987 units were sold from 1991 to 1994.

In August 1992, at MacWorld Boston, Eastman Kodak announced a second digital camera, the DCS200, based on the autofocus Nikon N8008s (also known as the 801s) camera body. The DCS200 targeted desktop publishing rather than photojournalism, and, in sharp contrast to the

RIGHT **The Nikon DCS100 with its kit.**

FAR RIGHT **U. S. Supreme Court Justice William Rehnquist swears in George H.W. Bush as president, by Ronald A. Edmonds, 1989.**

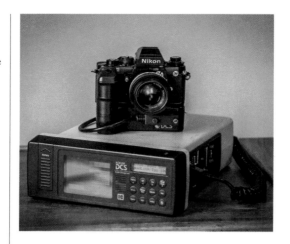

complexity and cost of the original DCS, it was a much simpler design. A total of 3,240 cameras were sold from 1992 to 1994.

As John Henshall, an early commentator on digital and consultant for Kodak, noted in a 1993 review of both cameras: "I make no apology for my genuine enthusiasm for these fine professional products, the most inspiring pointers so far to the revolution which is upon us. What of the future? Even more pixels? Removable hard disks? Faster "motor" drives? Maybe. What is certain is that these Kodak digital cameras are the future of imaging. And they are here, right now."

New models appeared, including the AP NC2000 of February 1994, which was developed in cooperation with Associated Press. It was offered first to AP member newspapers for $17,500 ($28,000 today) and became the standard digital news camera. Late in 2002, the Eastman Kodak Company took the decision to end the Kodak Professional camera business, which had yet to make a profit. However, there was a last-minute reprieve, with a dramatic announcement of a new camera that had the potential to improve sales. Eastman Kodak's 14 MP DCS Pro 14n, priced at only $4,995 ($6,500 today), stole the show at Photokina 2002. This came just after Canon pre-leaked its announcement of the "world's highest resolution digital SLR," the 12 MP EOS-1Ds, at $9,000 ($11,800 today). At $4,995, the DCS Pro 14n was a very cheap studio camera that signaled the demise of the medium-format digital back. But unfortunately it was months late, and at high ISO settings, image noise was disappointing. The reprieve was short-lived and in 2004 the last DCS was launched, the DCS Pro SLR/c, which used a Sigma body with a Canon lens mount.

The use of the familiar and respected Nikon and Canon bodies for most DCS cameras had proved to be a marketing advantage. However, because the Kodak name did not appear on the front of the DCS camera body itself until the production of the DCS Pro 14n (though it did appear on the DSU), it seemed that Eastman Kodak Company was downplaying its involvement with digital technology and many photographers saw the DCS as a Nikon product.

A NEWS WIRE FIRST

In January 1989, Associated Press photographer Ronald A. Edmonds made history when he transmitted the first photos of President George H.W. Bush's inauguration (see below), 40 seconds after he had been sworn in, to newspapers around the world. He captured the moment with a Nikon QV-1000C Still Video Camera. The implications for news gathering were enormous. Photographs from anywhere in the world where there was a telephone line or satellite link could be on the front pages of newspapers within a matter of minutes. Edmonds made history again on July 15, 1992, when he used the Kodak DCS100 camera at the Democratic Party National Convention, capturing Governor Bill Clinton accepting the Democratic nomination for president. Edmonds' picture was available within five minutes of the event and featured on front pages nationwide the next morning. The picture was made with the DCS100 and transmitted via a computer modem. Tom Stathis, AP's senior photo editor for North America, regarded this scoop as the most effective use of digital still photography in the agency's history. A *New York Times* piece on August 2, 1992, reported that this was the first time the "100" designation was applied to the camera.

The Apple QuickTake 100

PRODUCED: **1994** | COUNTRY: **U.S.A.** | MANUFACTURER: **Apple**

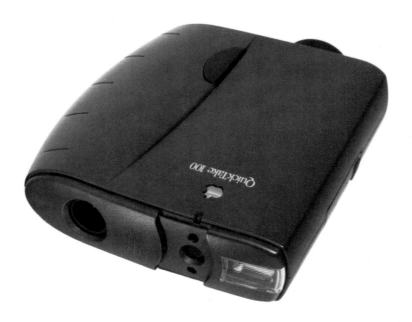

ABOVE **The first mass-market consumer digital camera, which paved the way for the subsequent digital revolution.**

WHILE the Eastman Kodak Company had directed its first efforts in digital photographic technology at the professional market, with the DCS100 marketed primarily as a "professional digital camera system," Japanese electronics companies were more perceptive. They saw the market for digital technology as lying with the consumer with a home computer, sales of which were starting to grow rapidly. Cameras such as the Canon Ion may not have been true digital cameras (they used removable floppy disks to record analog video, and additional hardware was required to turn these fully digital), but they did give an indication of how the nascent digital market might develop.

The first consumer digital camera was developed, built and marketed by the American Dycam Inc. and named the Dycam Model 1. It went on sale in 1991. The technology was licensed to Logitech, which built its own camera, the Logitech Fotoman FM-1, sold from 1992. The Dycam and Logitech cameras digitized their images internally and were ready to download directly into a personal computer. Both cameras produced 8 bit (256-level) grayscale images, 376 × 240 pixels, on a CCD sensor and could store up to 32 images.

A DIGITAL CAMERA FOR THE MASSES

The Apple QuickTake 100 was the first mass-market digital camera, built for Apple by Eastman Kodak (Japan) and released in 1994. Apple was interested in expanding its consumer base away from personal computers to photography, which in the United States was a $12 billion market. The camera initially worked with the Apple Macintosh computer and had a 0.3 MP maximum resolution. It took between eight images at 640 × 480 pixels and 32 images at 320 × 240 pixels, depending on the resolution at which they had been shot, in 24-bit color. The camera had 1 MB of nonremovable flash memory and once this was full, images had to be downloaded and files deleted from the camera memory before any further pictures could be taken. The camera had automatic exposure control and a fixed-focus lens. Images were recorded in Apple's own QuickTake format or PICT formats and could be cropped or rotated and saved as TIFF, PICT or JPEG files.

The camera was launched at the Tokyo MacWorld Expo on February 17, 1994, and was ready for retail in May, priced at £535 ($749). Apple saw the camera being used in business and education and for capturing memories. In March 1994, digital guru John Henshall noted: "If it catches on, it will be the forerunner of a line of products which could change the way families take, manage and print their social pictures."

As digital cameras from brands directly associated with photography such as Canon, Nikon and Kodak entered the digital market, sales of the QuickTake declined, and it was discontinued in 1997. For Apple, this foray into digital photography was not wasted: the company built on the experience with the launch of the first iPhone, with a built-in 2 MP camera, in 2007. The iPhone quickly became the ultimate must-have smartphone, with the camera a key selling point, coupled with the ability to share and edit images through a multitude of apps. The iPhone 6 (and 6 Plus) of 2014 had an 8 MP camera; over 10 million units sold within the first three days of release.

From 1994 to 1995 the number of consumer digital cameras grew dramatically as the advantages of digital photographs, even at relatively low resolution, became apparent to the general public. The QuickTake did not start the digital revolution, but it was an important milestone; it showed both users and manufacturers what was possible.

A QUICK TAKE

On December 20, 1996, Apple staff member Tim Holmes was working late at Apple's headquarters in Cupertino, California, when he was summoned to a mysterious meeting: "My manager came rushing past my office door saying to come with him to Town Hall, Apple's theater for announcements, company meetings and the like. It was clearly not a company meeting ...

We had no idea what was about to happen." He was to witness the historic return of Steve Jobs, who had founded the company in 1976. Jobs had left after a boardroom power struggle in 1985. Holmes happened to take his Apple QuickTake 100 camera (a product Jobs discontinued the following year) to the meeting, and captured informal shots of the momentous occasion. He released the photographs on his Flickr account in May 2014.

49 The Canon EOS 5D Mark III

PRODUCED: **2012** | COUNTRY: **Japan** | MANUFACTURER: **Canon**

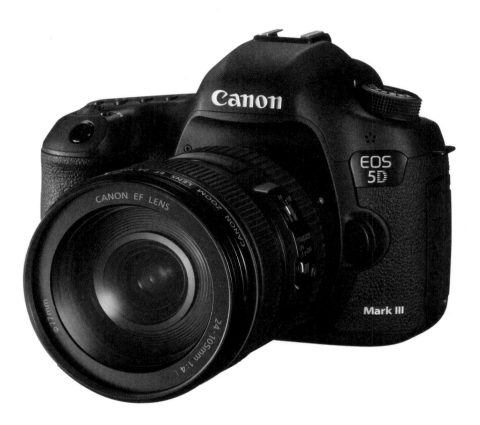

ABOVE **The Canon EOS 5D Mark III, launched in 2012.**

ON February 5, 2014, Canon's combined production of its film and digital electro-optical system (EOS) series of interchangeable-lens cameras surpassed the 70-million mark. Manufacture of Canon's EOS single-lens reflex (SLR) cameras had started in 1987 with the EOS 650, a 35 mm film SLR, and digital EOS cameras followed in the early 2000s. The EOS range was the first to incorporate an electronic mount system enabling complete electronic control between the lens and body, and also throughout the whole camera system. Underlying it were principles of ease of use and high speed.

The EOS series included the top-of-the-range professional EOS-1 film camera (1989) and the popular compact, lightweight EOS 1000F (1990). As digital SLR cameras grew in popularity from the early 2000s, Canon developed its proprietary high-performance DIGIC digital image processors and CMOS sensors, supported by an extensive series of EF lenses. More than 100 million EF lenses had been manufactured by 2014.

The Canon EOS 5D was launched in 2005 after several years of research and development. Code-named "the Mid-Range Project," the goal was, in the words of Canon, "to provide a joy in owning a camera and taking pictures with the aim of stimulating a new desire for creativity." The development of an affordable full-frame DSLR was made possible, in part, by the advent of high-definition video equipment, which created a demand for high-specified sensors. Canon had invested heavily in sensor development and was well placed to transpose its knowledge into still cameras.

Canon announced the EOS 5D Mark I camera on August 22, 2005, and it began shipping by October. The camera, which had a resolution of 13.3 MP, was significant for being the first full-frame DSLR camera within a standard body size. It was also significant for its relatively low price, starting at Yen 300,000 ($3,299) without a lens. This was significantly less than conventional models and placed the camera within the reach of many consumers. The respected DPreview website praised the camera: "The EOS 5D is a fantastic photographic tool which is capable of producing really excellent results."

FULL HIGH-DEFINITION VIDEO

The EOS 5D Mark I was followed with the announcement on September 17, 2008, of the EOS 5D Mark II. This offered a number of incremental improvements and new features over the Mark I, including a 21.1 MP sensor. The Mark II was especially capable of shooting in low-light situations. More importantly, it was the first Canon EOS camera to have full high-definition video capability, and the first DSLR to do so within a body that was affordable when compared with professional video cameras. It was launched with a 30-frame-per-second video mode, which was upgraded via firmware in 2010 to make it compatible with conventional motion-picture film cameras.

The HD (high definition) video capability began to garner interest from other manufacturers, who began to supply products to improve the sound recording and accessories more usually found on professional video and film cameras, such as mounting rigs, matte boxes and follow-focus controls.

MIRRORLESS TECHNOLOGY

Most amateur digital cameras contain sensors that are smaller than the traditional 35 mm frame size of 1 × 1½ inches (24 × 36 mm). This offers an advantage in that it allows the camera itself to be smaller, but it does affect the pixel count. Professional DSLR cameras often have full-frame sensors, reflecting the need to get the best from images. A number of manufacturers are now offering mirrorless full-sensor amateur cameras. This technology allows designers to keep the size of the camera small without compromising on the ability to digitally process images. Importantly, they also offer interchangeable lenses, just like a DSLR. These cameras include Sony's A7 and Leica's M and M-E cameras. Even compact cameras without interchangeable lenses, for example Sony's DSC-RX1, now offer a full-frame sensor, and photojournalists such as Reza Deghati are now carrying them for serious work.

ABOVE An example of how efficient the Canon 5D is in dealing with extreme lighting conditions is shown at this nighttime performance at Chatsworth House Derbyshire, England, photographed by Maria Falconer. The camera can be used at a very high ISO as it handles "noise" very well; ideal for low light conditions where you need a fast enough shutter speed to "freeze" the actions of the performer as well as the movements of the photographer, who was using quite a heavy telephoto lens.

The ability to shoot in 3-D was also offered with dual camera mounting and control. In addition, third-party firmware updates further extended the camera's capabilities.

The Mark II camera began to be used on serious television and movie film productions as a regular part of the cinematographer's equipment. It garnered a whole raft of credits, from NBC's *Saturday Night Live* opening titles (2009) to episodes of *House* (2010). In the UK, the comedy series *Shelfstackers*, first broadcast in September 2010, became the first BBC production to use the camera, and eventually all six episodes of the series were shot on the Mark II. Feature films, both big-budget and low-budget, were also shot, in part, on the Mark II camera, with credits including *The Avengers*, *Breaking Bad*, *Iron Man*, *Red Tails* and *Dimensions*.

In 2009, White House photographer Pete Souza made the first official portrait of the president of the United States to be taken with a digital camera, the Canon EOS 5D Mark II. Soon, Souza was regularly shooting with the Mark III with his favorite lens, the Canon EF f/1.4L 35 mm. The Mark III's improved image quality at high ISO settings and impressively quiet silent shooting mode gave it the edge over the Mark II for covering the president unobtrusively in meetings. All of Souza's images are uploaded to the White House Flickr photostream and can be viewed at https://www.flickr.com/photos/whitehouse.

THE MARK III

The Canon EOS 5 Mark III, a 22.3 MP camera with a full-frame CMOS sensor, was announced on March 2, 2012, further cementing the reputation of the camera. The date was also the 25th anniversary of the announcement of the first camera in the EOS line, the EOS 650 in 1987, and Canon's 75th anniversary. The Mark III went on sale with a retail price of $3,499 in the United States and £2,999 in the UK. It built on the success and features of the game-changing Mark II with a DIGIC 5+ imaging processor and a 61-point high-density reticular autofocus array. Continuous shooting of up to six frames per second was available, improving on the Mark II by more than 50 percent. The Mark III's enhanced weather protection appealed especially to sports and wildlife photographers. New image processing options included a built-in high dynamic range (HDR) mode that allows the photographer to capture extreme contrasts of luminosity across a whole subject; a standard exposure would require compromises.

The camera quickly became a fixture among professionals at press calls and sporting events and among amateur photographers. With the introduction of the Mark III, Canon announced on December 24, 2012, that the Mark II would be discontinued. The camera that had effectively started high-definition DSLR filming came to the end of its production. It was described by Canon Rumors, an influential online blog, as "quite possibly the most popular and influential DSLR in history."

LORENZO AGIUS

British photographer Lorenzo Agius (b. 1962) is one of the Canon EOS series' biggest fans — he takes the 5D Mark III and 1Ds Mark III on every shoot. He is part of the Canon Ambassadors program and recently commented: "The EOS-1Ds Mark III is a beautiful camera. There is a lot to learn about the digital process and how to treat it. I'm surprised and delighted by what the EOS-1Ds Mark III does. I'm finding it very liberating." Despite working as a professional freelance photographer since 1989, it was not until 1996 that Agius' work came to the public's attention with the release of the film Trainspotting, starring Ewan McGregor. Agius had been commissioned to create the posters' grainy black-and-white portraits of the film's main characters. His honest, refreshing photographs printed on lith paper were inspired by 1990s Calvin Klein CK1 ads and Richard Avedon's book In the American West. They catapulted him onto the international stage. Agius found himself shooting Liam Gallagher and Patsy Kensit for the cover of Vanity Fair and publicity images for the Spice Girls' movie. Despite being known for his love of traditional photographic disciplines, Agius admits digital has changed the way he works: "I've always said that a photographer should be able to adapt to anything, and I think that I have a style and approach that's not obvious."

The Nokia Lumia 1020

PRODUCED: **2013** | COUNTRY: **Japan** | MANUFACTURER: **Nokia**

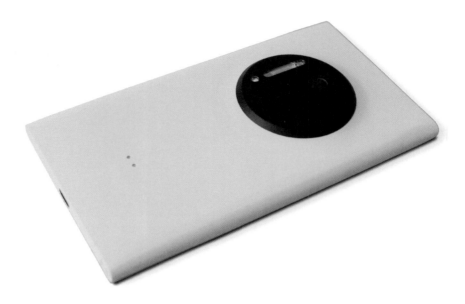

ABOVE **The Nokia Lumia 1020 camera phone brought more pixels and processing power to the camera phone than many DSLRs offer.**

IF THE Nokia Lumia 1020 were a camera, its specifications would put it on par with many of the leading compact cameras and, arguably, many digital single-lens reflex (DSLR) cameras currently available. Although it is unlikely to match the iPhone in terms of sales and its place in popular culture, it is nevertheless worthy of note as a far superior camera.

The story of how cameras came to be incorporated into cell phones is an interesting one in itself. From the 1880s, cameras had regularly been incorporated into other devices which, by the 1950s and 1960s, included transistor radios. The radio was easily carried and both the camera and radio had associations with modernity, the outdoors and an emerging youth culture. This did not apply to the telephone, a device still tethered by wire to a wall socket, but mobile telephony was to change that.

In 1972, Dr. Martin Cooper of Motorola made a prototype cell phone and in April the following year he made the first "mobile telephone" call in New York to the head of research at Bell Labs, Motorola's main competitor in the race to develop a practical portable phone. It was some years later that Motorola was able to commercialize the cell phone when it released the Motorola DynaTAC in 1983, with a price tag of $4,000 ($9,300 today). By 1986 Motorola's "brick" had become pocket-sized and the cell phone was firmly established and becoming increasingly accepted by business users and consumers.

TOWARD THE FIRST CAMERA PHONE

From the mid-1990s, with commercial maturity, the emphasis of manufacturers was on adding new features to the phone handset such as color screens, games and new stylish designs. In June 2000, the South Korean company Samsung announced its SCH-V200 digital camera phone, which incorporated a camera able to take 20 pictures at 350,000-pixel resolution in Regular Mode and 26 pictures in Conserve Mode. Samsung saw the market for the camera phone as being "the younger generations, who are accustomed to using digital cameras, and … young parents of small children."

It was into this exciting mix of new and rapid innovation that the SoftBank Mobile J-SH04 cell phone, made by the Sharp Corporation of Japan, was released. Available from November 1, 2000, the J-SH04 was only sold in Japan and it was the first portable phone with a built-in, integrated camera. Technically, the camera was simple: a 110,000-pixel (0.11 MP) CMOS sensor with a 256-color display. Technologically, the J-SH04 was important. Whereas the Samsung SCH-V200 had a camera and phone in the same phone casing, the J-SH04 integrated the camera and the resulting pictures with the phone so that images could be sent via the phone. The Samsung required images to be downloaded via a cable to a personal computer. The J-SH04 was the point of origin for today's mobile-camera phones.

Other phone manufacturers began to include cameras as part of their phone handsets. Initially, most offered low-resolution cameras, but by 2004 Sharp's 902 offered a 2 MP camera and Samsung, with its SCH-S250, a 5 MP camera. In 2006 Samsung's B600 included a 10 MP camera and the following year it brought out the SCH-B710, which had a 3-D screen and a 1.3 MP camera with two lenses to create 3-D images.

THE BEST-SELLING CAMERA PHONE EVER?

The iPhone was launched in 2007, having been in development since 2004. Designed by British industrial designer Jonathan Ive, it included a touchscreen and virtual keyboard, and a 2 MP camera. By the release of the iPhone 5 in 2012, the camera had been improved to 8 MP, and the iPhone 6 retained that specification. The iPhone's success was not owed to its design (although it was distinctive compared with its competitors) or specification (it was not the most highly specified), but to its branding and the fact that it gave the user access to so many apps. As with their range of personal computers, Apple's brand positioning ensured that the iPhone was aspirational for many users, despite the high price tag when compared with competitors' models. A key factor was the support it gave to external applications, or apps, written for Apple's proprietary iOS operating system, which extend the usefulness of the iPhone. Sales of the iPhone in 2007 were around 1.4 million, rising to more than 150 million units worldwide in 2013. In total, Apple sold more than 400 million new iPhones between 2007 to 2013 and it has held a 13 percent to 23 percent share of the worldwide smartphone market. It is only recently that models from Samsung running the Android operating system appear to be making a dent in sales figures of the iPhone.

BETTER THAN AN ACTUAL CAMERA?

In 2013, the Nokia Lumia 1020 brought a whole new dimension to the camera phone with a 41 MP camera — far higher resolution than most standard digital cameras could offer. Its origins lay with Nokia's 808 PureView camera phone, announced on February 27, 2012. This had a 41 MP camera, but the real technological advance lay in the way that the electronics processed the pixels. High pixel count allowed the camera to offer the digital equivalent of a zoom lens without the usual loss of quality. A second generation of PureView phone, the Lumia 920, was released on November 2, 2012. It was the first smartphone to implement optical image stabilization (OIS) and was particularly efficient in low-light imaging.

By 2013, Nokia had two kinds of camera phone in its PureView range: one had excellent capturing of detail, and the other was adept at imaging in low light. The Nokia Lumia 1020, announced on July 11, 2013, combined these features. It incorporated a second-generation $1/1\frac{1}{2}$ inch 41 MP sensor, up to five times larger than typical smartphone sensors.

The Lumia 1020 returned to basics, with a new camera lens from Carl Zeiss AG, which designed a new optical system to match the resolution of the camera sensor. The physically large lens was supported by a new kind of optical image-stabilization system, which used a sensing system linked to very small motors to actively move the lens to counteract the user's movement.

The 41 MP sensor could capture 34 MP and 38 MP image files at 16:9 and 4:3 aspect ratios, respectively. More importantly for the average user, the Lumia 1020 camera captured 5 MP oversampled images so that every pixel in the 5 MP image had been created using the data from up to seven pixels of the sensor. The sweet spot for image quality is 5 MP; it is easy to share and printable up to Tabloid (ANSI B/A3) size.

The Lumia 1020 garnered generally positive reviews, with many commending the quality of the camera and the resulting photographs. Some continued to question whether the market would bear the cost of the handset and whether most users needed such a highly specified camera. Stephen Alvarez, a *National Geographic* photographer, commented that the Lumia 1020 "performed like a DSLR under every condition — from low light to moving airplanes." But whether such impressive specifications will appeal to ordinary consumers remains to be seen.

THE RISE OF THE SELFIE

Social media sites such as Facebook, which launched in 2004, gave an outlet to the millions of images created through camera phones. Increasingly, the only camera that the person in the street owned was a camera phone. The quality of the image was such that, for the first time in 120 years, a separate camera was no longer seen as necessary. Users carried their camera phones everywhere and at all times, unlike conventional cameras. Wi-Fi connectivity and social media apps ensured that images could be shared immediately with family and friends via social media, Bluetooth, instant messaging programs such as WhatsApp, and by products designed specifically to share photographs such as Flickr and Instagram. In addition, the type of photograph made had changed. Informal pictures were taken in every imaginable situation and then published immediately.

The technology of Apple's iPhone and other camera phones meant that users could take photographs of themselves with no one else present, when traveling or with others in situations where a traditional or digital camera would not have been appropriate. Self-portraits could be taken with the subject seeing the image on-screen before making the exposure. The true "selfie" has become a whole new genre of photography, practiced by everyone from presidents and prime ministers to celebrities and regular people on the street, and then shared globally.

The impact of the selfie and the use of social media on photography was highlighted when Ellen DeGeneres shared her selfie taken at the 2014 Academy Awards ceremony. It was retweeted some 779,295 times within half an hour and by the end of the ceremony this stood at 2,070,132. It went on to rise into multi-million figures, crushing the record of 780,000 held by President Barack Obama and his wife, Michelle, for their self-portrait posted after his 2012 re-election.

The Future

T HE 50 cameras featured in this book represent some of the landmarks in photography. They show some of the technical milestones: cameras that were popular with the general public, those which allowed photographers to make the photographs they wished to make, and some of the quirky cameras produced over the past 175 years. The camera has progressed technically, with simplification and automation for the amateur and technical refinements for the serious user. It has also become portable and ubiquitous in a way that the early pioneers could have only dreamed.

The trend apparent from the mid-2000s has been one of convergence with other devices, principally the smartphone. Although the camera phone lacks some of the refinements and controls that a photographer would expect on either a compact camera or a DSLR, sales figures show that today's typical photographer — the equivalent of the 1900 Brownie photographer, the 1963 Instamatic user or the 1986 single-use camera owner — has become quite satisfied with just using a cellular device. The camera phone is striving toward the end-point of simplification and portability that started in 1839.

For many photographers the camera is no longer a separate device. It is part of a combined phone, MP3 player, gaming console, satnav and computer to access the Internet. In the past this might have meant that photographic quality was sacrificed as functionality was compromised, but this no longer holds true.

By 2012 there were some 6.7 billion active cell phone accounts, representing 5.2 billion active phones in use across the world. This represented around 4.3 billion unique cell phone owners/users — 60.1 percent of the world's population. Today, 22 percent of all phones in use globally are smartphones, although more than half of all phones in use can accept apps. In 2013 smartphones surpassed sales of all other types of phones for the first time, with some 6.7 billion in use around the world.

Of all the phones in use today, 83 percent are camera phones, and more than 90 percent of all humans who have ever taken a picture have only done so on a camera phone, not with a stand-alone digital or film-based traditional camera. On average, camera phone users capture still and moving pictures about eight times per day.

SHARING
The sharing of photographs through Facebook and specialized apps such as Instagram, which launched in 2010, shows no signs of diminishing. People are taking more photographs than ever before. In 2000 it was estimated that some 85 billion photographs had been taken since the invention of photography; today that number is 3.5 trillion. 250 million photographs are uploaded onto Facebook daily and some 40 million on Instagram. Photojournalists are now using their smartphones to shoot professional images.

LEFT **Photograph by Paul Hill, taken on the iPhone at night.**

Alongside the growth in the taking and sharing of photographs, the traditional camera is in decline. Between 2012 and 2013 the total shipment of cameras from Japan declined by some 43 percent, cameras with interchangeable lenses — mostly DSLRs — showing an 18 percent drop. While it is likely that the camera will continue in its traditional form for some time, servicing the professional or serious amateur photographer, for the majority of people there are few reasons to buy a separate camera.

The smartphone with a camera will be the way forward for many users. Innovations such as the Sony QX lenses can transform an iPhone or Android smartphone into a high-performance camera. They are cameras without screens that connect wirelessly to a smartphone so that its screen can be used for composing images. More importantly, they show how even the smartphone's lack of interchangeable lenses may yet be overcome.

Google Glass, too, offers the potential for new ways of making and sharing images beyond that of the smartphone. New technology such as the Lytro light field camera, which offers the ability to change the point of focus after exposure, could evolve into something more. The Lytro is now a niche product, but it may yet end up being incorporated into all imaging devices as part of the technological journey of simplification.

The history of the camera suggests that the next innovation will come out of nowhere. It may come from an established company but, more likely, it will be from an individual or a company in a different sector able to bring a new technology to bear on imaging — or one that develops a completely new device to make and share images.

For now, it seems the DSLR will continue to cater for a narrowing market of camera users, while the majority of us exclusively use our camera phones. And yet, photography's rich history as captured by the cameras featured in this book shows no sign of being forgotten. The popularity of applications such as Instagram and Hipstamatic demonstrates an enduring fascination with analog formats, while iconic models such as the Leica and Rolleiflex continue to be sought after; not just as collectors' items, but as a means by which to reconnect with the bare essentials of the photographic medium.

Glossary

Albumen process
Invented in 1850, using albumen (egg white) to hold the image. It was popular until the 1890s when gelatin overtook it.

Analog image
Generally used to refer to traditional photography methods as opposed to digital.

Aperture
The hole through which light passes, usually in front of or within the lens; it may be adjustable using washers or an iris diaphragm.

Aperture priority
A camera setting where the user sets the aperture, and the camera's electronics or mechanics determine the shutter speed.

Bakelite
An early thermoplastic invented by Leo Baekeland in 1907.

Bellows
A concertina arrangement of cloth, leather or card between the lens and camera back, to exclude light.

Bright lines
Guidelines visible in a camera viewfinder that show the angle of view of the fitted lens.

Calotype process
Patented by W.H.F. Talbot in 1841, this formed the basis of negative–positive photography.

Camera obscura
Optical device used by artists and others from the 17th century to aid drawing and painting.

CCD
Charge coupled device, which converts light to a digital signal.

Celluloid
Originally cellulose nitrate, it was used as a support for photographic emulsions, in sheets from 1879 and as flexible film from 1889; increasingly replaced by cellulose acetates from c.1934.

Chemical focus
A point of focus closer to the lens than the light ray point of focus. A corrected lens will ensure that chemical and visual foci coincide.

Collodion process
Described by Frederick Scott Archer in 1851 and popular until the 1870s.

Daguerreotype process
Announced in 1839 by Daguerre and popular until the late 1850s, it produced a highly detailed one-off image on a metal plate.

Digital image
An electronic image, usually produced directly using a CCD (see also still video capture).

Extinction meter
A device to measure light for gauging photographic exposure. Usually separate, but sometimes built into a camera.

Ferrotype/tintype
A photograph made using a direct positive process in the camera on to iron sheets coated with a sensitive emulsion.

Flash memory
A type of data storage with no moving parts, making it less susceptible to damage; invented by Toshiba in 1984.

F-number
A number that indicates the size of the aperture through which light passes through the camera lens.

Focal-plane shutter
A shutter usually consisting of one or more blinds of metal or cloth mounted at the back of the camera, close to the camera's focal plane.

Full-aperture meter
A light meter that measures the light entering the lens at the aperture at its widest setting.

Gelatin process
Gradually introduced from c.1871, gelatin was used to suspend light-sensitive compounds, and it remains in use today.

Great Exhibition 1851
The first international trade exhibition, which took place in London and gave a major boost to photography.

Half-plate
A glass negative measuring approx. $4\frac{3}{4} \times 6\frac{1}{2}$ inches (120×165 mm).

Lens
An optical device designed to transmit and refract light.

Megapixel (MP)
One million pixels; used to describe the number of sensor elements in a digital camera.

Meniscus lens
A simple lens with one convex and one concave face; usually found on the cheapest cameras.

Negative
Processed photographic emulsion where the blacks appear clear, and the light areas black; when printed it produces a positive.

Panorama
A wide-angle image made up of one or more separate photographs.

Pentaprism
A five-side prism used to redirect a light beam by 90 degrees, typically found in the single-lens reflex camera viewfinder from the mid-1950s.

Photogenic drawing
A process invented by W.H.F. Talbot c.1835, the forerunner of the calotype.

Photojournalism
The taking of images to present a news story in a factual manner.

Plate
Usually refers to a glass plate coated on one side with a light-sensitive emulsion, exposed to produce a negative.

Positive
An image showing the correct tones, printed from a negative or produced directly.

Quarter-plate
A glass negative measuring approx. 3¼ × 4¼ inches (90 × 120 mm).

Rangefinder
A device that uses two lenses and a mirror to measure distance. It may be a separate accessory or mounted in a camera and either uncoupled or coupled directly to the camera lens.

Reflex camera
A camera that uses a mirror to direct light from the subject for viewing. It may be combined with the taking lenses (SLR) or separate (TLR).

Roll film
A paper, or more usually celluloid, strip, coated on one side with a light-sensitive emulsion.

Roll holder
A device mounted inside or on the back of a camera to hold and transport roll film.

Shutter
A device mounted in front of, within or behind a lens to allow light to pass through for a predetermined period of time.

Shutter priority
A camera setting where the user sets the shutter speed, and the camera's electronics or mechanics determine the correct aperture.

Single-lens reflex (SLR) camera
A camera in which the taking lens is used to view the image via a mirror that is moved out of the way when the exposure is made.

Stereograph
A paper, glass or metal support holding two images taken from slightly different viewpoints, for viewing in a stereoscope.

Stereoscope
A device in which two slightly different images are viewed to produce a 3-D effect.

Still video capture
An analog electronic image capture that requires further conversion to a digital format.

Stop-down meter
A light meter that measures the light entering the lens at the set aperture.

Subminiature camera
A camera producing a negative smaller than a standard 35 mm negative (1 × 1½ inches/ 24 × 36 mm).

Time setting
A shutter setting where the shutter remains open from an initial pressure on the shutter release button and closes when pressed a second time.

Twin-lens reflex (TLR) camera
A camera with two lenses, usually mounted above each other, sometimes horizontally, one for viewing, the other for making the exposure.

Whole-plate
A glass plate measuring approx. 8½ × 6½ inches (165 × 215 mm), used from 1839.

Bibliography and Acknowledgments

FURTHER READING AND RESOURCES

Aguila, Clément and Michel Rouah, *Exakta Cameras 1933–1978*, Hove Foto Books, 1987.

Brayer, Elizabeth, *George Eastman*, John Hopkins, 1996.

Cecchi, Danilo, *Asahi Pentax and Pentax SLR 35mm cameras 1952–1989*, Hove Foto Books, 1991.

Channing, Norman and Mike Dunn, *British Camera Makers: An A–Z Guide to Companies and Products*, Parkland Designs, 1996.

Coe, Brian, *Cameras: From Daguerreotype to Instant Pictures*, Marshall Cavendish, 1978.

Coe, Brian, *Kodak Cameras: The First Hundred Years*, Hove Foto Books, 1988.

Eder, J. M., *History of Photography*, Columbia University Press, 1945.

Gaunt, Leonard (ed.), *Cameras: The Facts: A Collector's Guide 1957–64*, Focal Press, 1981.

Harding, Colin, *Classic Cameras*, Photographers' Institute Press, 2009.

H.P.R., *Leica Copies*, Classic Collection Publications, 1994.

van Hasbroeck, P.H., *Leica: A History Illustrating Every Model and Accessory*, Sotheby Publications, 1993.

Koch, Uli, *Nikon F*, vols. I-III, Westlicht, 2003.

Lager, James L., *Leica: An Illustrated History*, vols. I-III, Lager Limited Editions, 1993.

Lea, Rudolph, *The Register of 35mm Single-Lens Cameras*, Wittig Books, 1993.

Lothrop, Eaton S., *A Century of Cameras*, Morgan and Morgan, 1982.

McGarvey, Jim, *The DCS Story: 17 Years of Kodak Professional Digital Camera Systems 1987–2004*, privately published, June 2004.

Olshaker, Mark, *The Instant Image*, Stein and Day, 1978.

Pritchard, Michael, *Photographers*, Reel Art Press, 2012.

Pritchard, Michael and Douglas St Denny, *Spy Camera: A Century of Spy, Subminiature and Detective Cameras*, Classic Collection, 1988.

Pritchard, Michael, *The Development and Growth of British Photographic Manufacturing and Retailing 1839–1914*, unpublished PhD thesis, 2010.

Spira, S. F., *The History of Photography: As Seen Through the Spira Collection*, Aperture, 2001.

Sugiyama et.al., *The Collector's Guide to Japanese Cameras*, Kodansha Amer Inc., 1985.

White, William, *Subminiature Photography*, Focal Press, 1990.

ORIGINAL MATERIALS

For the pre-1980 cameras, extensive use has been made of original photographic periodicals, manufacturers' trade catalogs, trade literature and contemporary reviews. In particular, the *British Journal of Photography* and *Photographic News* and their respective year books, the *Almanac* and *Year Book*. *Photographica World*, the journal of the Photographic Collectors Club of Great Britain (www.pccgb.com), has also been consulted.

WEBSITES AND ONLINE RESOURCES

www.canon.com/camera-museum
Canon online camera museum.
www.digicamhistory.com
A history of the digital camera.
www.earlyphotography.co.uk
A collection of British and historic cameras.
http://foxtalbot.dmu.ac.uk
The correspondence of William Henry Fox Talbot.
www.gsmhistory.com
A history of the mobile phone.
www.olympus-global.com/en/corc/history
Olympus company history.
www.the-impossible-project.com
The Impossible Project and modern instant photography.
www.vivianmaier.com
Official website of the photographer Vivian Maier.

MUSEUMS

Deutsches Museum, Munich, Germany. www.deutsches-museum.de
FoMu – FotoMuseum Provincie Antwerpen, Belgium. www.fotomuseum.be
George Eastman House, Rochester, NY, USA. www.eastmanhouse.org
JCII Camera Museum, Tokyo, Japan. www.jcii-cameramuseum.jp
Musée des arts et métiers, Paris, France. www.arts-et-metiers.net
Musée suisse de l'appareil photographique, Vevey, Switzerland. www.cameramuseum.ch
National Media Museum, Bradford, UK. www.nationalmediamuseum.org.uk
Preus Museum, Norway. www.preusmuseum.no

ACKNOWLEDGMENTS

With thanks to Paul Hill; Robert Tooley; Jonathan, The Spira Collection; Jonathan Bell, Magnum Pictures; Rydwan bin Anwar, Singapore; John Chillingworth; Colin Harding, curator, National Media Museum, UK; Takayuki Kawai, USA and Japan; and Gerjan van Oosten, Netherlands.

Index

Index

Image Credits

p. 8, 14, 17, 25, 33, 36, 62, 79, 101 © SSPL via Getty Images

p. 12, 31 (top), 34, 35, 50, 52, 53 (top), 60, 80 © www.earlyphotography.co.uk

p. 23, 49 © Hulton Archive | Getty Images

p. 28, 44, 46, 200, 204 © The Spira Collection

p. 41 © Roi Boshi | Creative Commons

p. 43 © Photo: Størmer, Carl Fredrik Mülertz | Norsk Folkemuseum

p. 56 © 2014 by AUCTION TEAM BREKER, Cologne, Germany (www.Breker.com)

p. 63 © picture by Ruud Hoff

p. 65 © Simon Strijk | Creative Commona

p. 73 © Digital image courtesy of the Getty's Open Content Program

p. 74, 94, 111 (bottom), 125, 166, 172, 176, 192 © Donald Baldwin

p. 83 © image kindly provided by the Royal Air Force Museum

p. 86 © Copyright bpk - Bildagentur fuer Kunst, Kultur und Geschichte 2005

p. 91 © Michael Pritchard

p. 92 (left) © Henri Cartier-Bresson | Magnum Photos

(right) © Les Hotels Paris Rive Gauche | AlainB | Creative Commons

p. 93 © Henri Cartier-Bresson | Magnum Photos

p. 98/9 © Robert Capa | International Center of Photography

p. 105 (bottom) © Leif Skandsen | Creative Commons

p. 106 © 2014 by AUCTION TEAM BREKER, Cologne, Germany (www.Breker.com)

p. 109, 136, 137, 175, 213 © Getty Images

p. 113 Time & Life Pictures/Getty Images

p. 115 © Josef Koudelka | Magnum Photos

p. 126 © John Kratz | Creative Commons

p. 134 © Popperfoto | Getty Images

p. 135 © Joe Rosenthal | AP/PA Images

p. 142 © Morinaka | Creative Commons

p. 143 (top) © Rainer Knäpper | Free Art License

p. 144 Collection Center for Creative Photography, The University of Arizona © 2014 The Ansel Adams Publishing Rights Trust

p. 146–149 © from the Pinsky-Starkman Collection

p. 153 © Elliott Erwitt | Magnum Photos

p. 154/5 © The Harry Ransom Center, The University of Texas at Austin

p. 156, 157 © Chicago Press

p. 158 © Vivian Maier | Maloof Collection – Courtesy Howard Greenberg Gallery

p. 163 © Photos 12 | Alamy

p. 164 © AFP | Getty Images

p. 165 (top) © Paul Hill

p. 165 (bottom) © Bruce Davidson | Magnum Photos

p. 168 © Matthias Lensing-Rossbach, Germany

p. 169 © Joost J. Bakker IJmuiden | Creative Commons

p. 170 (top left) © John Nuttall | Creative Commons

(top right) © Alfred Wein | Creative Commons

p. 171 © Guy Le Querrec | Magnum Photos

p. 178 © Jussi | Creative Commons

p. 179 © Uberprutser | Creative Commons and © Daft racer | Creative Commons

p. 180 © Dennis Stock | Magnum Photos

p. 182, 197, 199, 202 © Marc Aubry | Creative Commons

p. 186 © 2014 The Andy Warhol Foundation for the Visual Arts, Inc. | Artists Rights Society (ARS), New York and DACS, London

p. 189 © The Washington Post | Getty Images

p. 190 © John Nuttall | Creative Commons

p. 194 © Morio | Creative Commons

p. 196 © John Wade

p. 203 © Ronald A. Edmonds | AP/PA Images

p. 206 Canon 5D Mark III © Canon

p. 208, 215 © Maria Falconer and © Paul Hill

p. 210 © Karlis Dambrans | Creative Commons

All other images are either © Michael Pritchard or are in the public domain.